IMAGES
of America

CEMETERIES
OF TACOMA

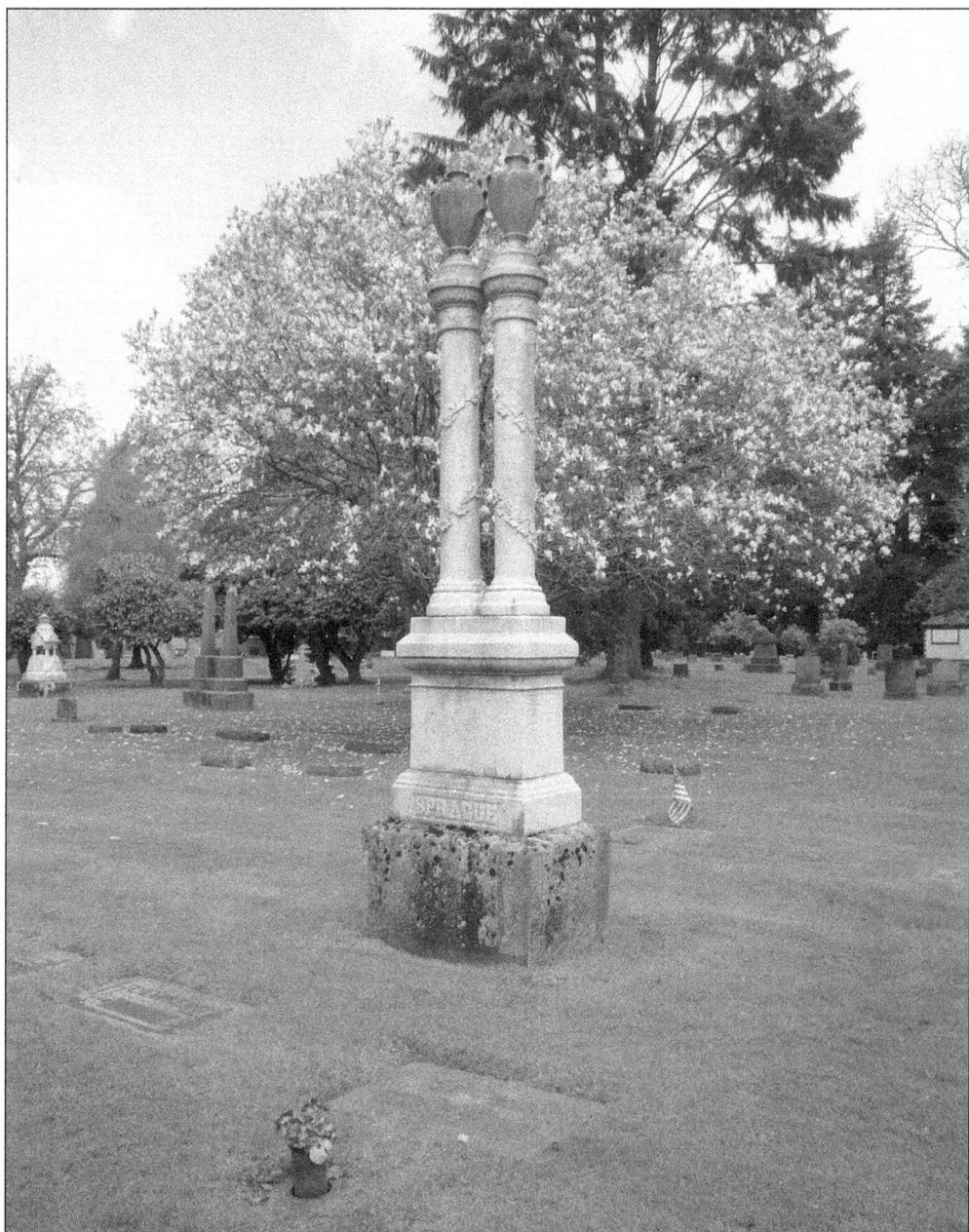

SPRAGUE FAMILY MONUMENT. Brig. Gen. John W. Sprague, a hero of the Civil War, cofounded Tacoma and served as the fledgling city's first mayor. Sprague received the Medal of Honor from Congress for gallantry during the Battle of Decatur in 1894. (Courtesy of author's collection.)

ON THE COVER: Thea Foss was born June 8, 1857, and died June 7, 1927—one day short of her 70th birthday. Foss was a celebrated businesswoman, and her funeral was attended in grand style and in grand numbers. It was the largest funeral memorial the cemetery had seen to date. It has been reported that all the trademark green and white flags of the Foss Company flew at half-mast in honor of "Mother Foss." (Courtesy of the Tacoma Public Library.)

IMAGES
of America

CEMETERIES
OF TACOMA

Kris Anderson Reisinger

ARCADIA
PUBLISHING

Published by Arcadia Publishing
Charleston, South Carolina

Library of Congress Control Number: 2010942564

For all general information, please contact Arcadia Publishing:
Telephone 843-853-2070
Fax 843-853-0044
E-mail sales@arcadiapublishing.com
For customer service and orders:
Toll-Free 1-888-313-2665

Visit us on the Internet at www.arcadiapublishing.com

To my husband, Dave, the love of my life. Dave has always encouraged me to pursue my passions. And more than anyone else, he has shown me and comforted me with the fact that the only true thing that remains immortal is love.

"Unable are the loved to die. For love is immortality."

—Emily Dickinson

CONTENTS

ACKNOWLEDGMENTS

I want to thank my children, D.J. and Jessica, for affording me precious time during the holidays to work. To my dear husband who took over carpool and basically every other responsibility of mine so that I could concentrate on this project: You have my respect, gratitude, and love.

A quick thank you to my best girl friends: Linda Hendrickson, Alison Pride, Kathryn Sharp, Gail Brock, Jean Coy, and Stephanie Yonker. Your friendship broadens my world view and my heart. Plus, you help me to be brave and take on ambitious goals, like this book.

To all the cemeteries and funeral homes that opened their doors for me: it is my pleasure to know you and my privilege to tell part of your story.

To Bill Habermann: your zeal for cemetery history is inspiring. To Fred Morley: thank you for allowing me to use your desk and scan images and documents from your personal collection. To Jack Harding and Tom McKee: thank you for being so welcoming and for letting me photograph special rooms and equipment in your funeral homes. And to Christopher Engh: my heart-felt appreciation for your support and guidance throughout this entire endeavor.

To the countless people who took time out of their days (and evenings) to help me locate images and information, thank you. To Gerry Knight for savvy technical support, thank you.

All photographs are from the Tacoma Public Library (TPL) unless otherwise noted. I am indebted to the Northwest Room staff for all their gracious help and assistance.

Regarding certain facts and time lines: Cemetery and funeral home history is sometimes hard to nail down. I based most of my information on what was available to me through the Tacoma Public Library, stories from local funeral directors, history websites, various books and news articles, and cemetery folklore. What you have before you is my best effort to accurately bring you a slice of the Tacoma cemetery history that has long captivated me.

Funeral director Bill Habermann contributed the following reflection as I researched this book: "Gone are the carriage roads, gone are the park areas, gone are the picnics on Sundays, and gone are the family members. In the early days of Tacoma cemetery lore, Sunday picnics in the cemetery were a regular thing. Can't you just imagine the hoof-beats and the creaking, wooden-spoked wheels making sounds in the quiet of the cemetery? Children running about among the polished, yet silent, headstones while the smells from the picnic baskets made one hungry. I remember my grandmother telling me, "Don't walk on the graves!" Yes, gone are those good old days but thanks to the writing of this book, the memories of cemeteries, and those resting there will be given new life. Perhaps after you have read this volume, you may want to take a trip to one of the cemeteries highlighted by this book, and try to imagine the century gone by and a Sunday trip for a picnic in the cemetery. Isn't nostalgia great?"

Finally, thanks to my niece Ashleigh Midkiff Lamken, who, in the midst of so much thinking about death, allowed me to rejoice in the miracle that is life by inviting me to attend the birth of her beautiful daughter Lauren.

INTRODUCTION

Celebrated poet, author, and funeral director Thomas Lynch had a very creative solution to the idea that, sooner or later, we will run out of room for places to bury our dead. In his book *The Undertaking*, he muses, "There are roughly 10 acres in every par four. Eighteen of those and you have a golf course. Add 20 acres for practice greens, clubhouse, pool and patio, and parking and 200 acres is what you'd need. Now divide the usable acres, the 100 and 80, by the number of burials per acre—1,000—subtract the greens, the water hazards, and the sand traps, and you still have room for nearly eight thousand burials on the front nine and the same on the back . . . laugh all you want, but do the math."

Of course there was no fear of running out of room to bury townspeople when Tacoma could barely be considered a village. Job Carr arrived on the shores of what would soon be called Commencement Bay in 1864. In 1868, Matthew McCarver arrived on the scene and liked what he saw: mountains, rivers, and the potential for a railroad. In 1873, the Northern Pacific Railroad chose Tacoma over Seattle for its western terminus. It also deeded 60 acres of prairie land for burial purposes in the south end of Old Tacoma. An early advertisement for Tacoma read, "Come to Tacoma—it's a good life!" And indeed it was becoming just that. Thea Foss bought her first boat in 1889. Now, 122 years later, the company she founded is thought to be one of the largest tugboat firms on the West Coast. Tacoma had become the "City of Destiny," full of hope and life.

As pioneers staked their claims, loved ones would sometimes be buried on their homesteads. Many of these burial grounds have long been abandoned and any evidence lost. However, smaller cemeteries that contain up to 100 graves can still be located. One such cemetery is found within the compound of Joint Base Lewis-McChord. Visitors are required to gain clearance from the firing range because the cemetery is in the red zone where active fire occurs on a regular basis. Another pioneer cemetery is located 100 yards from the South Tacoma State Game Farm's offices, known as the Byrd Cemetery. It began when pioneer Adam Byrd was laid to rest in 1853. One last example is the Settlers Cemetery in Lakewood. Over time, it has shortened its boundaries. It is rumored that some of the deceased are even buried under Washington Boulevard!

Another intriguing cemetery rumor is that of the Old Woman's Gulch, located in the Stadium District of North Tacoma. The gulch was originally named after the old longshoremen's widows who were displaced during the construction of the sports field attached to Stadium High School. The area was once filled with makeshift homes lining the waterway. Women lived in the area, waiting for their men to return from war or from fishing. Some men—many whose funeral records cannot be located—came home in pine boxes. The gulch is rumored to have had many handmade, wooden crosses that dotted the area. Women would bring flowers and leave them at what seemed to be burial sites. As time passed and the land was sold, it is believed that this area was simply paved over and made into what is now the Stadium Bowl. When the author tried

to verify this rumor, an anonymous, second-generation Tacoma pioneer said he remembered his grandfather telling him about the gulch being sold, and about all the little wooden crosses that the backhoes unearthed and pitched into piles along with all the dirt.

Many vintage images and stories have been lost since people in Tacoma started burying their dead more than a century ago. Funeral homes have changed hands several times, and many stories have disappeared with each family. The last chapter of this book includes a special, behind-the-scenes look at the tools of the funeral trade. Please enjoy this collection of cemetery history—exclamation points in an otherwise long history of caring for the dead and their loved ones.

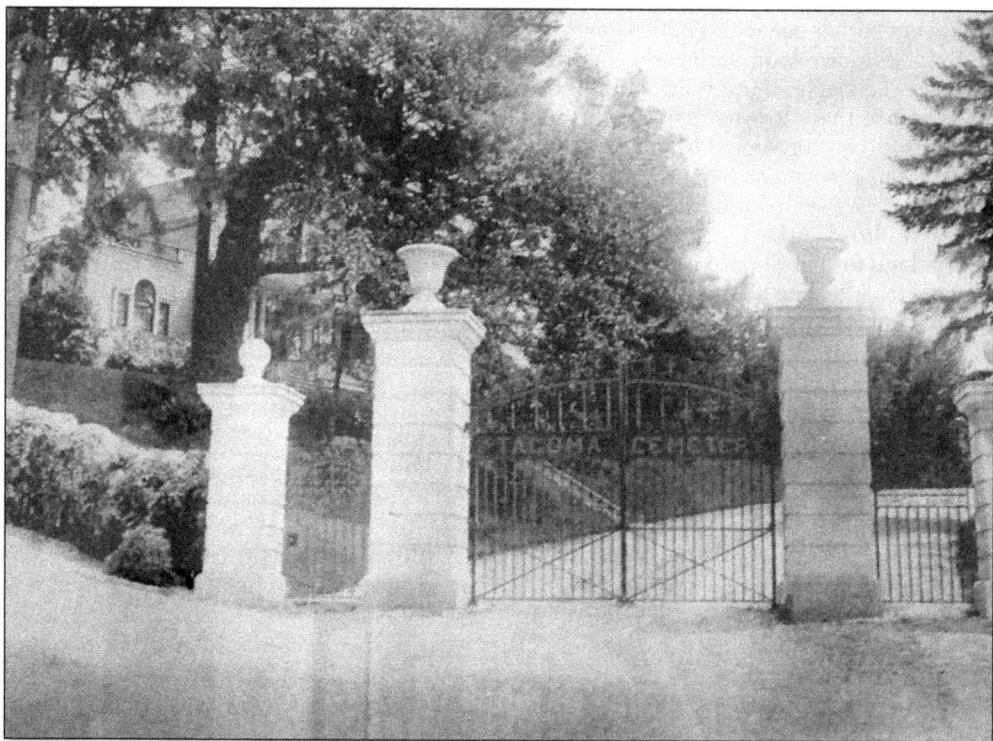

OLD TACOMA GATE. Back in the horse-and-buggy days, one-road entrances were commonplace. The Old Tacoma Cemetery gate pictured here dates back to 1885. A dirt road leads to the cemetery and the caretaker's cottage. The cottage was a beautiful example of the Craftsman-era architecture of the early 1920s. In addition to housing the caretaker and his family, the house served as the main office for the cemetery. The cottage was eventually moved across the street, and at some point, it was demolished. The inner columns of the gate were also razed to make room for the automobile; a two-way traffic entrance was needed. (Courtesy New Tacoma Cemeteries and Funeral Home.)

One

New Tacoma Cemeteries and Funeral Home

The Prairie Cemetery, which later became the Old Tacoma Cemetery, was established in 1874. Officially, the first adult burial on record was of Gen. Morton Matthew McCarver in 1875. But according to Bill Habermann, a funeral director with Piper-Morley-Mellinger Funeral Home, the earliest burial could have been a 19-year-old girl by the name of Frances Desdemona Coulston. According to Habermann, her burial is recorded on page 40 of the Old St. Peter's Church register under the heading, "Buried—Entry No. 5." The church register goes on to say, "[buried] . . . in the ground just allotted for a cemetery by the R.R. or Town Co. being the first burial there." It is quite curious, and Habermann speculates whether or not her burial was indeed the first burial at the Prairie Cemetery or the first burial that the priest presided over at that cemetery. Perhaps she is buried outside of the cemetery wall. By 1884, about 1,300 lots had been platted, and some of these graves were outside the bounds of the 20 acres sold to the Tacoma Waterworks (now South Park).

The Old Tacoma Cemetery was run by the city until 1884, when it was turned over to the families who owned plots. It is uncertain when the Prairie Cemetery split apart and became what is known today as the Old Tacoma Cemetery and the Oakwood Hills Cemetery. A rumor suggests that two brothers were at odds with one another; one ran the Old Tacoma Cemetery while the other ran Oakwood Hills Cemetery.

It seems that no sooner had a good portion of land been set aside for burial that other folks came forward with different ideas about how the land could be put to good (that is, profitable) use. At some point, those who were acting as trustees for the cemetery sold 17 acres to the Tacoma Light & Water Company. Subsequently, the Tacoma Light & Water Company sold 11 acres to Byron Barlow and others who wanted to develop the land into a racetrack. A racetrack next to the dearly departed as they try to sleep—it was a scandal, to be sure.

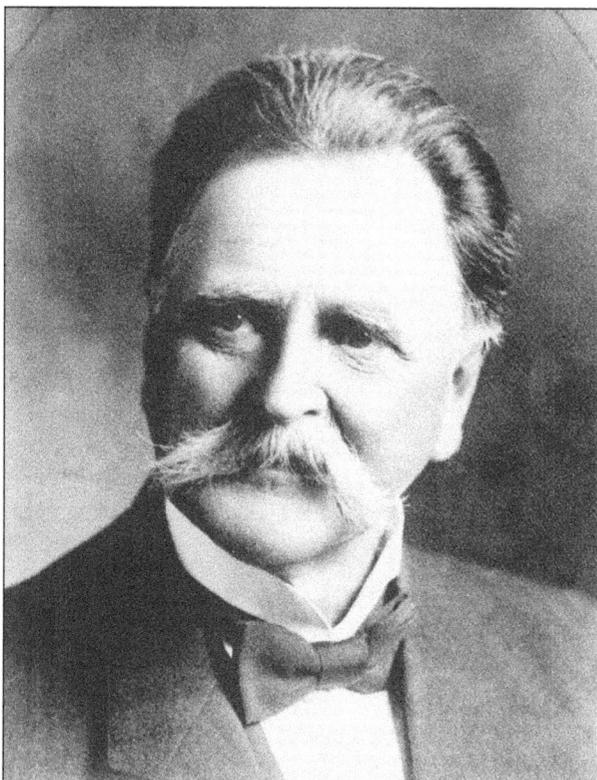

ANGELO VANCE FAWCETT. Angelo Fawcett was said to be one of Tacoma's most charismatic mayors. He served four separate terms as mayor: 1896–1897, 1910–1911, 1914–1919, and 1922–1926. According to the Tacoma Public Library, he finally retired after a defeat by Melvin G. Tennent in 1926. Pictured with a full mustache, Fawcett poses in this photograph from about 1910, which is part of the Richards Studio collection held by the Tacoma Public Library.

FAWCETT FAMILY MARKERS. Buried in this older section of the cemetery is Angelo Vance Fawcett and son C. Val Fawcett. (Courtesy author's collection.)

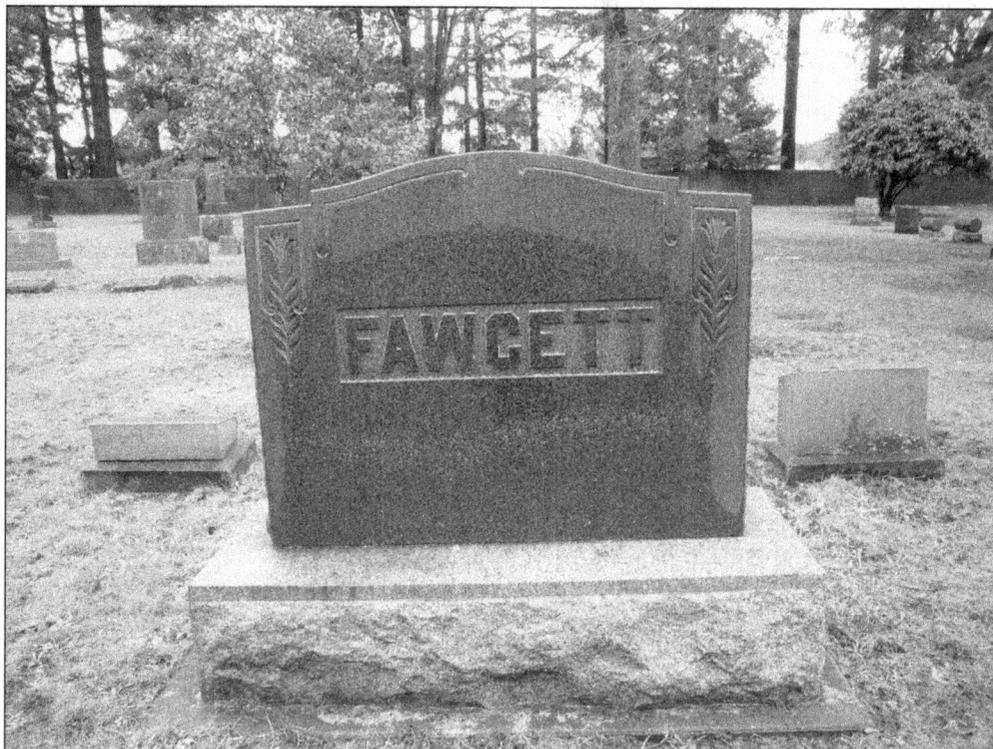

C. VAL FAWCETT. C. Val Fawcett is pictured in a suit and tie in the late 1940s. The younger Fawcett followed in his father's footsteps and became the mayor of Tacoma in 1946. Val was an expert in finance and served the public as a finance commissioner. After retiring in 1950, he became a consultant for McLean & Company.

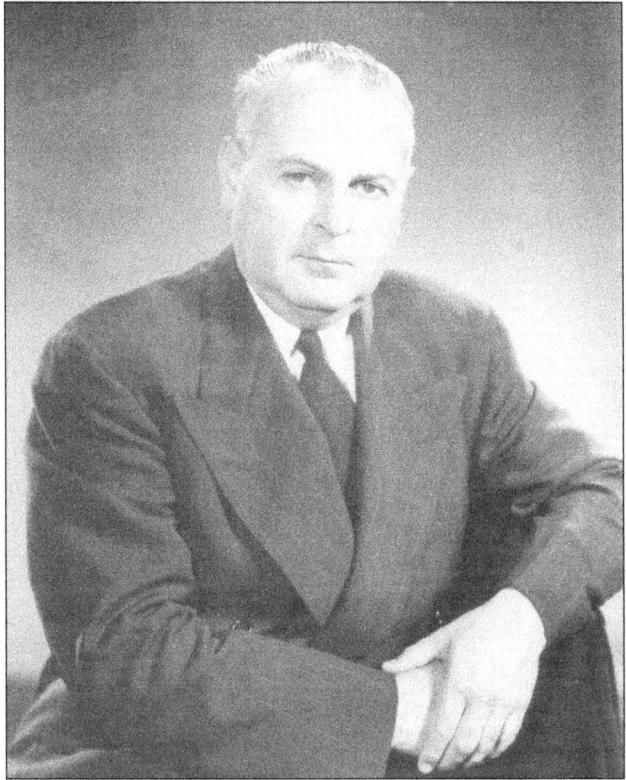

TUBERCULOSIS IN THE 1940S. The X-ray was invented in 1895 and proved to be quite handy in the diagnosis of tuberculosis. Attempts at a cure were largely unsuccessful, even up to the late 1940s. Pictured here, mayor Val Fawcett (left) and mayor Nelson Morrison promote free X-rays.

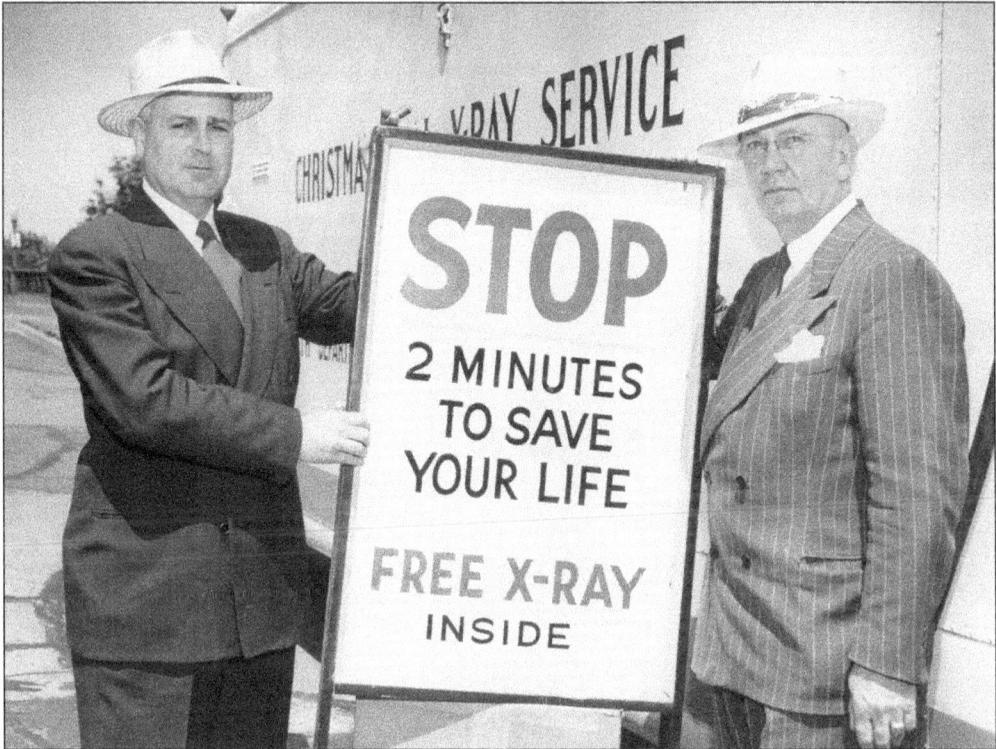

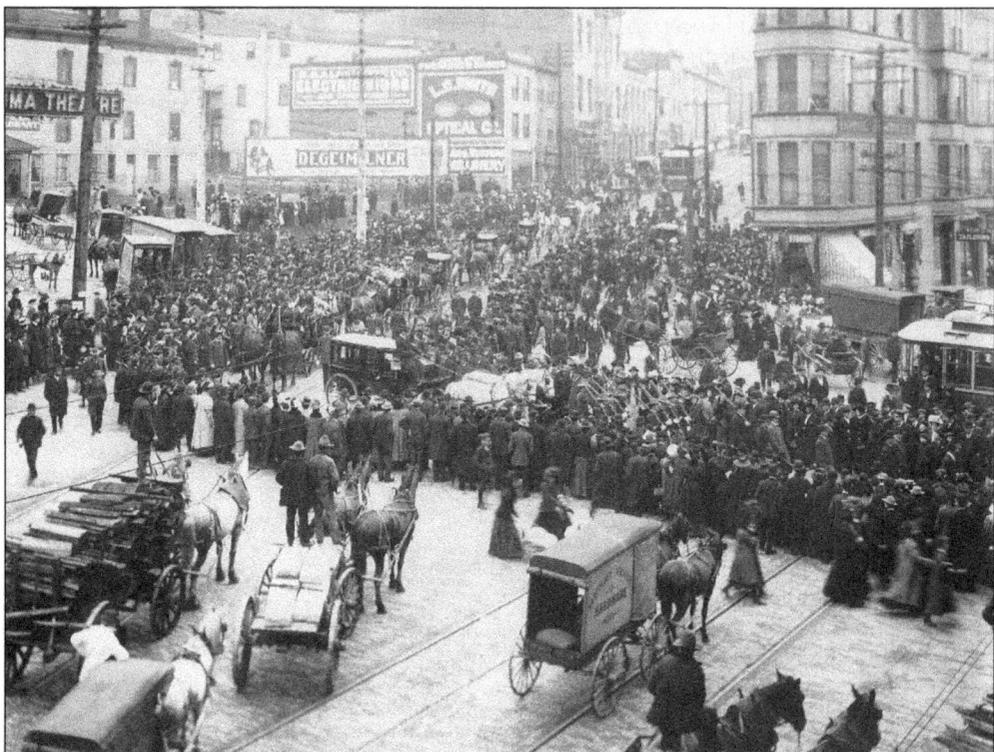

EARLY-1900S FUNERAL PROCESSION. According to a copy of the *Tacoma Daily Ledger* from 1908, a tremendous group gathered in downtown Tacoma to watch the funeral procession of Lt. George M. Hill, a fireman with Fire Engine Company No. 4. Hill was killed while trying to manage a fire at the Davis Smith & Company building on February 24, 1908. Hose wagon No. 4, which had transported Hill to the fire, carried his remains to the Tacoma Cemetery. A platoon of patrolmen, an 18-piece band, visiting fire chiefs, representatives of the fire department, and a guard of Spanish-American War veterans marched in the procession. It was estimated that 5,000 to 10,000 sorrowful residents paid tribute to the fallen firefighter as they flanked both sides of St. Helens Avenue and extended along Pacific Avenue.

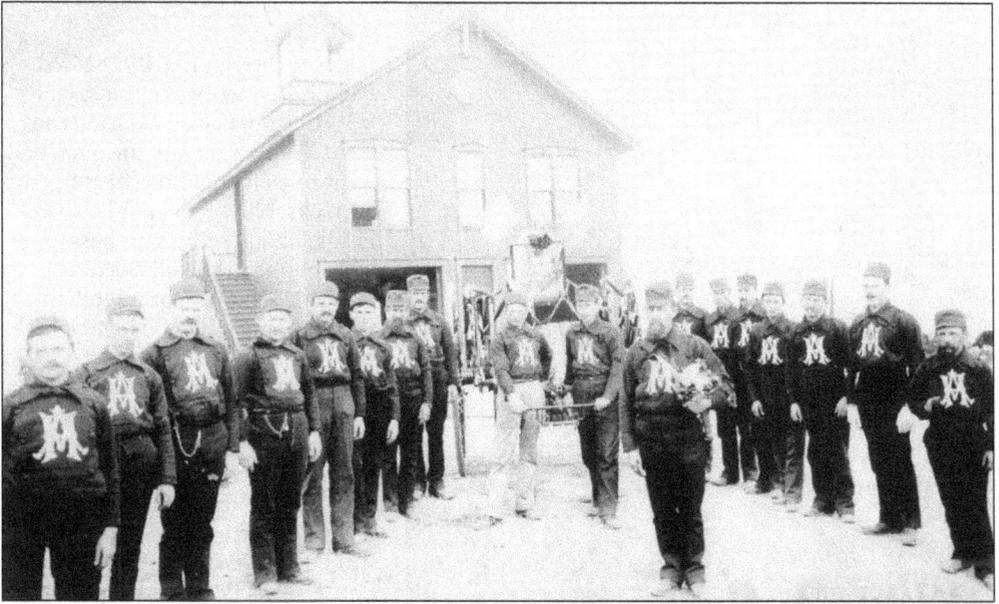

TACOMA'S ALERT HOSE COMPANY No. 2. Capt. Adelbert Uriah Mills (center, holding bouquet) and Tacoma's Alert Hose Company No. 2 pose for a photograph from about 1885. The volunteer company members are dressed in their formal uniforms and waiting in queue to participate in the funeral parade for former president Ulysses S. Grant, who passed away on July 23, 1885. The wagon had an adorned, framed picture of the president on board. The territorial governor of Washington declared the day of his funeral an official day of mourning. In the early days of urbanization, volunteer companies like this one relied on a strong sense of brotherhood as well as an inventive spirit—it has been noted that the volunteers may have built the company's hose apparatus. (Right, courtesy author's collection .)

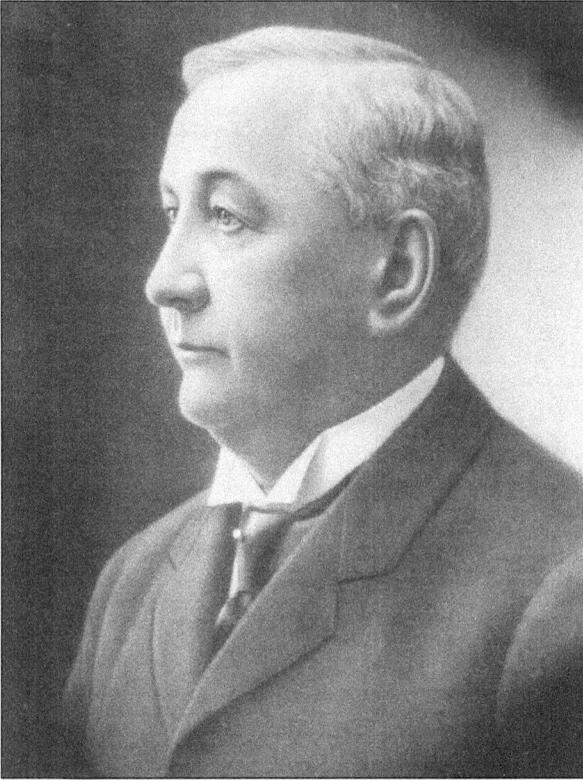

NELSON BENNETT, A BUSY MAN.
Nelson Bennett was a transplant from Sutton, Canada, during the Civil War. Settling in Tacoma, he went to work building government barracks. Nelson did not believe in idle hands, so he kept busy by dabbling in the oil business, teaching school, fighting Indians, and shipping freight. The freight business launched his career; Bennett built railroad tunnels and is best known for the Stampede Pass tunnel, which he built with his younger brother, Capt. Sidney Bennett. Nelson also built the Point Defiance tunnel, which still bears his name today. Widow Lottie Wells Bennett completed the tunnel after her husband's death. It has been said that Lottie was quite a businesswoman and finished the tunnel under budget. Nelson also owned the *Tacoma Daily Ledger* and the Tacoma Hotel.

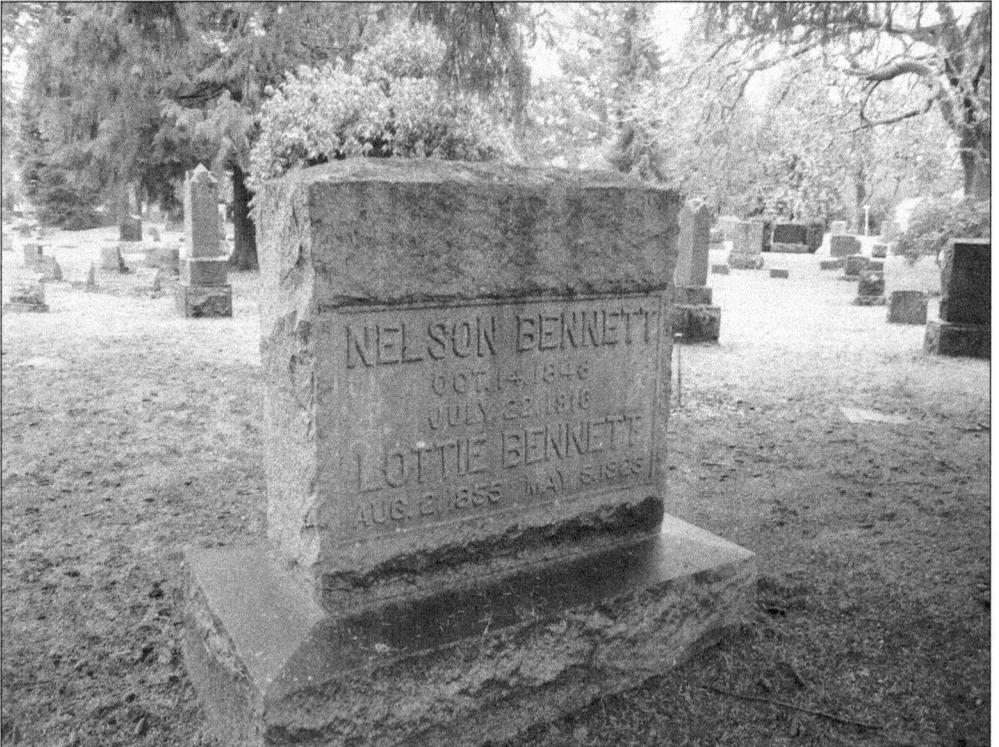

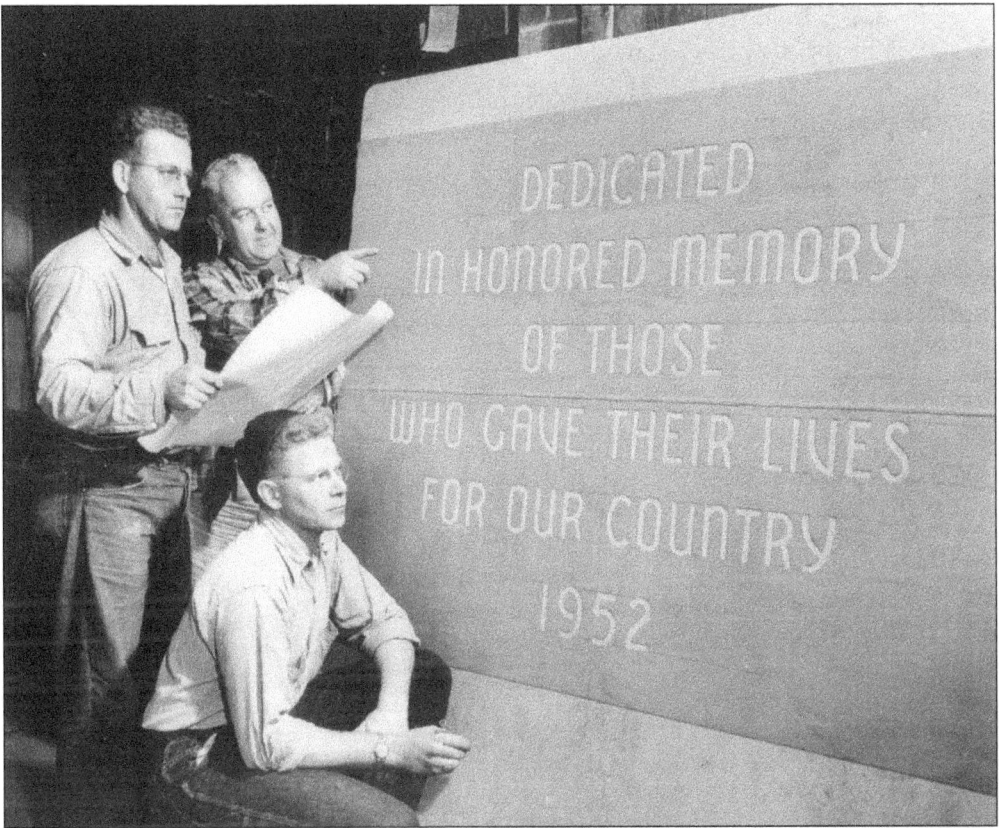

LIVING WAR MEMORIAL. Above, plans are being consulted before the six-foot plaque made of Wilkeson sandstone is placed into the 20-foot stone monument. The Tacoma Bricklayers and Hod Carriers Unions built the monument, which has now been removed for the construction of the new Tacoma Narrows Bridge. Pictured above are Don Wahlstrom (kneeling), George Robinson (holding plans), and father Earl Robinson.

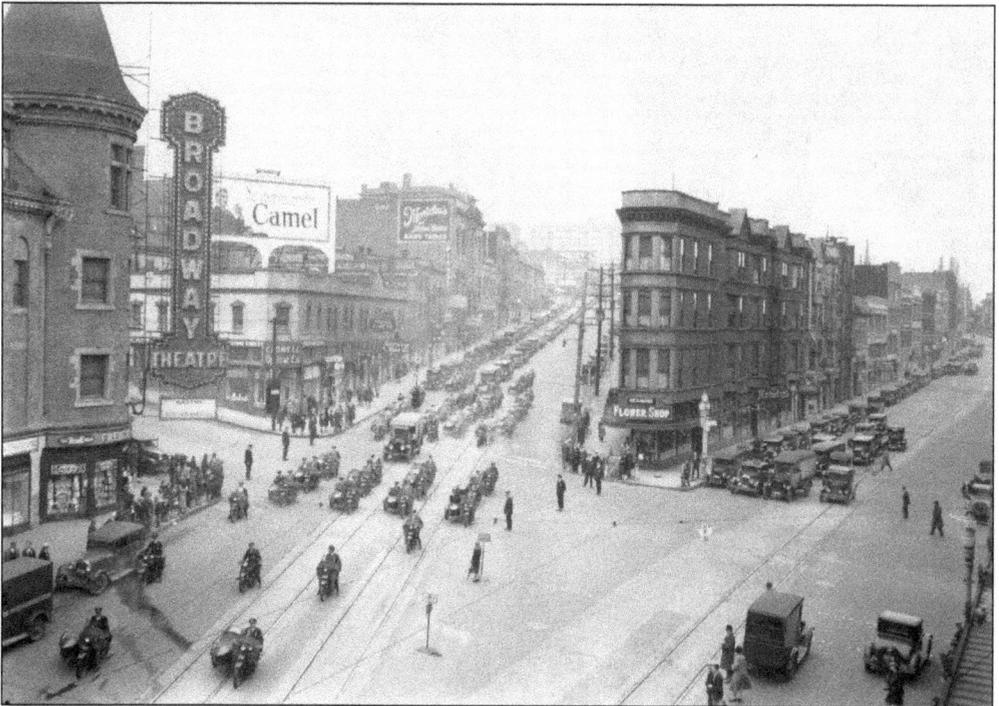

HONOR GUARD FUNERAL PROCESSION. The Officer Down Memorial Page, Inc., states, "Patrolman [Conrad C.] Tolson was killed in a motorcycle accident while patrolling the Seattle-Tacoma Highway near the Pierce County–King County line. Another vehicle came into his travel lane, and he swerved to avoid a collision. He was thrown from the bike and suffered fatal injuries. He succumbed to the injuries the following day." The date of passing, known as the "End of Watch," was Sunday, March 24, 1929. According to the Tacoma Public Library, an honor guard of motorcycle officers from Tacoma and Seattle led the funeral procession. This photograph can be compared to the photograph of an early 1900s funeral procession on Page 12; those two photographs show the same corner in downtown Tacoma approximately 20 years apart.

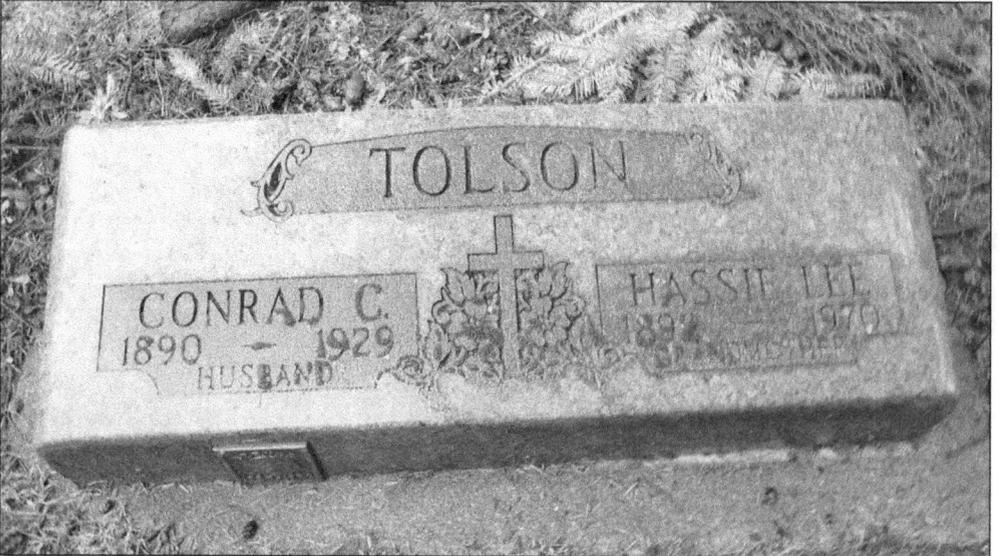

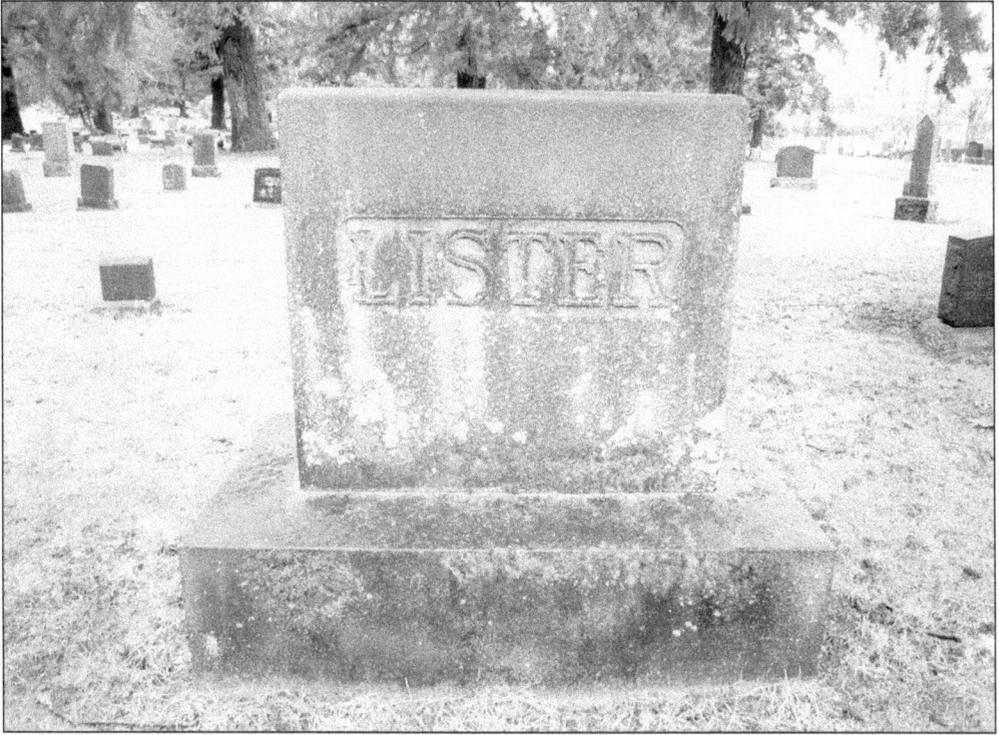

Gov. Ernest Lister Funeral Procession. Lister joined the Democratic Party in 1900 and was elected the eighth governor of the state of Washington in 1913. He died while in office on June 14, 1919, one day short of his 48th birthday. Lister was born in Halifax, England. He married Alma Thornton, and they had two children. As governor, he was especially concerned about agricultural aid, irrigation and reclamation projects, and state industrial accident insurance. It has been said that his efforts helped to bring the eight-hour workday to the Pacific Northwest. As the commander in chief of the Washington National Guard, Lister was buried with full military honors. Six hundred men from six companies marched in the procession. Armed soldiers boarded streetcars to the cemetery in South Tacoma. On June 14, 1919, the *Tacoma News Tribune* reported that Company D fired three volleys as the casket was lowered into the gravesite. Other companies present included Headquarters Company, Companies A, B, and C, the Regimental Infirmary of Seattle, and Company F of Tacoma.

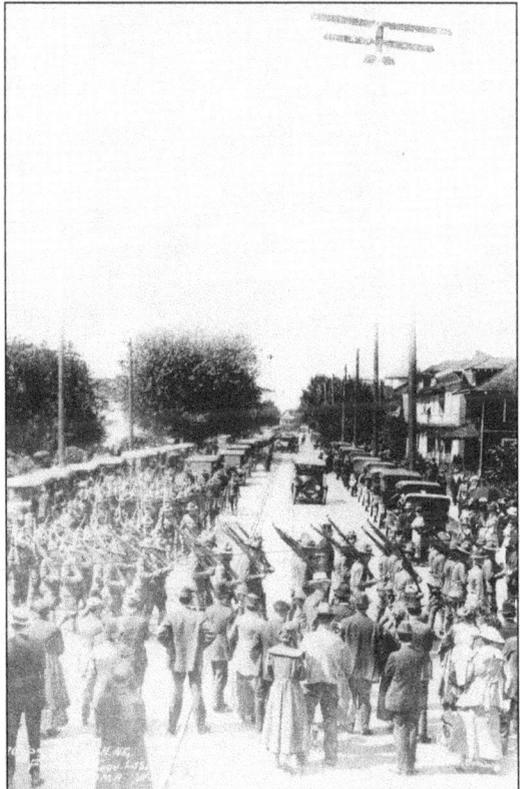

17

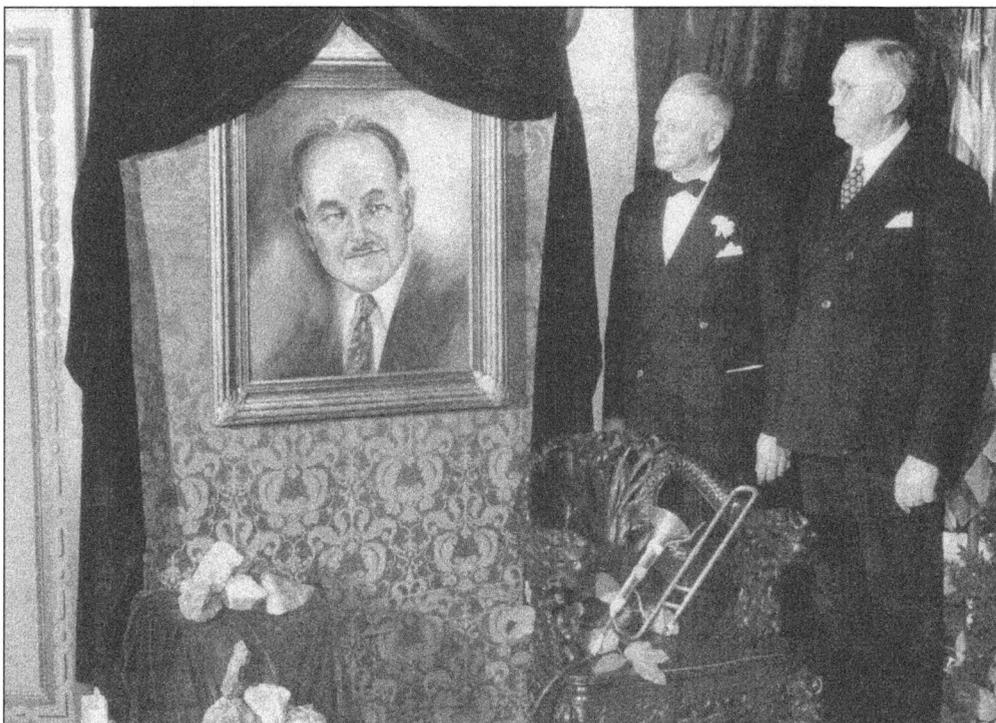

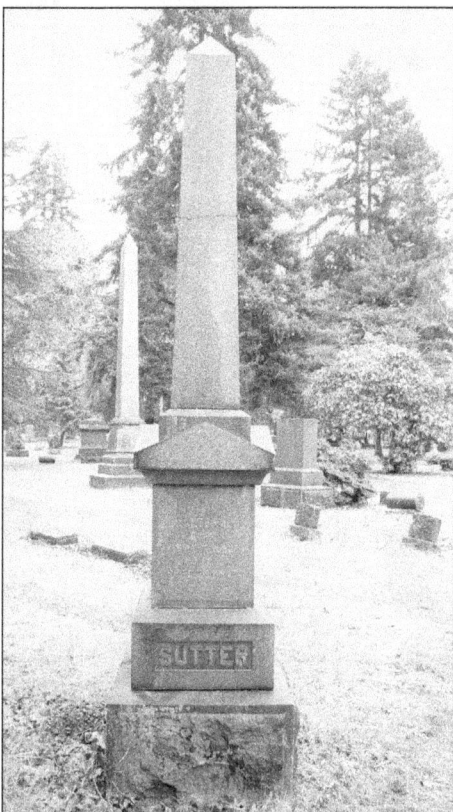

WALTER SUTTER'S GRAND MEMORIAL. Walter Sutter was active with the Shriners at the Afifi Temple in Tacoma for many years. He made quite a name for himself. The following is taken from the club's minutes of October 2, 1947: "In commemoration of the passing of our esteemed member and friend, Walter H. Sutter, the Patrol, Band, and Wrecking Crew, all in uniform, stood at attention while Potentate Howe read a very selective eulogy to our departed member there upon followed by the Nobility coming to attention and all standing in silence." The temple also established a ceremony known as the Walt Sutter Ceremonial as an initiation for new members. It was so named because Sutter was responsible for bringing in the largest number of applications and subsequent candidates for initiation in the history of the temple. Sutter had other interests as well: he attended musicals, collected international treasures, and designed parade floats. In 1940, he designed the Old Tacoma Improvement Club float. It was the most original of those entered. It featured a number of Tacoma firsts, including the first church, home, electric power plant, shipment of lumber, and survey of Puget Sound. It also included the oldest bell tower in America. (Above, courtesy author's collection.)

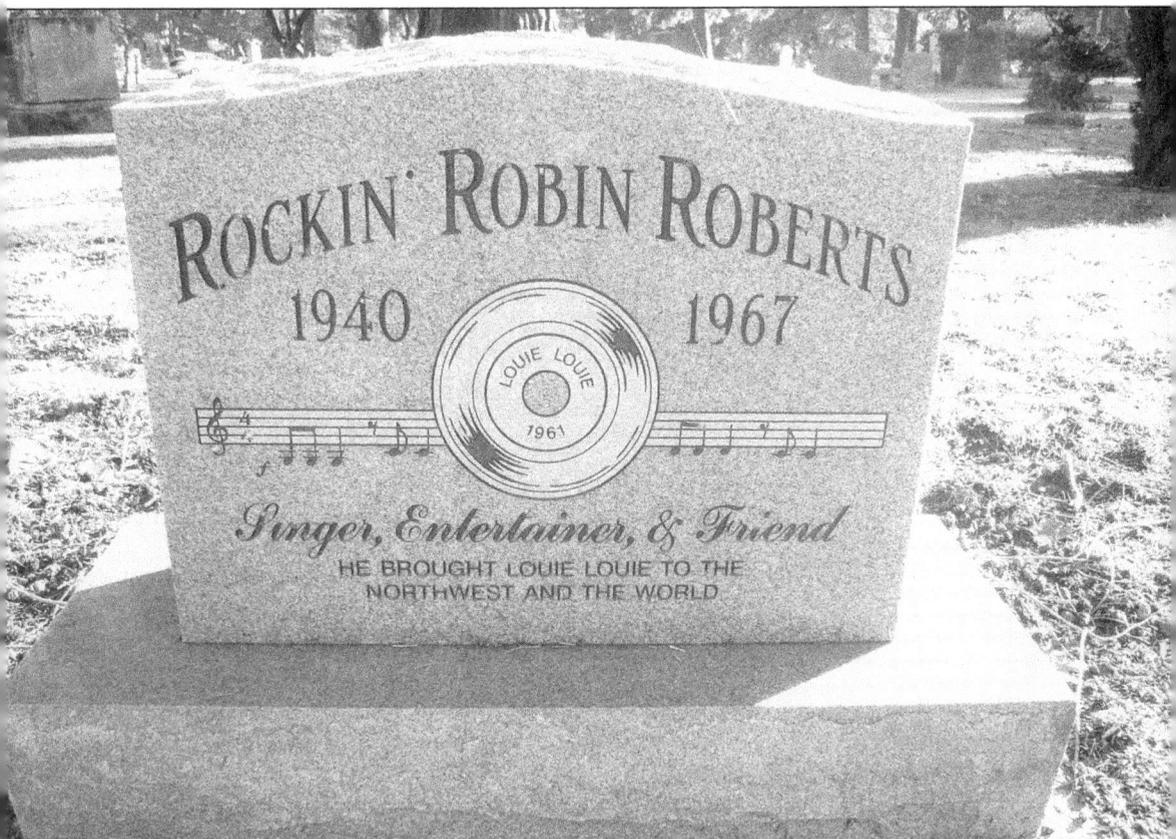

TACOMA GARAGE BAND MAKES IT BIG. Robin Roberts (1940–1967) was a teen when he and his friends formed the garage band the Bluenotes in 1956. Members of the original group were Buck Ormsby (bass), Lassie Aanes (drums), Bill Engelhart (guitar), Frank Dutra (tenor sax), and Robin Roberts (vocals). During this same period, the fame-motivated singer also made a guest appearance in the young band the Wailers. It is during this time that Roberts became known as "Rockin' Roberts." The Bluenotes made their first public appearance at Bellarmine High School. A favorite hub for the band was the JEM Café on Highway 99 (just past the Puyallup River bridge). The café was packed with teens who were hot for the new sound (and literally hot because there was no air-conditioning). The pioneer rock band was best known for "Louie, Louie," which was recorded in 1961 and became a national hit. The Kingsmen, a rival band based in Oregon, recorded an uncopyrighted version of the hit song. But Rockin' Roberts rests assured that the fame belongs to him. His grave marker boasts a picture of a vinyl record and the title of the song. (Courtesy author's collection.)

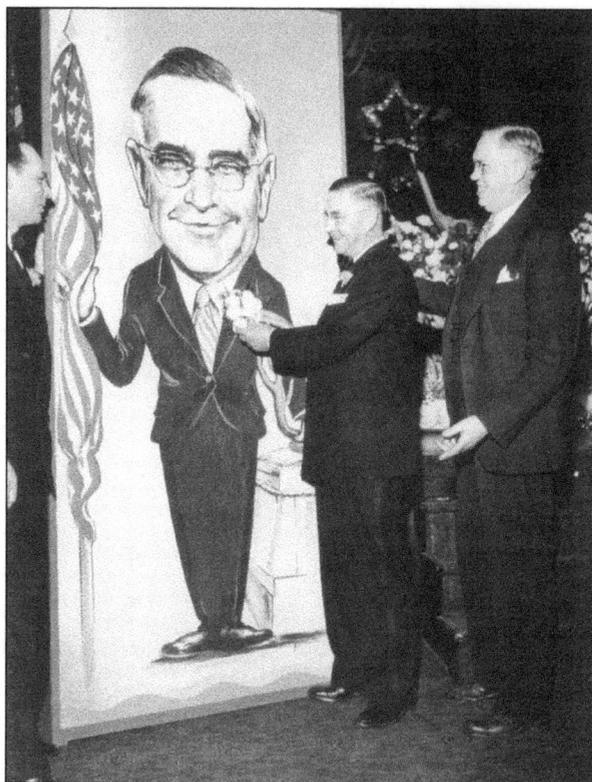

EMMETT "T" (FOR TACOMA) ANDERSON. Emmett Anderson was the president of Anderson Printing Company (founded in 1921) and a prominent civic leader. He was voted the Grand Exalted Ruler of the Benevolent and Protective Order of Elks of the USA in 1949. The *Tacoma Times* exclaims in a front-page spread, "Tacoma's Own Comes Home!" Anderson was welcomed with a parade in his honor on July 27, 1949. Mayor Val Fawcett presented Mrs. Anderson with roses. No longer residents of California, the Andersons made Tacoma their home. Anderson was a lieutenant governor of Washington from 1953 to 1956, at which time he also became the Republican Party nominee for governor. Pictured with fellow Elks members, he stands in front of his caricature at a celebration in his honor.

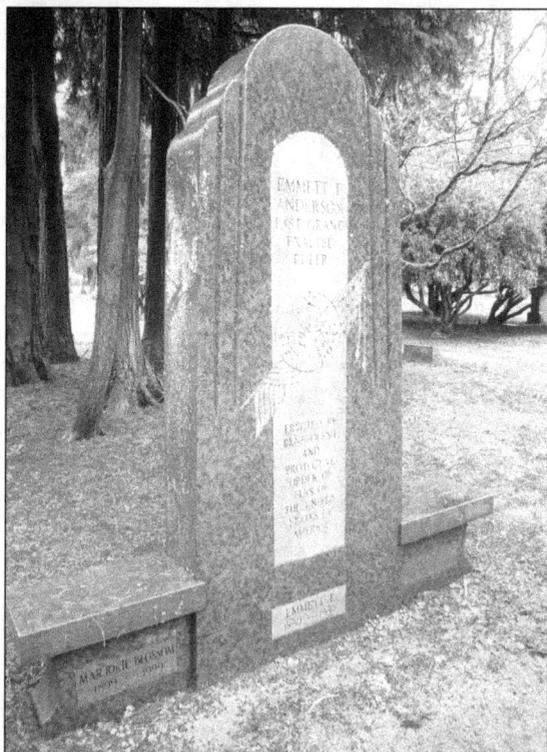

ANDERSON MONUMENT. Standing more than seven feet tall and five feet wide—like the man around town—the monument is quite a presence in the cemetery. (Courtesy author's collection.)

RAGS TO RICHES. Pictured is Aaron R. Titlow. Born November 22, 1857, Titlow traveled to Washington just before it achieved statehood. He grew up on a farm in Indiana and later studied law at Washington University at St. Louis. In 1888, Titlow came to Tacoma and invested heavily in real estate. In 1896, he was elected on the Democratic ticket to the office of prosecuting attorney and served for two years. Titlow is known best for Titlow Beach. He built a hotel on the property and named it Hesperides (after his daughters). The hotel has since closed and been renovated. It now serves as a community center known as Titlow Lodge. Titlow is also known for installing the first public pool in the area. The pool began as a saltwater pool and was dedicated on June 4, 1955. The following year it was drained and filled with freshwater. The new dedication was on Memorial Day, May 31, 1956. With its parks, buildings, and pool, Titlow Beach is a favorite destination spot year-round.

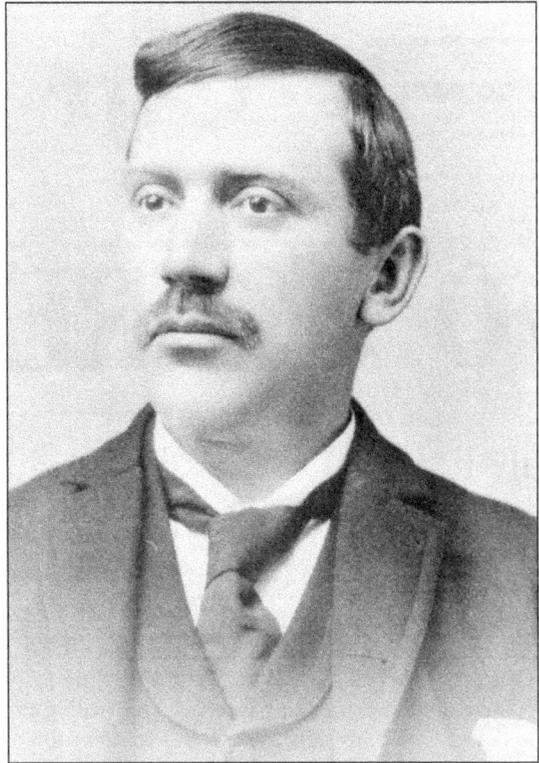

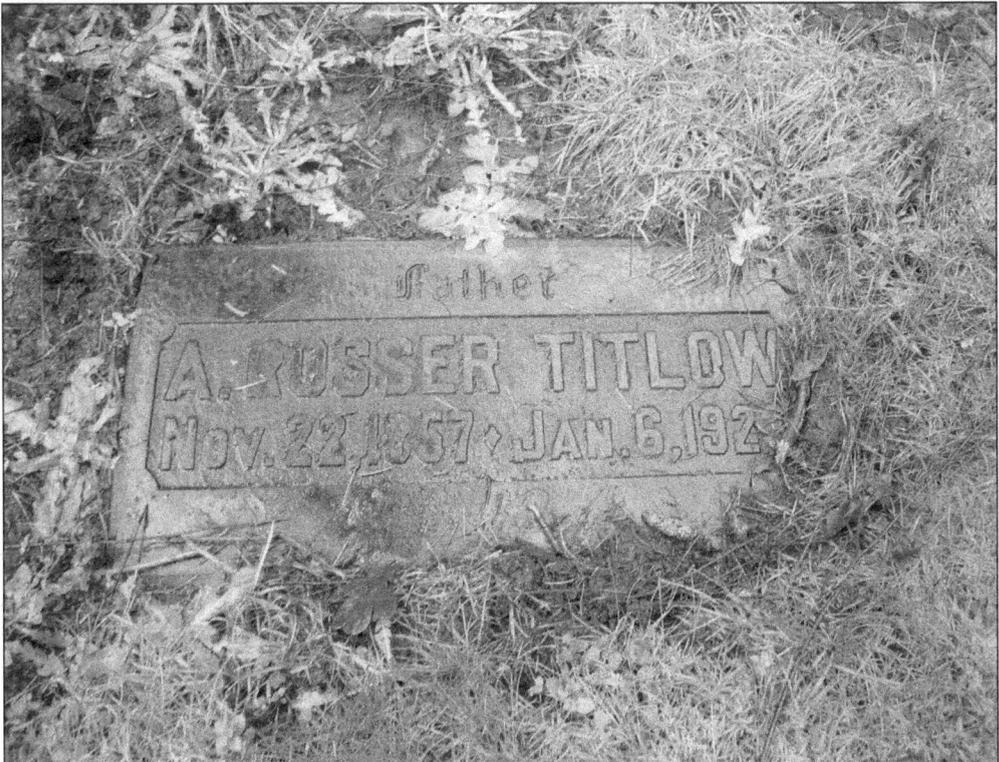

The Tacoma

VOL. XVIII. NO. 186. TACOMA, WASHINGTON,

TWO SCORE KILLED I

Frightful Plunge Over a High Bridge Sends a Happy Fourth of July Crowd Into Eternity and Saddens Many Homes.

LIST O

DRAKE,
of telephor
South Taco
GLASS, AN
SUITER, I
coma.
DINGER, I
DINGER.

TWISTED TROLLEY CAR WRECKAGE. On July 5, 1900, the *Tacoma Daily Ledger* reports, "Two Score Killed in Street Car Wreck." The trolley car No. 116 was owned by the Tacoma Railway & Power Company. It was en route to downtown Tacoma for the Independence Day parade. It never arrived. Instead, it plunged 100 feet from the C Street trestle into the gulch below. The twisted wreckage was massive. The car was traveling about 30 miles per hour when it approached the sharp curve just before the trestle. Railway company engineers examined the

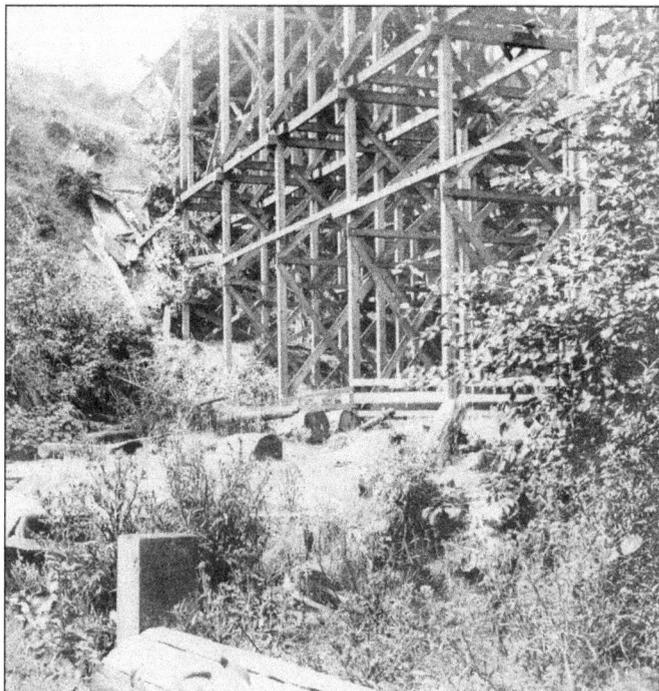

REMOVING DEAD BODIES. Gallagher's Gulch became a makeshift morgue with undertaker Conrad L. Hoska in charge. The final death toll for the wreck was 43, and 65 more were maimed and injured. The *Tacoma Daily Ledger* reported, "Such a spectacle of battered mutilated humanity has scarcely ever been seen. . . . Kind hearted people placed handkerchiefs over the faces of the dead until the undertaker's wagon came down loaded with coffins." Nearby morgues, funeral homes, hospitals, and medical facilities were full with the injured and the dead.

DAY, JULY 5, 1900. PRICE FIVE CENTS.

STREET CAR WRECK

EAD

mploye
lives at

acoma.
th Ta-

e View
View.

List of the Injured Swells the Total Number of Victims to Over One Hundred---Thrilling Stories of Survivors.

trestle and found that it was structurally sound. The tracks showed no signs of damage or reason for concern. After a full investigation, the verdict was against the Tacoma Railway & Power Company. Motorman F.L. Boehm was found to have caused the accident when he started down the steep grade at a high speed. The company was nearly forced into bankruptcy; it paid out $100,000 to the claimants and lawyers involved. The trolley crash remains one of the worst transportation disasters in Tacoma's history.

A FATHER GRIEVES HIS SON. In this photograph is the grave marker for LeRoy Lingerman, a victim of the fated trolley car crash. LeRoy and his father, J.B. Lingerman, shared a carriage to the St. Joseph Hospital. However, LeRoy died on the way. When the boy's father realized that his son had passed, he threw himself over the body, and witnesses said his grief was so great that he literally had to be torn from the boy. (Courtesy author's collection.)

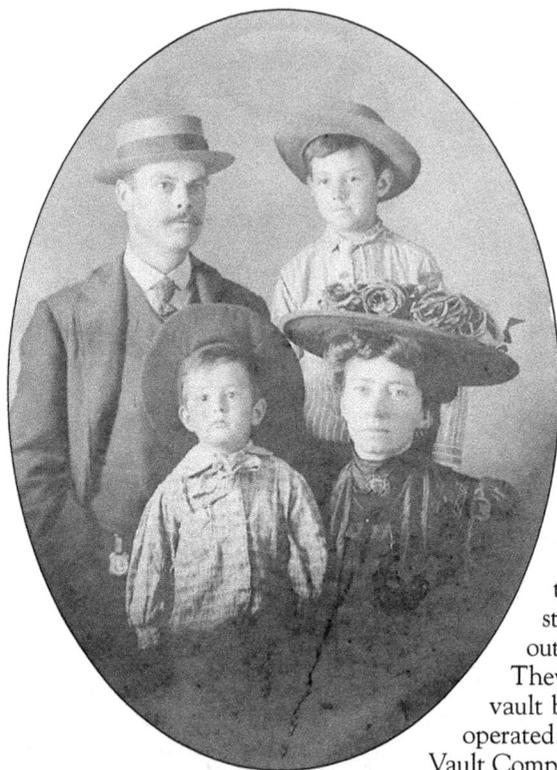

BURIAL VAULT COMPANY FOUNDER. This Victorian family portrait is dated to the early 1900s. Pictured here, from left to right, are Daniel and Jenny (seated) and Jack and Danny Trippear, founders of the Automatic Sealing Burial Vault Company. Daniel was a first-generation American. His prior home had been in Blackpool, England. Daniel and his family arrived on the shores of the Puget Sound merely as a stopover on their way to Australia, but they ran out of money and made their home in Tacoma. They made the best of things and started the vault business, which is still family-owned-and-operated today. (Left, courtesy Automatic Wilbert Vault Company; below, courtesy author's collection.)

FLAGPOLE DEDICATION. In 1957, a flagpole and memorial were created to honor the sacrifice of Billy Desinger at Guadalcanal in the Battle of Tassafaronga. Family and friends attended the ceremony for Desinger, which was performed by a funeral detail team from the US Navy. Many groups from the Veterans of Foreign Wars (VFW) organizations of Pierce, King, and Thurston Counties also attended. Pictured, from left to right, are Alice Colbert (daughter of Jack Trippear), Tom Zulauf (boy), Jack Trippear (oldest son of Daniel Trippear Sr.), unidentified, and Delma Desinger Trippear (sister-in-law to Jack Trippear and mother of Billy Desinger). The remaining four people are unidentified. Also pictured in the background is the caretaker's house at the Old Tacoma Cemetery. It is uncertain when the house was demolished, but, as seen here, it was still standing in the late 1950s. (Courtesy Automatic Wilbert Vault Company.)

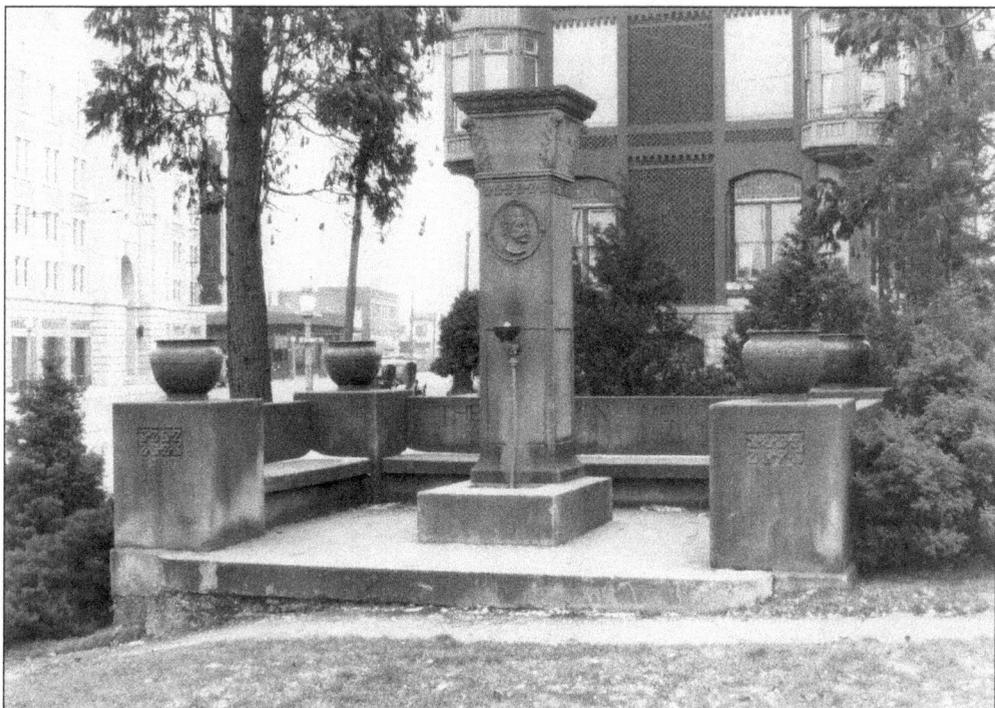

PERCY DUNBAR NORTON MEMORIAL FOUNTAIN. This picture of the Norton Memorial is dated December 31, 1927, and is part of the Marvin D. Boland collection at the Tacoma Public Library. Little is known about this memorial, and local historians often try to seek it out. It stood on a plot near St. Helens and Tacoma Avenues. The fountain portion of the memorial was removed around the time of World War II; scrap metal needed for the war effort fetched a premium price. Norton was born on February 5, 1856, and was 44 years old when he died. He was one of the founders of the Tacoma Lumber Company, president of the city council of Tacoma, and president of the Lumber Manufacturer's Association of the Northwest.

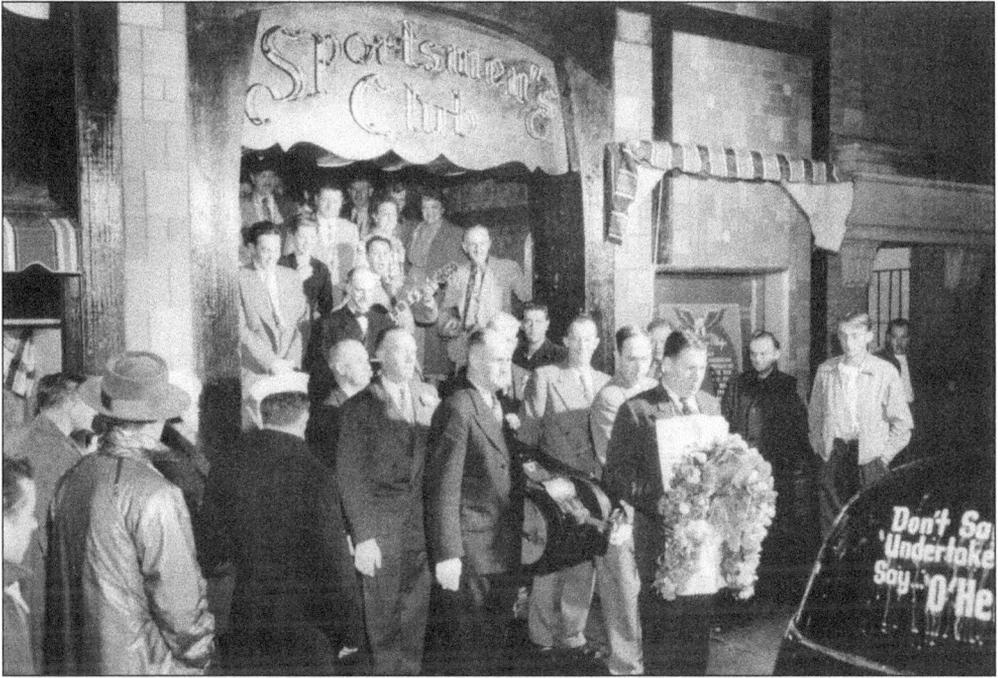

SPORTSMEN'S CLUB MOCK FUNERAL. Perhaps as a bit of a parody, the Tacoma Sportsmen's Club held a mock funeral for the club's slot machine. The laws surrounding gambling had begun to tighten. According to the *Tacoma News Tribune* from November 2, 1950, safety commissioner James T. Kerr banned slot machines. The prevalence of organized crime and the forming of mobs on the West Coast motivated Kerr to ban gambling within Tacoma's city limits. The first address given to the Tacoma Sportsmen's Club was 902 Pacific Avenue–Rear. Charles Wright constructed the building, which was known as the Brick Building (and later as the Wright Building.) First occupied by Tacoma Savings Bank, it was destroyed by fire in April 1884. Wright rebuilt in the same location, but was assigned a new address, 902–904 Pacific Avenue; the site also included 901–903 Commerce Street. In 1928, the building was stuccoed and improved, and in 1942, it was sold to the Tacoma Sportsmen's Club.

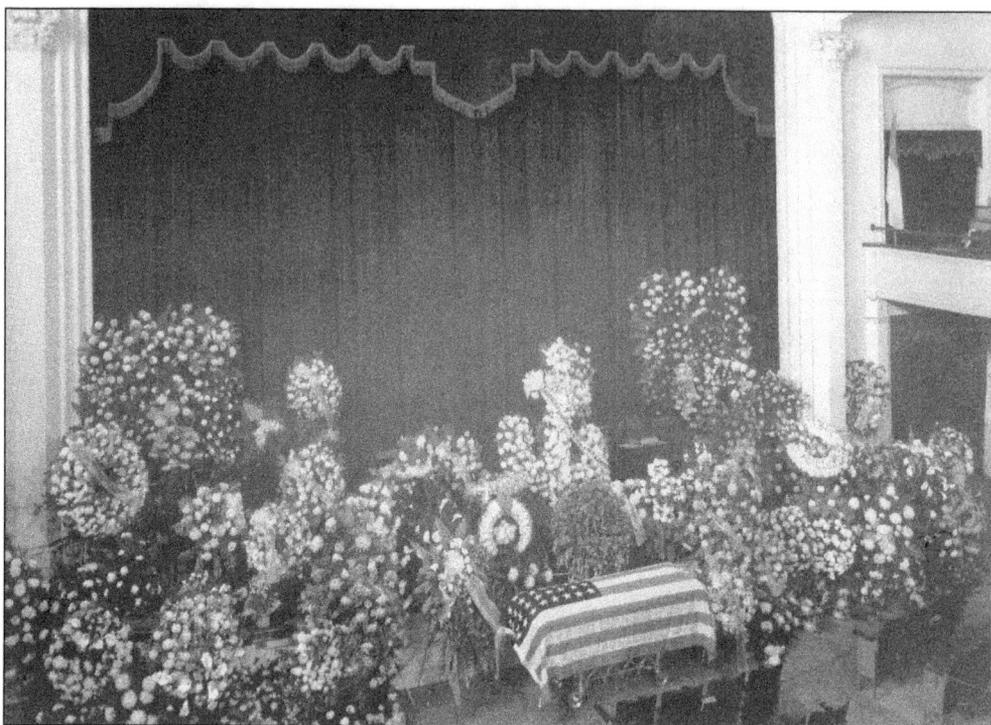

US CONGRESSMAN FUNERAL. Attorney Wesley Lloyd was serving his second consecutive term as the Democratic representative for the new Sixth Congressional District when he suffered a fatal heart attack on January 10, 1936. His casket was draped with an American flag, and the First Baptist church was overflowing with flower arrangements for the congressman.

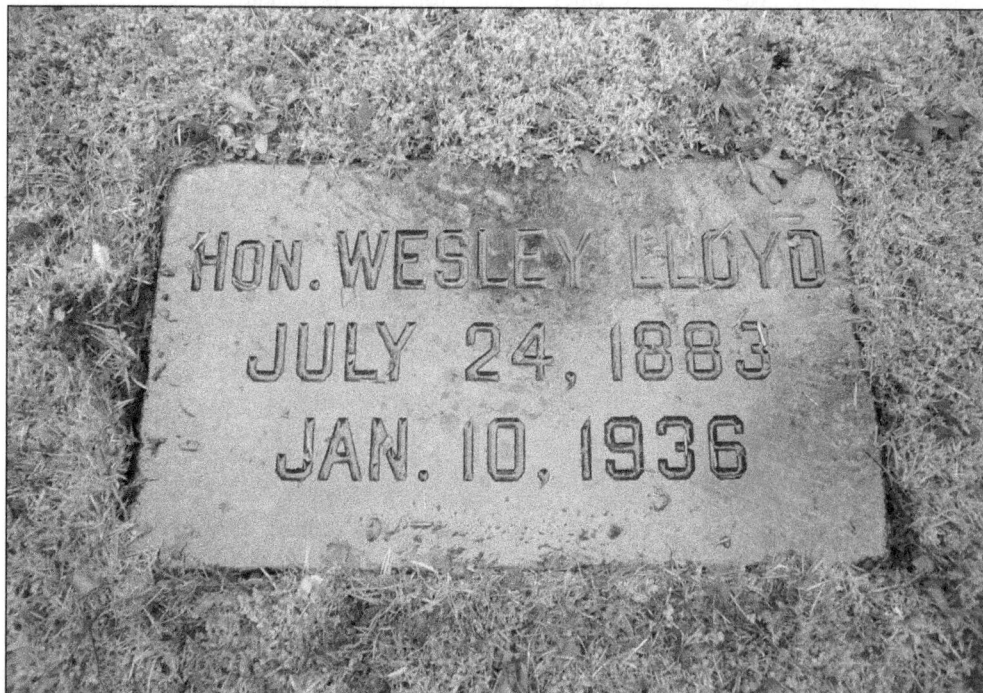

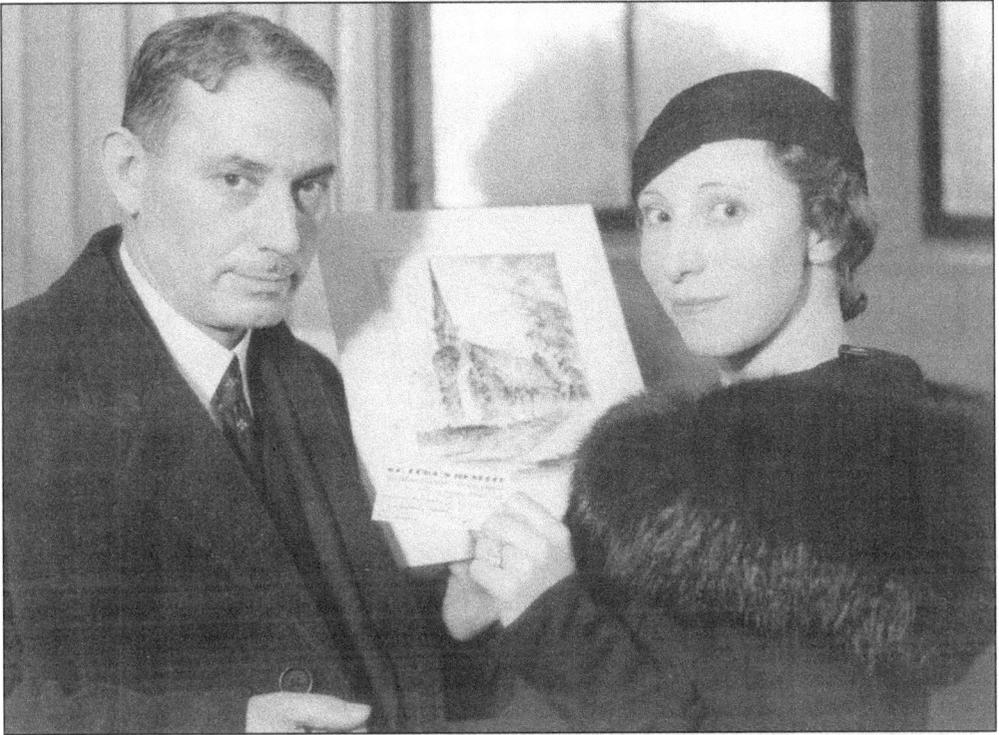

TICKETS TO A FIGHT. Pictured is Wesley Lloyd holding a ticket for St. Luke's Benefit Golden Gloves Tournament. Tickets were 40¢ apiece. The benefit was organized to raise funds needed to relocate the church. Representative Lloyd also helped pass a vote to remodel the Indian Hospital. This photograph is dated 1935 and is part of the Richards Studio collection at the Tacoma Public Library.

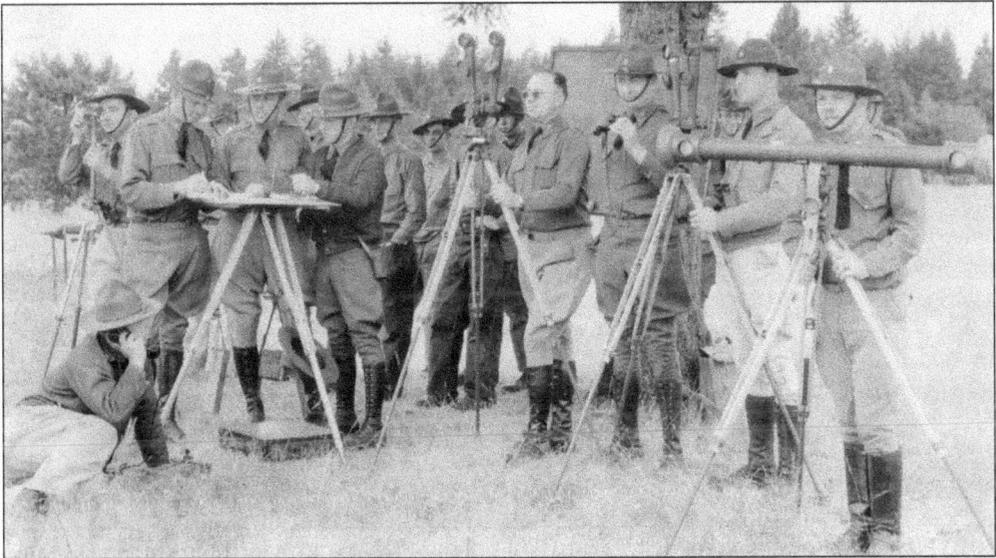

CAMP WESLEY LLOYD. The 1936 encampment of the Washington National Guard was named after Wesley Lloyd. The National Guard was responsible for organizing a training encampment every year at this location. Pictured during a typical training session, officers use various wartime equipment and instruments.

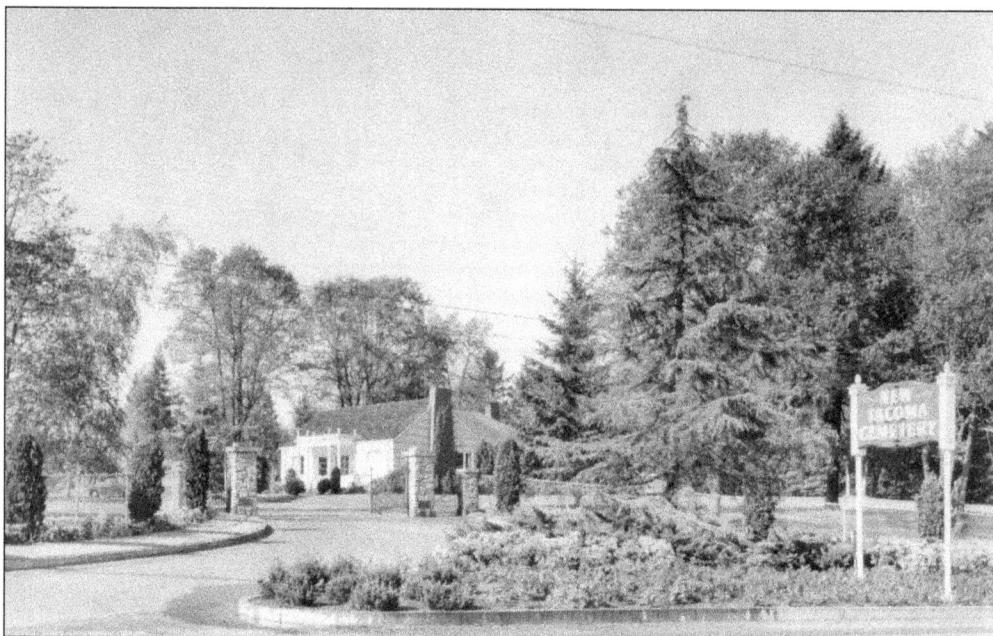

1950s NEW TACOMA CEMETERY ENTRANCE. The Tacoma Cemetery Association, a mutual nonprofit association that had served the community since 1884, operated both the New Tacoma Cemetery and the Old Tacoma Cemetery. The New Tacoma Cemetery began serving Tacoma families in 1932. The cemetery is located at 9221 Chamber Creek Road. This photograph was taken in 1958.

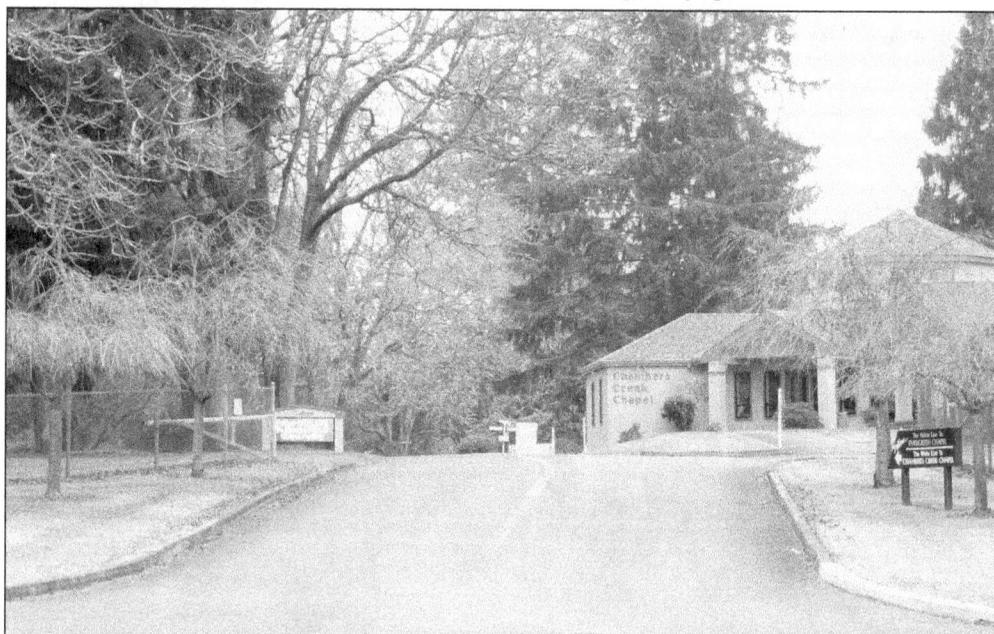

2010 NEW TACOMA CEMETERY ENTRANCE. The address and entrance location remain the same as they were in 1958; however, the cottage house has been remodeled and several additions were made. The stone gate is gone, replaced by a more practical chain-link and iron combination. The post sign has also been replaced by a modern, digital one. The offices are no longer located in the cottage but are now across the street. (Courtesy author's collection.)

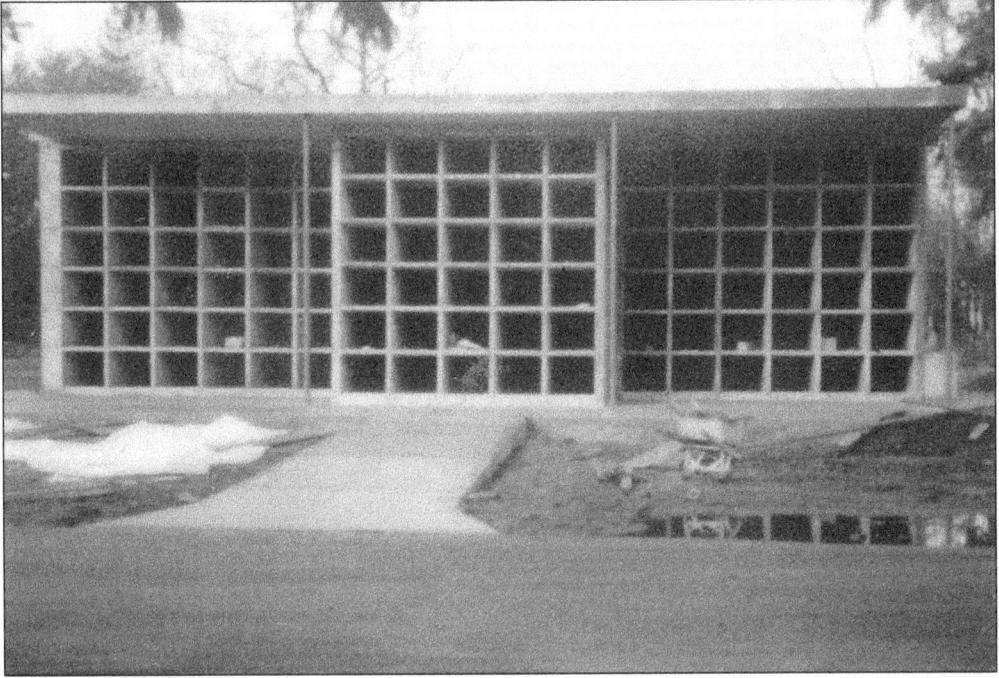

MAUSOLEUM CONSTRUCTION AT NEW TACOMA. New Tacoma Cemetery boasts several beautiful mausoleums. Shown here is one of the mausoleums under construction. Made of solid concrete, these sections were built to last. (Courtesy New Tacoma Cemeteries and Funeral Home.)

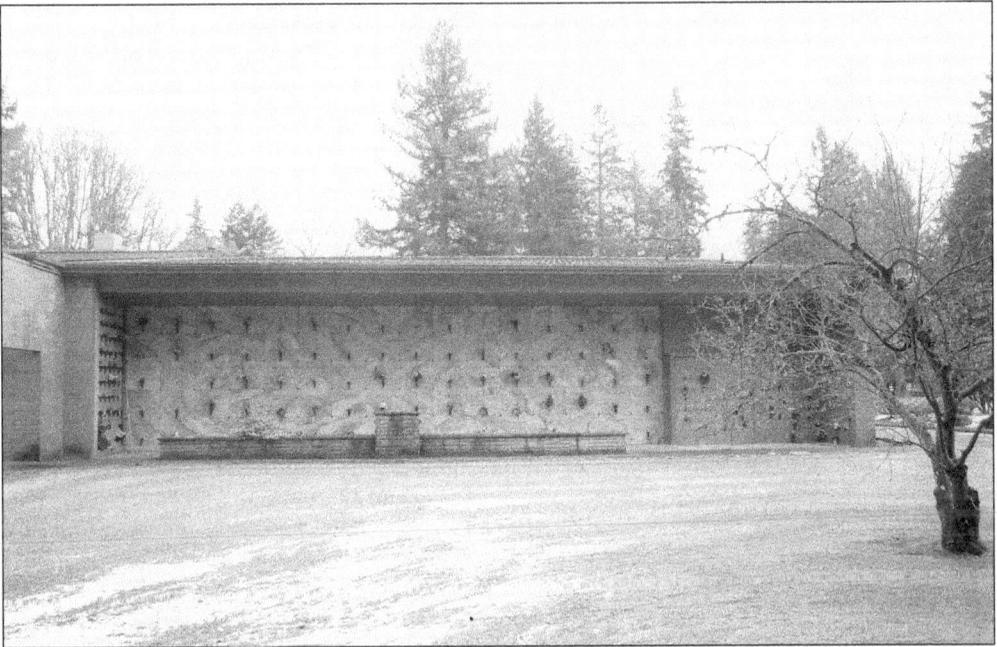

MAUSOLEUM CONSTRUCTION COMPLETE. Taken December 10, 2010, this photograph shows the mausoleum is completely full. The building design looks modern. A note on the door asks visitors to go to the office located across the street to obtain a key. Doors are locked at all times. (Courtesy author's collection.)

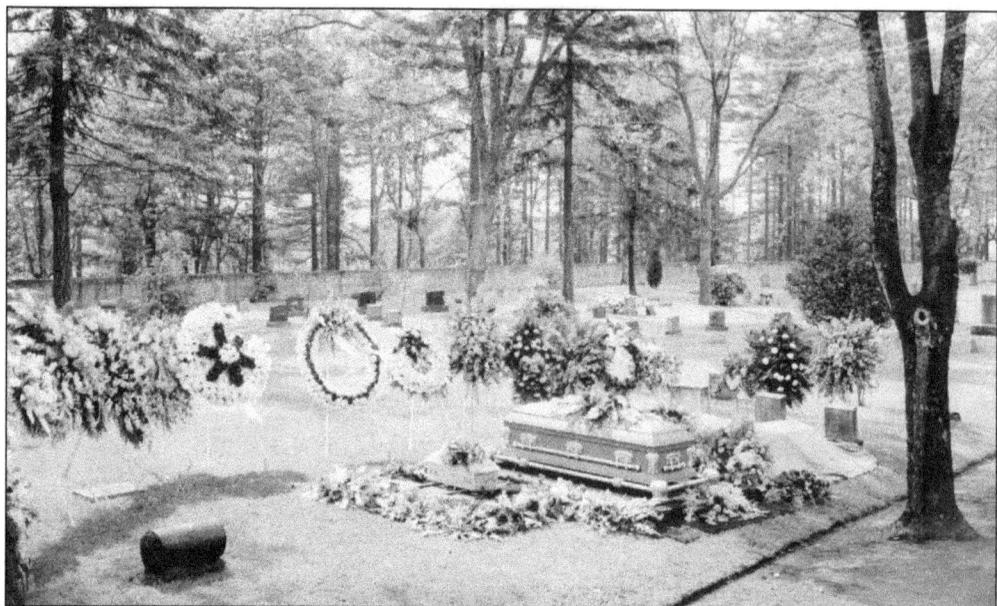

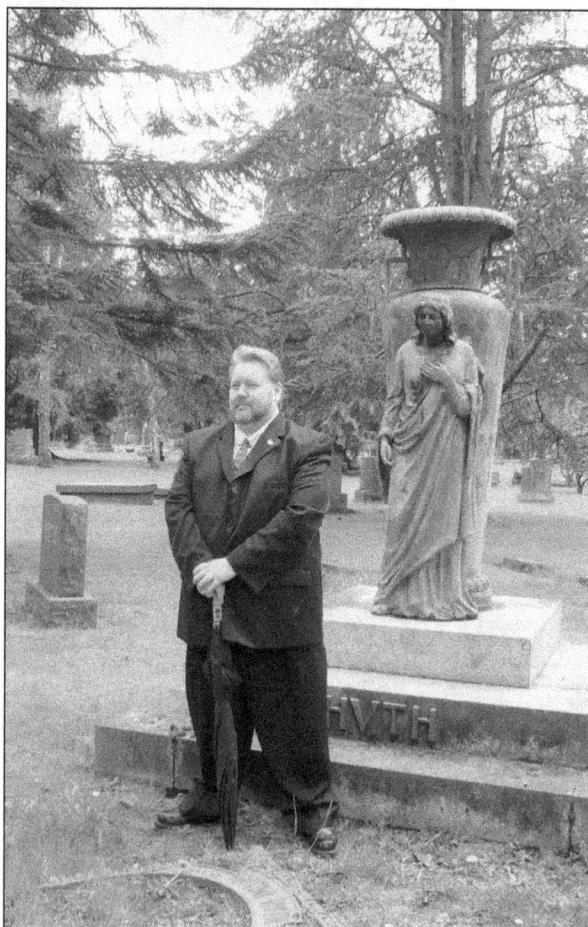

POSSIBLE MOTHER AND CHILD. A typical after-funeral photograph at the cemetery shows an adult casket next to an infant casket—possibly those of a mother and child. Both will rest next to one another forever. Surely, they were dearly loved and missed, as the burial site is adorned with massive flower arrangements and wreaths. The photograph lists this as an unidentified cemetery, but the concrete wall in the background gives it away as the Old Tacoma Cemetery.

OLD TACOMA CEMETERY MANAGER. Christopher Engh, manager of the historic Old Tacoma Cemetery, is standing in front of the monument of Anton Huth, a much-visited site for those in need of quiet reflection. This and other memorials are appreciated by Tacomans all year long—especially during the annual summertime Living History Tour, a popular event enjoyed by those of all ages. The Tacoma Historical Society organizes the event and has a current listing of tour dates and times. (Courtesy author's collection.)

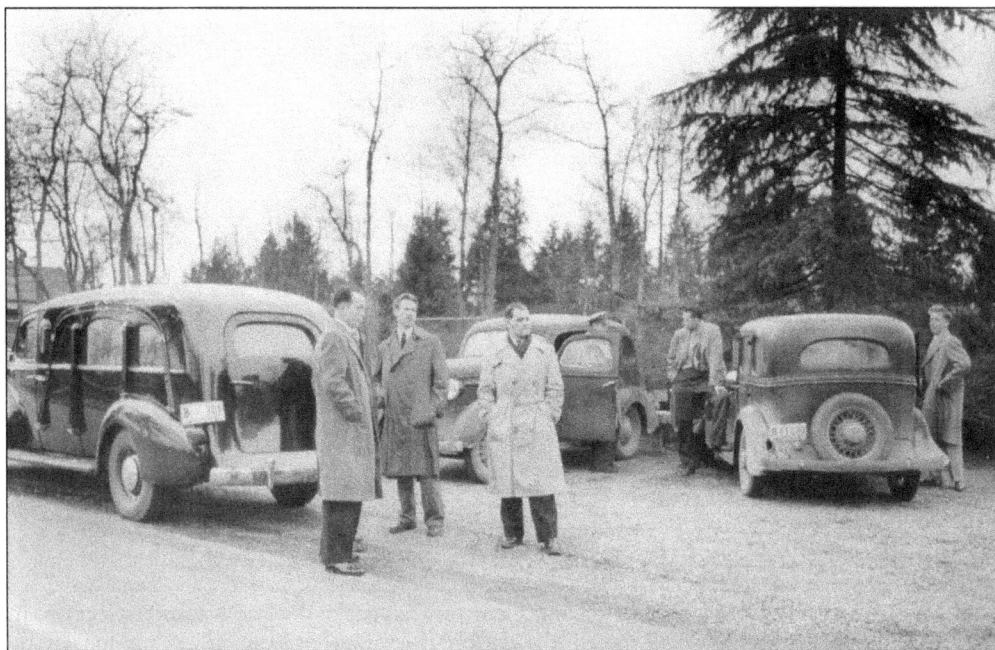

HEARSE PARKED AT NEW TACOMA CEMETERY. It is uncertain whether or not the hearse is waiting inside or outside the cemetery. It looks as if there is a public road right in front of the gentlemen dressed in overcoats. The cars are from the late 1940s. The Tacoma Public Library lists this as a New Tacoma Cemetery funeral. The photograph was ordered by C.O. Lynn & Company and is dated April 14, 1950.

MONUMENT WITH GLORIOUS FLAG. The Bell family included Mr. and Mrs. Wellesley Bell and daughters, Ruth, Kathleen, and Janice (right). Also on hand to help with the raising of the flag was William B. Reed (left), manager of the cemetery. On Memorial Day, May 30, 1949, the memorial at the New Tacoma Cemetery was dedicated to all US soldiers who had died in wars.

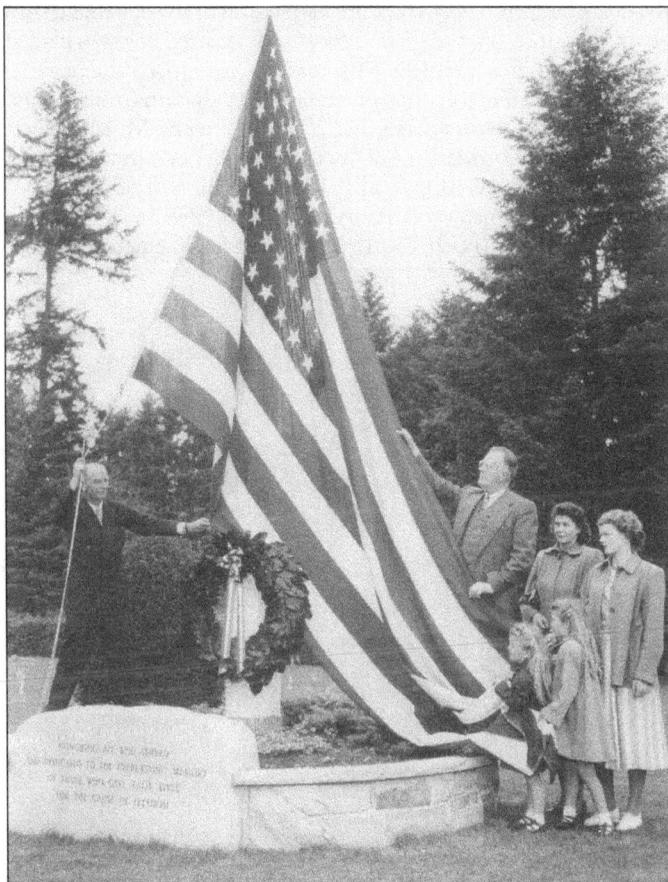

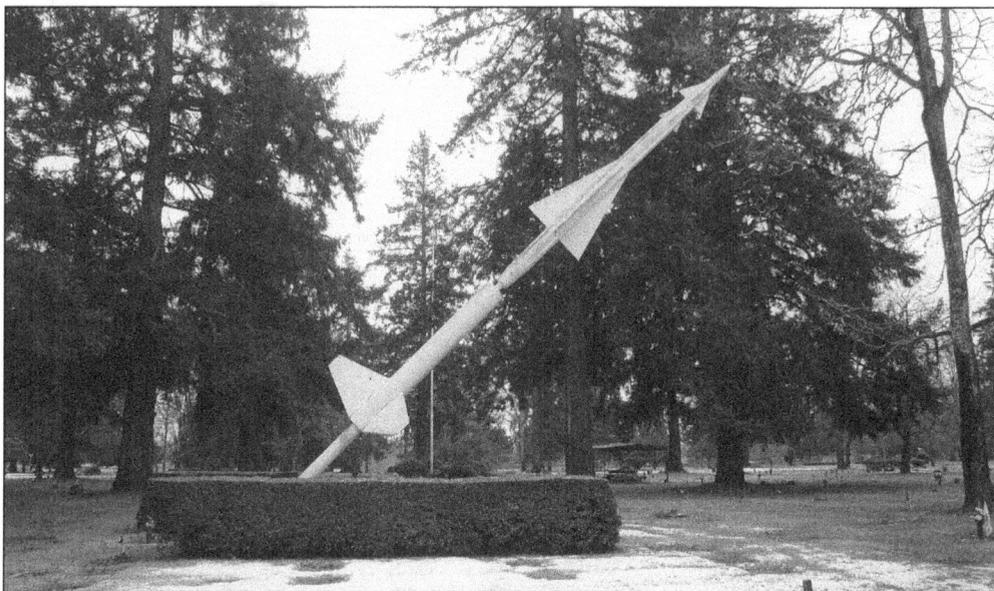

NIKE MISSILE AND SKY GUN. The New Tacoma Cemetery has one of the largest veterans sections in the area. Not much is known about these intimidating structures that loom larger than life among the dead. Unfortunately, there are no pictures of the day that they were dedicated or any information about their installation. On the Sky Gun pictured below, a plaque reads, "SKY GUN. In service in World War II, now obsolete. This materiel comprised the heaviest anti-aircraft artillery in service, being designed for protection of rear-area installations from high-altitude bombing. Caliber is 119.37 millimeters (4.7 inches). Length is 25 feet 11 inches. Muzzle velocity is 3,100 feet per second. Range, vertical is 15,800 yards. Rate of fire is 12 rounds per minute. Weight of tube is 10, 675 pounds. Weight of complete round is 101 pounds. Overall weight is 61,500 pounds or 30 tons. This material has been placed here as a memorial TO ALL VETERANS by Wild West Post No. 91, Veterans of Foreign Wars. June 1961." (Both, courtesy New Tacoma Cemeteries and Funeral Home.)

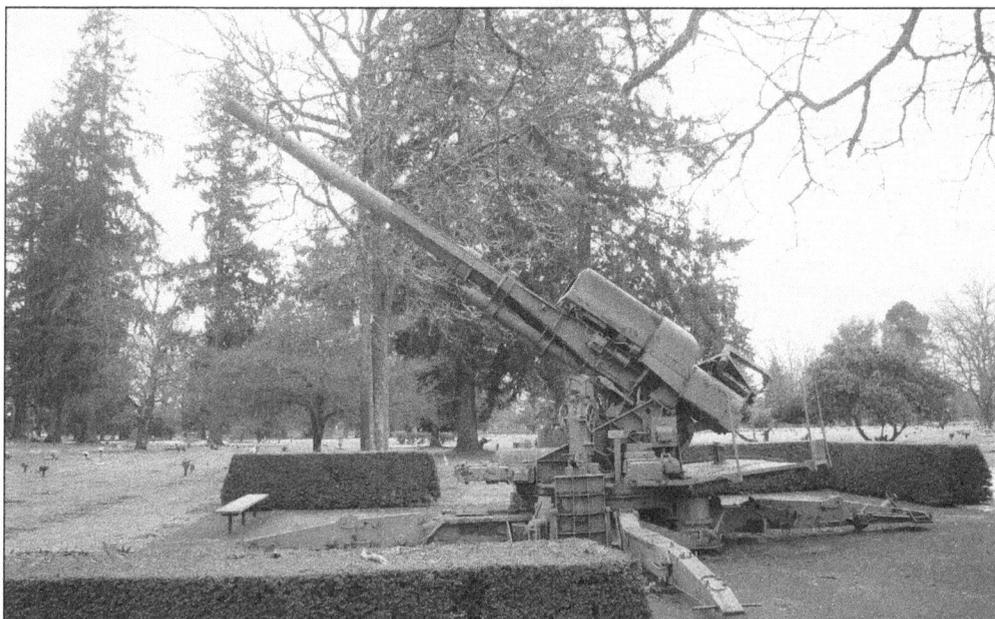

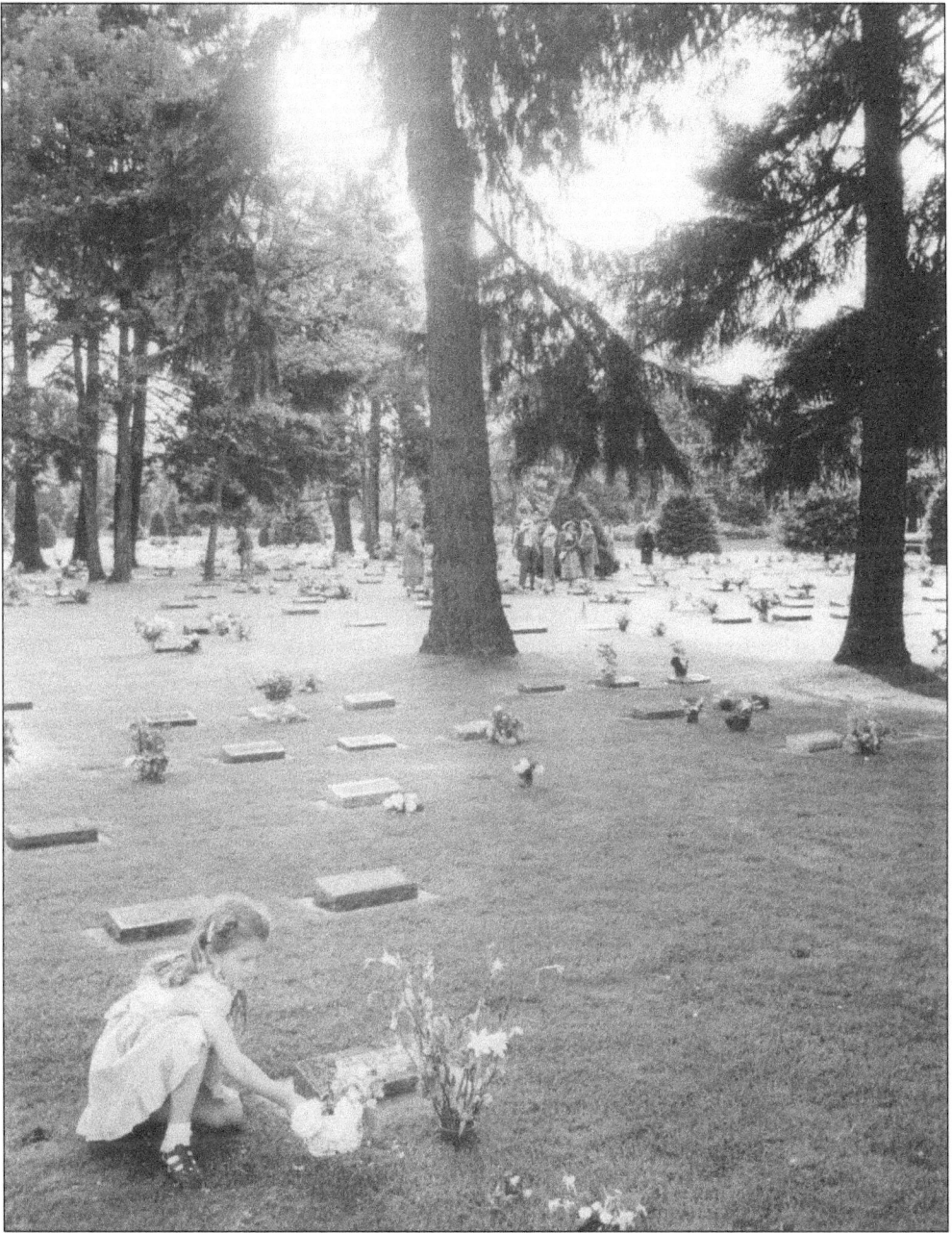

GIRL AT GRAVESIDE. As a ceremony takes place in the background, a little girl finds her way to a grave that has not been forgotten—flowers had already been placed there before she arrived. Perhaps they were laid there by another family member or friend. Adding to the apparent devotion, the young girl places her own tokens of love. This image is part of the Richards Studio collection at the Tacoma Public Library. It was taken at the Grove section of the New Tacoma Cemetery and is dated May 29, 1949. This image brings to mind the famous line from the poem "Hallowed Ground" by Thomas Campbell: "To live in hearts we leave behind is not to die."

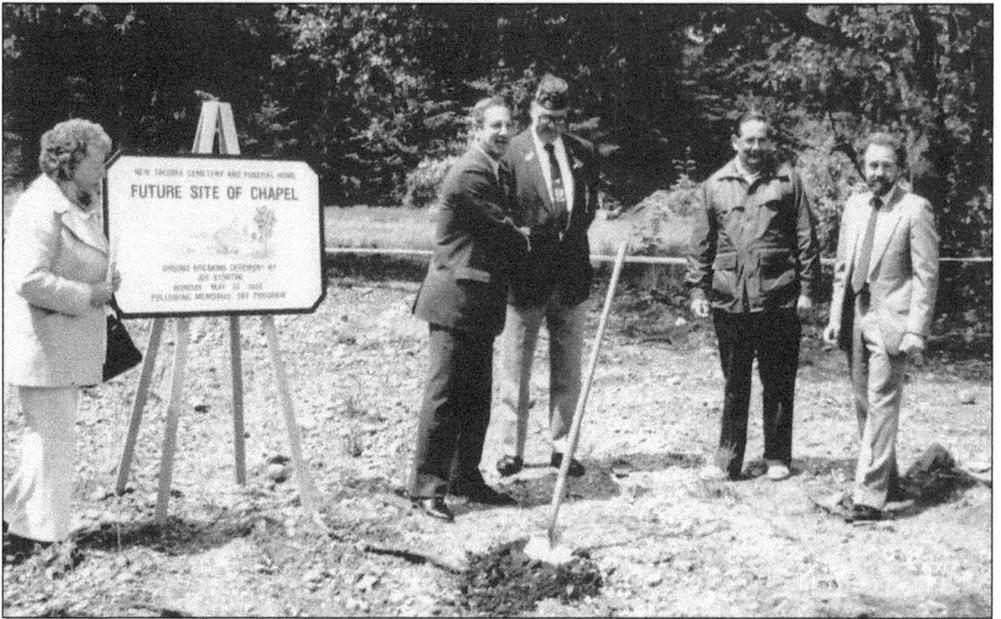

FUTURE SITE OF NEW TACOMA CHAPEL. Pictured here is the current president of the New Tacoma Cemeteries and Funeral Home, Jack Harding (far right), and a group of others posing for a ground-breaking ceremony. The displayed sign reads, "New Tacoma Cemetery and Funeral Home, Future Site of Chapel, Ground Breaking Ceremony by Joe Stortini, Monday, May 30, 1988, Following Memorial Day Program." (Courtesy New Tacoma Cemeteries and Funeral Home.)

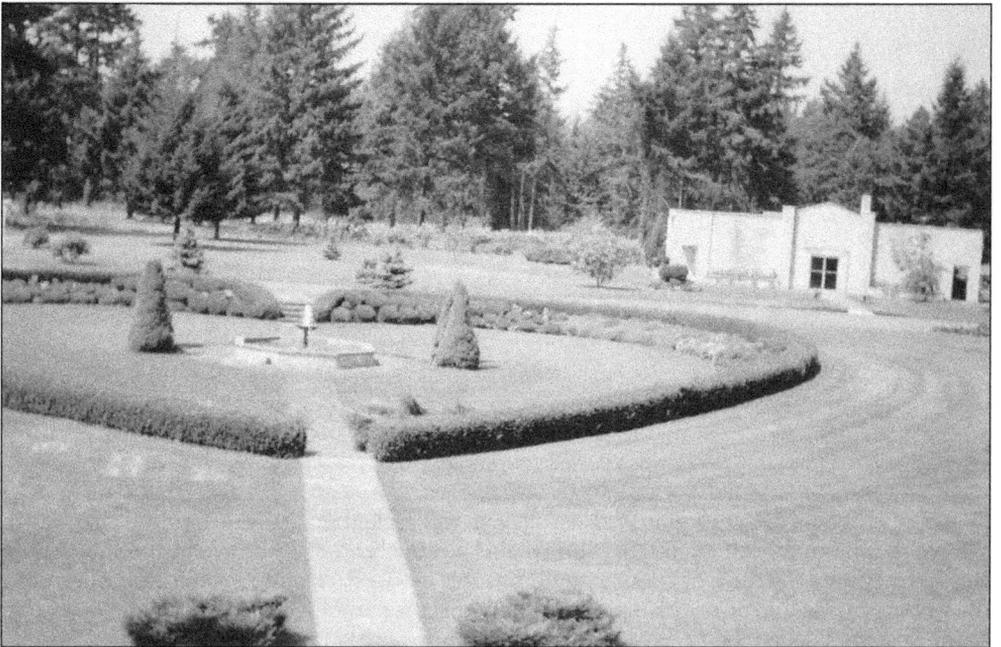

CHAPEL COMPLETED. This undated photograph shows the chapel under construction but nearly completed. New Tacoma Cemetery has many lovely chapels and outbuildings. They have made several improvements to the property throughout the years. (Courtesy New Tacoma Cemeteries and Funeral Home.)

36

Two

Oakwood Hills Cemetery and Columbarium

Charles Dickens's A Tale of Two Cities is set in London and Paris around the time of the French Revolution (1859). Another tale—the tale of two cemeteries—is set in the south end of the infant city of Tacoma in Washington Territory around 1874. Both tales speak to the human capacity for change.

Traditionally, most Victorians preferred monumental cemeteries. That is, headstones made of marble, granite, or similar materials that would rise vertically above the ground. In the proper Christian burial of the era, bodies were embalmed, viewed, waked, and buried in the earth. Cremation did not become an acceptable Christian practice until the early 1900s when clergy were sought to give their public blessing to the practice. The Reverend Dr. Frederick T. Webb of St. Luke's Memorial Church in Tacoma writes, "It is the spiritual body which he says shall rise again; and that being spiritual cannot be effaced by fire. If touched at all, it is only by the fires which burn in the discipline of life; and these do not destroy, but purify." Soon after Webb's words were circulated, a Tacoma Daily Ledger article dated September 25, 1910, proclaimed, "A great change is apparent in the attitude of the public . . . in regard to cremation. Where only three or four bodies were cremated a month . . . the manager now reports from 10 to 20 incinerations in the same period."

Oakwood Hill Cemetery offered both inground burial and cremation. In fact, Oakwood was one of the first crematories on the West Coast. The original columbarium, built in 1908, had 157 niches, but with the trend growing, more space was needed. The building was added onto and a new columbarium was constructed in the early 1920s. The new space, which is still in use today, has 979 niches with space for about 3,000 urns. The design of the building includes niches faced with leaded glass windows, faux patina framing, and a stained glass dome rising 23 feet from the floor. According to Bill Habermann, the dome is nine feet in diameter and contains 3,560 individual pieces of stained glass, which he has painstakingly counted himself.

Columbarium walls are a space-efficient use of land in a cemetery compared with inground burials. In the 21st century, thanks in part to a keen interest in environmentally friendly alternatives, cremation and columbaria continue to increase in popularity.

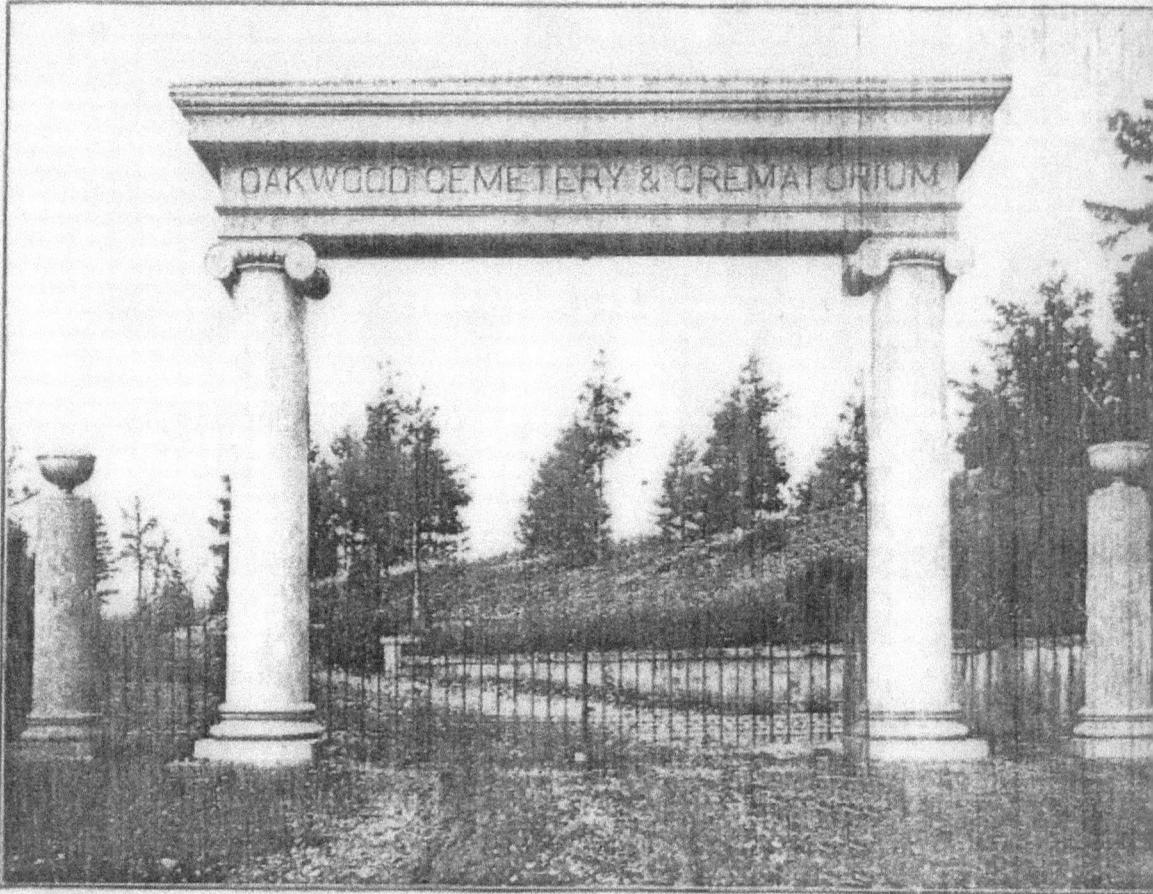

ENTRANCE TO OAKWOOD CEMETERY AND CREMATORIUM, TACOMA.

ORIGINAL OAKWOOD CEMETERY AND CREMATORIUM GATE. While no one knows for sure when this beautiful entrance was erected, it is safe to assume that the entranceway was standing by 1909 or shortly thereafter. The crematorium opened in 1909, and the archway reflects its architectural style. The material is concrete, and the lettering was stamped, as per usual for the era. The gate is also present in the first funeral picture of the cemetery taken in 1913. The entrance may have been removed for safety reasons. Concrete tends to crumble and deteriorate over time, or a crack may have developed and compromised the gate's structural integrity. The large and small columns remained until the 1980s when a cemetery employee accidently drove a vehicle into one of the larger columns, pushing it over. At this time, it was decided to remove the other large columns as well. The smaller columns remain today. (Courtesy of Bill Habermann.)

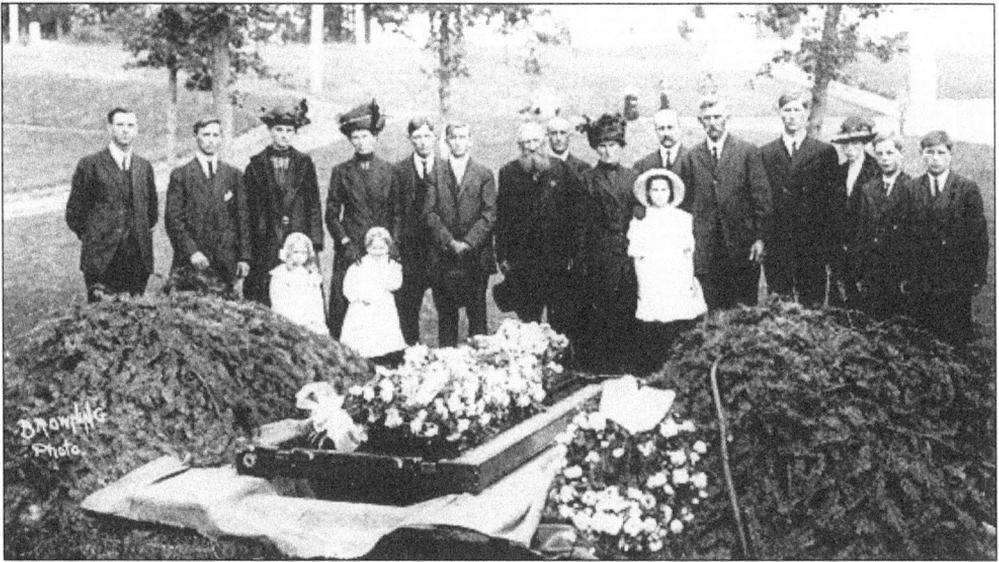

1913 FUNERAL PORTRAIT AT OAKWOOD. This is the first known funeral photograph taken at the Oakwood Cemetery. The original Oakwood gate, along with the Tacoma Mausoleum, can be seen in the background. (Courtesy Bill Habermann.)

CLARK MONUMENT. Frank Clark was born on February 10, 1834. He was orphaned but taken in by close relatives. He studied law in Lowell, Massachusetts, and after graduation, he set out for the West. He was a young man of 18 when he arrived in Steilacoom in 1852. He eventually became a prominent member of the Washington Bar Association. In addition to practicing law, Clark was the chairman of the Pierce County Democratic Party in 1855. He is best known for his role in the trial of Chief Leschi. Clark was successful in temporarily halting the execution of the Nisqually Indian chief. (Courtesy *Steilacoom Historical Museum Quarterly*, Vol. 15, Winter 1986.)

RUSSIAN SECTION OF OAKWOOD HILLS CEMETERY. In this photograph is a lovely and lively looking section of Oakwood Hills Cemetery. Laser technology is a fairly new concept when it comes to grave marking. Lasers enable monument makers to create an exact duplicate of a photograph and etch the image in granite or marble. The renderings are surprisingly lifelike. The image is smooth to the touch, making a rubbing of the marker impossible. No one is yet certain about the longevity of the art, but the images are expected to last because they are created in stone. This section of the cemetery has been purchased by several different Russian churches in the area. Many of the markers tell a story or include a picture of a favorite object, like a car. All markers are placed at the foot (instead of at the head), and the face of the marker faces the head, as is the Russian custom. (Courtesy author's collection.)

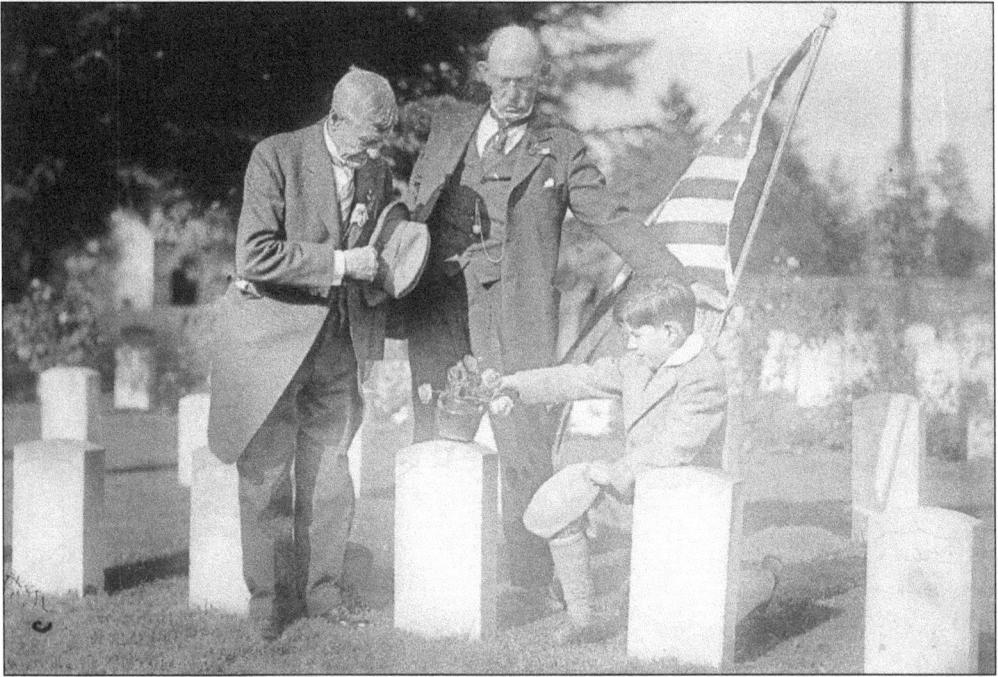

MEMORIAL DAY 1926 AT OAKWOOD HILLS. Veterans from the Grand Army of the Republic (GAR) and the Spanish-American War united in a memorial service at the graves of the departed. Pictured is the patriotic instructor of Custer Post No. 6, Charles Cavender (right), and Post Chaplain Francis Thompson. The great-grandson of Cavender, Tilford Gribble, places roses at the GAR plot in the cemetery. (Courtesy Bill Habermann.)

1946 MEMORIAL DAY AT WRIGHT PARK. Civil War widows pictured from left to right are Millie Ball, Eleanor Crossen, and Lena Haskell. Millie's husband, Irvin Ball, is buried at Oakwood Hills Cemetery.

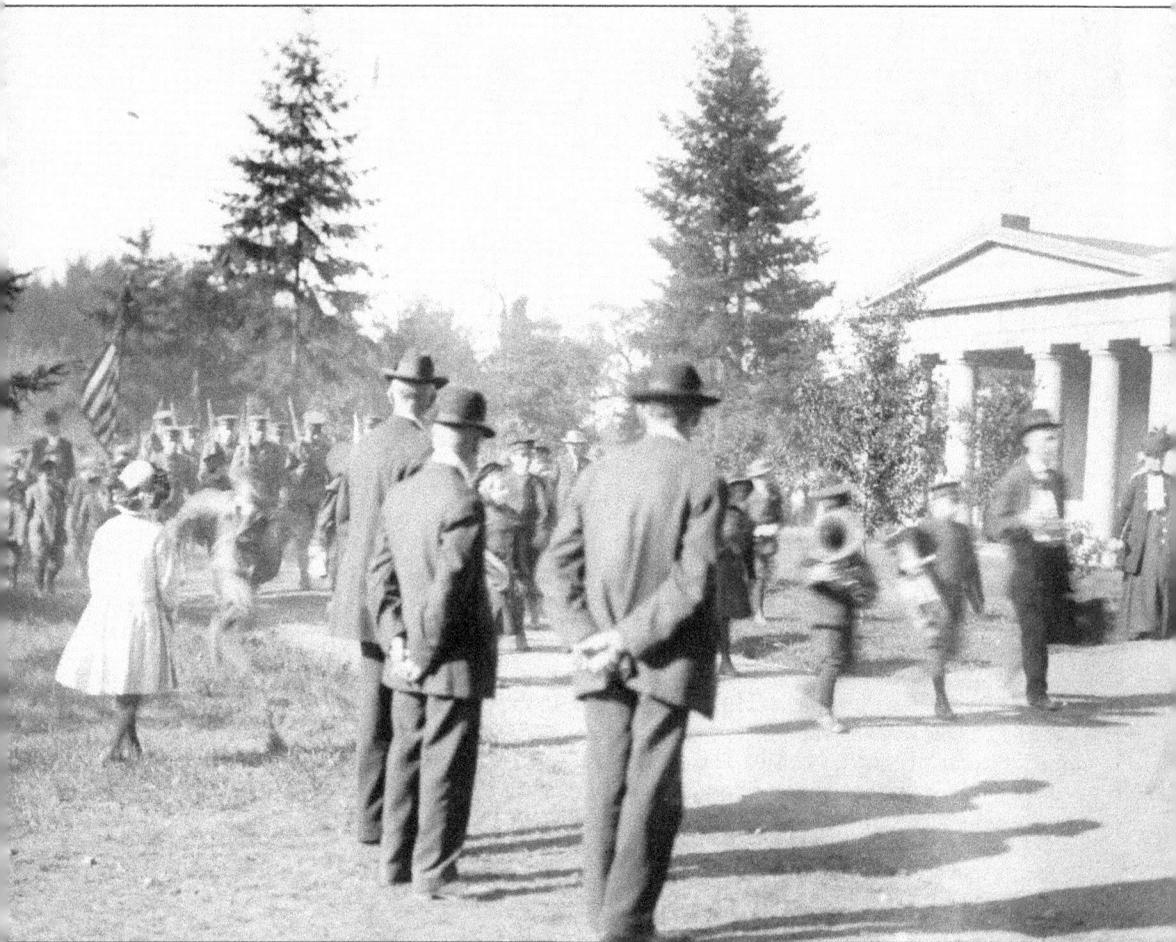

THE BAND MARCHES ON. Dated May, 31, 1909, this photograph is a part of the Amzie D. Browning collection at the Tacoma Public Library. The photograph is significant to cemetery history because it shows a time when visitors could wander freely between Oakwood Cemetery and the Old Tacoma Cemetery (or Prairie Cemetery, as it was called back then). Currently, a cement wall divides the two cemeteries. No one knows when the wall was erected, but this photograph shows that it was not built by 1909. People were free to wander from one cemetery to the next. The Oakwood Columbarium was built in 1908 and is pictured here with beautiful columns that would be removed in 1923 for an addition. (Courtesy Bill Habermann and TPL.)

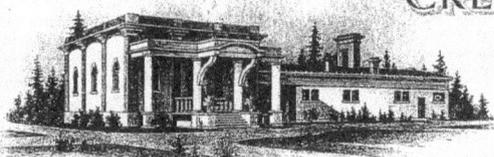

CREMATION SOCIETY
OF TACOMA

OAKWOOD CEMETERY

52nd. & ALDER STREETS

INTERIOR VIEW OF COLUMBARIUM

Tacoma, Washington
Prices

Perpetual Care Single Graves

Adults				Childrens	
Adult Single Grave			$ 40.00	Child's Single Grave	
"	"	"	45.00	Child One to Ten Yrs. Old	$ 30.00
"	"	"	50.00	Child Up to One Year	24.00
"	"	"	60.00		

Includes Opening and Lowering Device

OPENING GRAVES		CREMATIONS	
Adults	$ 10.00	Adults	$ 35.00
Child One to Ten Yrs. Old	6.00	Child One to Ten Yrs. Old	22.00
Child Up to One Yr. Old	5.00	Child Up to One Year Old	12.00

We discontinued the Perpetual Care of Ashes several months ago, but in some cases we will give Perpetual Keeping of Ashes including a pure copper receptical for $ 25.00.

Please destroy all previous price lists.

CREMATION PRICE LIST. On November 27, 1908, John T. Wills became the first person to be cremated at Oakwood Cemetery. Undertaker Conrad L. Hoska performed the cremation, and the bill amounted to $50. The later price list shown above reflects a drop in price from the original $50 to just $35 for adult cremations (bottom right). The document notes the discontinuation of perpetual care service for ashes, which may account for the lower price. (Courtesy Bill Habermann.)

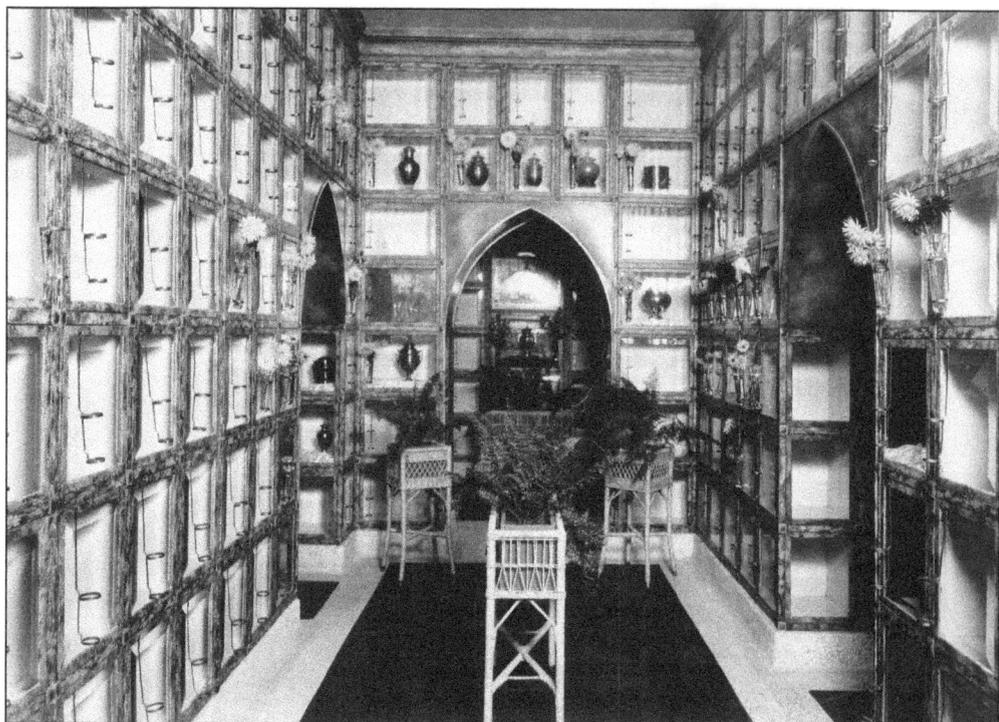

INSIDE THE LOVELY COLUMBARIUM. The image above shows the newer section of the Oakwood Columbarium, added in 1923. An older columbarium is within the original building, but it contains less than 200 niches. Most of the occupants have been moved to the newer section. With cremation growing in acceptance, the new building was needed to keep up with demand. The newer building still has space for inurnments. One of the occupants is Homer T. Bone (pictured below). Dated March, 12, 1940, the photograph was taken at Bone's desk in his Tacoma home. Bone was a Democratic senator. He was nominated by Pres. Franklin D. Roosevelt and appointed judge on the US Court of Appeals for the Ninth Circuit. He is credited with much of the campaigning to obtain the $2.7-million Works Progress Administration grant for the Tacoma Narrows Bridge construction.

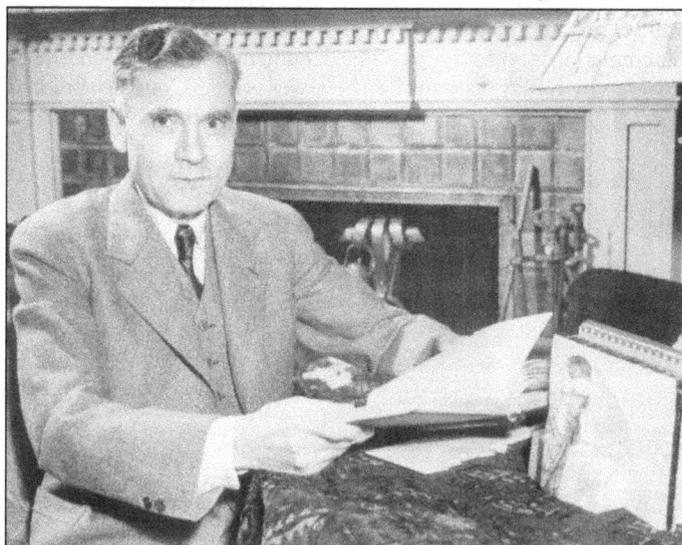

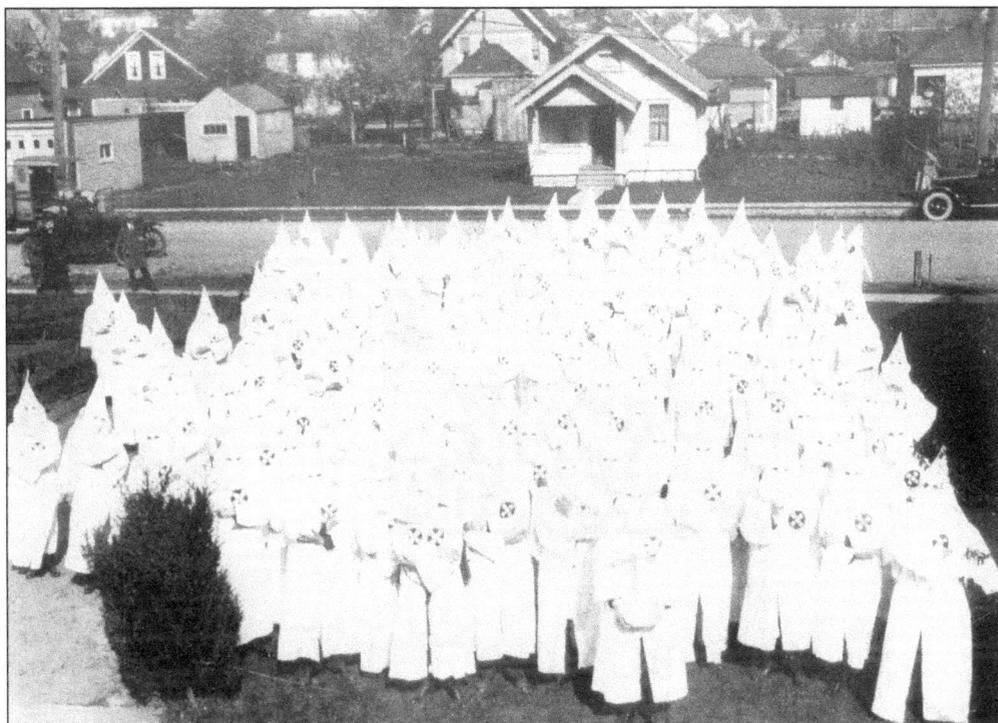

KU KLUX KLAN IN SOUTH TACOMA. Taken behind the Piper Funeral Home in 1924, this photograph shows a Ku Klux Klan gathering for the funeral of Edward J. Block (July 26, 1882–April 20, 1924). According to the Tacoma Public Library, when the photograph was published in the *News Tribune*, it was attributed to C. Tucker of South Tacoma. It is believed that the Ku Klux Klan members were not gathering to harass the funeral in progress, but to pay tribute to one of their own. It has been said that Block required a special casket, as he was nearly seven feet tall. Services were held in the chapel with the Klan in full dress and formation outside. The Klansman in the center is holding a cross that has been lit on fire. It is not known how long they gathered or if authorities were called.

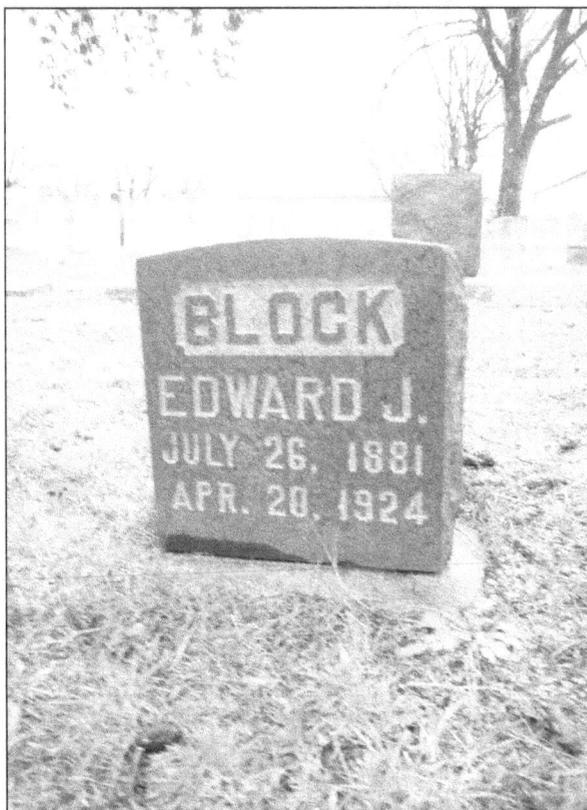

THE COLUMBARIUM, used exclusively as a repository for the ashes of the dead, is constructed of fire-proof material throughout, is bright and cheerful in aspect and built in such a manner as to insure permanency and stability.

THE BUILDING is at all times in charge of courteous and trust-worthy persons, whose duty is to receive visitors and to see that all rules and regulations of the Association are enforced.

ALL SPACE therein will be sold for *permanent occupancy* and *with perpetual care.*

CREMATORIUM- OAKWOOD CEMETERY

Cremation Society of Tacoma

This Certificate issued by the "CREMATION SOCIETY OF TACOMA," Pierce County, Washington

Witnesseth, that in consideration of _____ Dollars

in full payment by_____ for Niche No. _____

Row No._____Side of Room No. _____in the Columbarium of the Cremation Society

of Tacoma agrees that the said grantee and_____ heirs, shall have the exclusive right to use said Niche in

perpetuity as a place in which the cremated remains of said grantee and those of_____ heirs may be

deposited, and for no other purpose.

The said Association agrees to perpetually keep said Columbarium in good condition and repair without

expense to said grantee or_____ heirs.

This certificate is accepted by said grantee subject to any and all rules and regulations heretofore

adopted or which may hereafter be adopted for the regulation and operation of said Columbarium.

Dated Tacoma, Wash.,_____ 191___

Cremation Society of Tacoma

By_____

Secretary

CREMATION SOCIETY OF TACOMA. A swastika symbol is present in each of the corners of this Oakwood Columbarium certificate of niche ownership. The certificate shown here was used when the swastika denoted religious beliefs. It became the official symbol of the National Socialist Party much later. The symbol actually dates back to the Neolithic period, but because of its association with Adolf Hitler and Nazi Germany, it has become stigmatized in Western culture and is outlawed in Germany. (Courtesy Bill Habermann.)

Three

TACOMA MAUSOLEUM, HOME OF PEACE, PAUPER'S FIELD

According to Washington State's Historic Property Inventory Report and the Department of Archeology and Historic Preservation, the Tacoma Mausoleum was recorded as a legacy for Tacoma on January 1, 1900.

The Tacoma Mausoleum is located at 5302 South Junett Street in South Tacoma. Celebrated architect Silas Nelsen designed the mausoleum in the Classical Revival style. Built in 1910, the Tacoma Mausoleum was one of the first on the West Coast to offer an alternative to inground burials. Since then, it has added to its buildings and also offers pet cremation and burial.

The Tacoma Pauper Cemetery is tucked quietly between the Tacoma Mausoleum and the Oakwood Hills Cemetery. The unmarked cemetery is gated. It is thought that one of the first burials at Pauper Cemetery dates to 1883. Bill Habermann has researched the cemetery enough to provide the website www.findagrave.com with a few names of people who are buried there. He reports that during his investigations, quite a few individual records listed only such details as "unknown man," "skeleton," "baby found in toilet," "found in gulch," and "murdered." The cemetery is no longer in use and is monitored and cared for by the county. It has been said that fresh flowers are sometimes left on one of the few markers at the Pauper's Cemetery. Obviously, the inhabitants are gone but not forgotten.

A beautifully ornate gate encloses Home of Peace Cemetery. The cemetery is located on private property, and visitors are welcome to call for an appointment. The cemetery began in 1888 as the first Hebrew Benevolent Society. It has been reported that many markers date from as early as the 19th century. The folks who maintain this cemetery are dedicated to its preservation and perpetual care.

Chevra Kadisha Cemetery is a small cemetery within Home of Peace Cemetery; it is a Masonic Memorial Park.

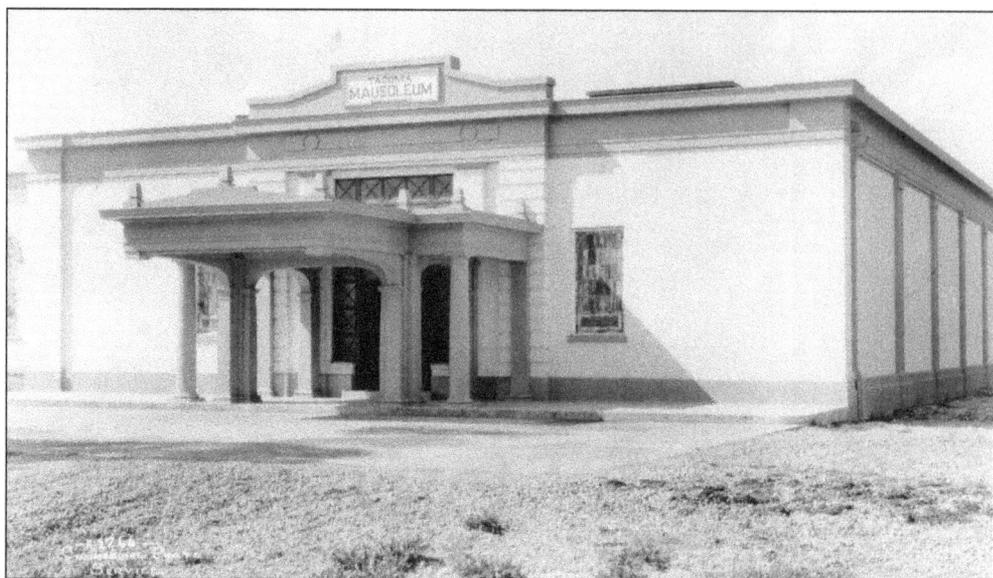

THE TACOMA MAUSOLEUM. The Tacoma Mausoleum is located within the Oakwood Hills Cemetery. This photograph shows the third addition to the mausoleum. It was designed by popular Tacoma architect Silas E. Nelson. It contains nearly 3,000 crypts and is on the Tacoma Historic Register.

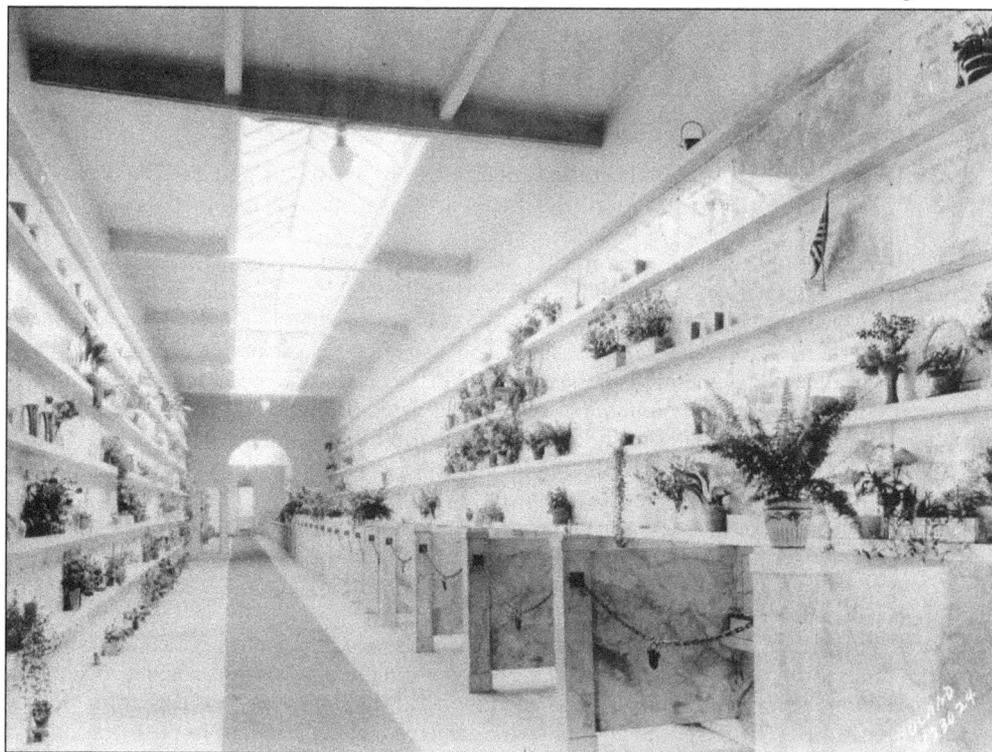

INSIDE VIEW OF MAUSOLEUM. This interior view of the Tacoma Mausoleum shows a long carpet leading to a stained glass window. The crypts are made of granite, and vases are placed for flowers. This photograph is a part of the Marvin D. Boland collection at the Tacoma Public Library. The date of this image is October 9, 1930.

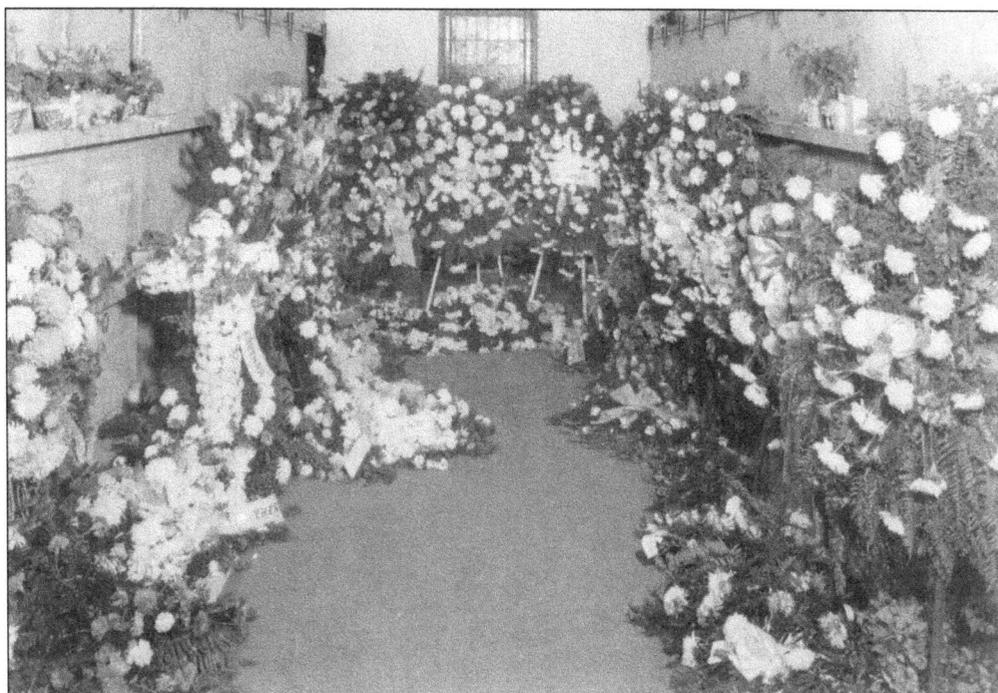

MAUSOLEUM FUNERAL. While funeral ceremonies often occur outside in a cemetery, they also take place inside mausoleums. This photograph from the Richards Studio collection depicts massive flower arrangements marked "Brother" and "Dad." The Tacoma Public Library notes the funeral was that of Joseph Loveridge. He worked as an inspector at the State Vehicle Safety Inspection Board.

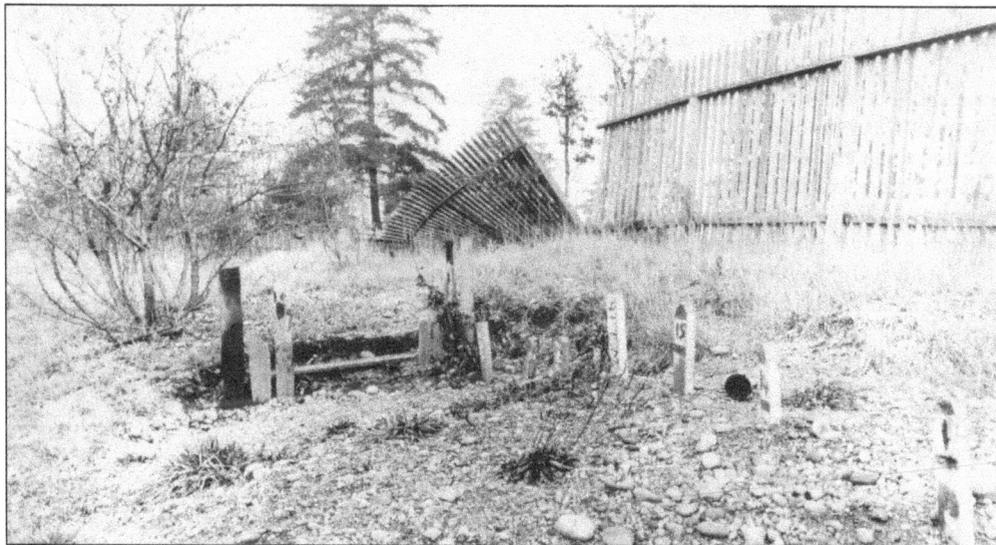

PAUPER'S FIELD. This photograph from 1924 captures the sad state of this forgotten cemetery. Some graves are marked with numbers, and others lay completely unmarked. A sketchy history regarding this cemetery results in way too much confusion about who was in charge of it. Originally, Tacoma's undertakers shared the responsibility of the cemetery, making sure graves were dug and covered and records were kept. At some point, joint undertaker upkeep of the cemetery waned, and the county was called in to take over. The county is still in charge of the cemetery today.

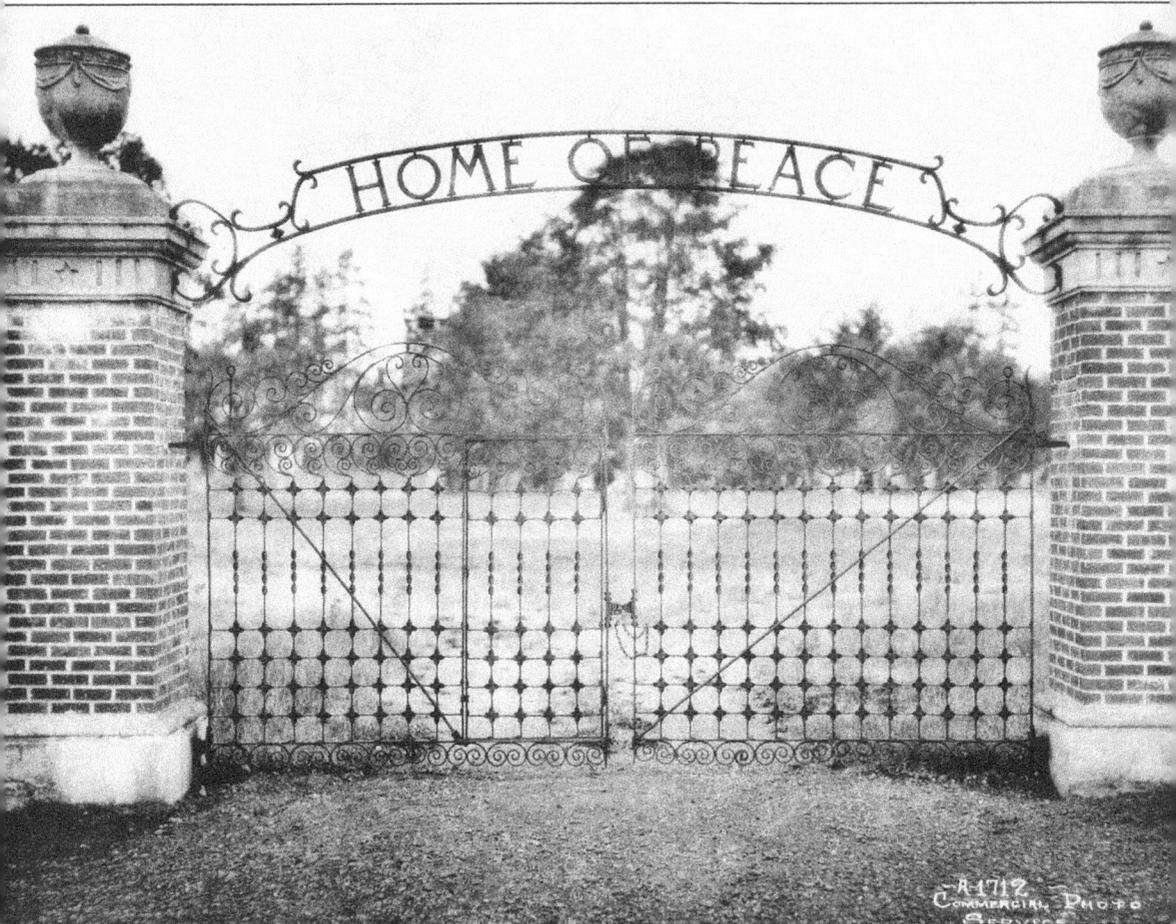

HOME OF PEACE CEMETERY. The Jewish community in the Tacoma area began with a few families in Steilacoom and Olympia in the 1860s. By the 1870s, several families were established in Tacoma. The cemetery began in 1889 as the First Hebrew Benevolent Society and was incorporated in February 1891. The oldest gravestone in the cemetery is from 1886. It was moved from Olympia when the cemetery was established. Many tombstones are datable from the 19th century. Of the more than 700 graves, more than one-tenth were unmarked until the congregation of Temple Beth El purchased tombstones for the unmarked graves in 2000. The cemetery association owns eight acres, but only about two acres are currently in use. The cemetery is private; however, tours can be arranged. The Home of Peace entrance gate is one of the most ornate of all the cemeteries in Tacoma. It was worked by the Western Iron & Wire Works Company. This photograph is dated September 14, 1926, and is a part of the Richards Studio collection at the Tacoma Public Library. (Courtesy TPL and Temple Beth El.)

Four

MOUNTAIN VIEW MEMORIAL PARK AND CREMATORY

In the 1950s, Mountain View Memorial Park was said to be one of the most modern examples of funeral homes in the United States. An advertisement in the 1951 Tacoma City Directory states, "A mourner could place complete responsibility in the very capable hands of Mountain View." Mountain View's claim was, "Everything in one place." Indeed, this was true with the combination of the cemetery, funeral home, chapel, mausoleum, and crematorium all in one location.

Mountain View even advertised having a private plane for the use of transporting the dearly departed from anywhere, at anytime. The advertisement says, "When a death occurs away from home, the Mountain View Funeral Home is now prepared to take immediate charge of all arrangements under its newly-established FLIGHT SERVICE." It goes on to note that the service "is equipped to operate on both land and water. Remote areas where pontoon landings are required present no problem."

Mountain View Memorial Park was incorporated in 1915 by James Richard Thompson. A funeral home was added to the cemetery grounds in 1942 by son J. Arthur Thompson; it was the second combination funeral home and cemetery founded in the United States. Four generations of Thompsons have owned and operated the memorial park, which has expanded to 180 acres.

Recently, the Thompson family sold their interest in the cemetery. Mountain View has an extensive staff that has remained loyal under the new management.

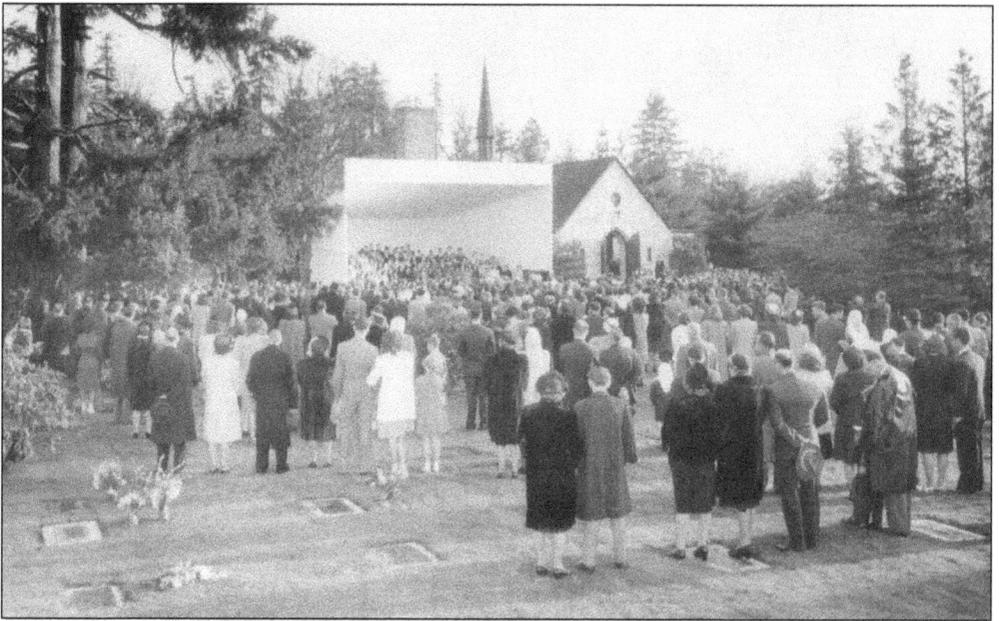

EASTER AT MOUNTAIN VIEW CEMETERY. Through the years, Mountain View Cemetery has been a popular location for Easter ceremonies. Pictured is a sunrise service beginning at 6:30 a.m. The organ began playing the prelude at 6:15 a.m. Mountain View's lovely grounds and chapel were the perfect location for such celebrations. In the photograph above, Christians of various churches stand on graves while they worship and celebrate the Resurrection.

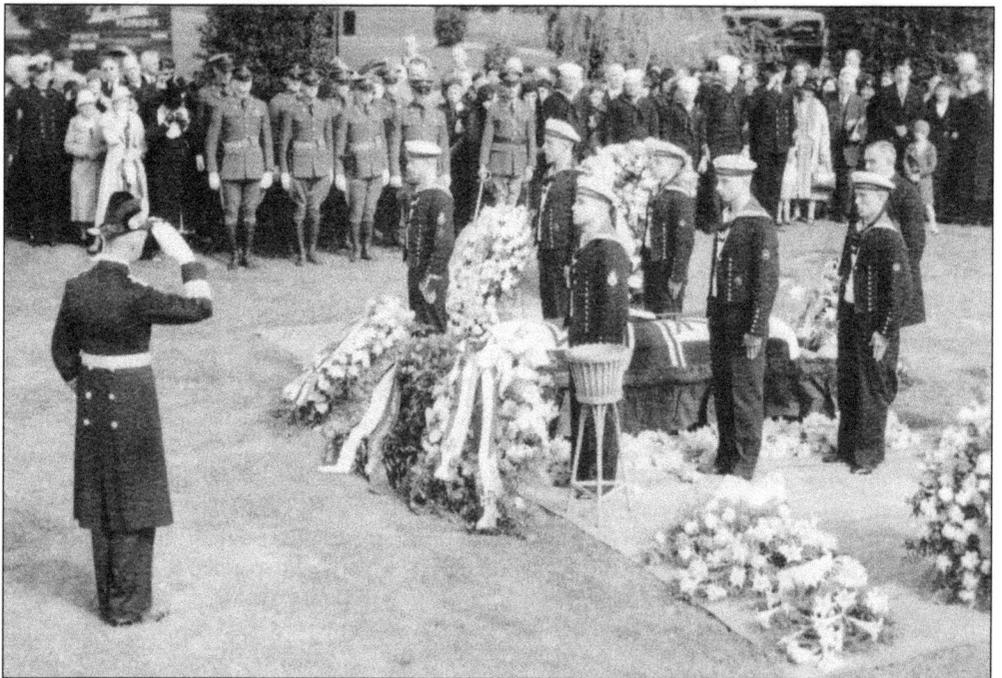

MILITARY FUNERAL. Buried with full honors is machinist mate Carl Lischke. His ship commander, Capt. Harsdorf von Enderndorf, is giving the final salute. Lischke was buried in Tacoma because his ship would not be returning to Germany. The funeral was attended by German and US military forces.

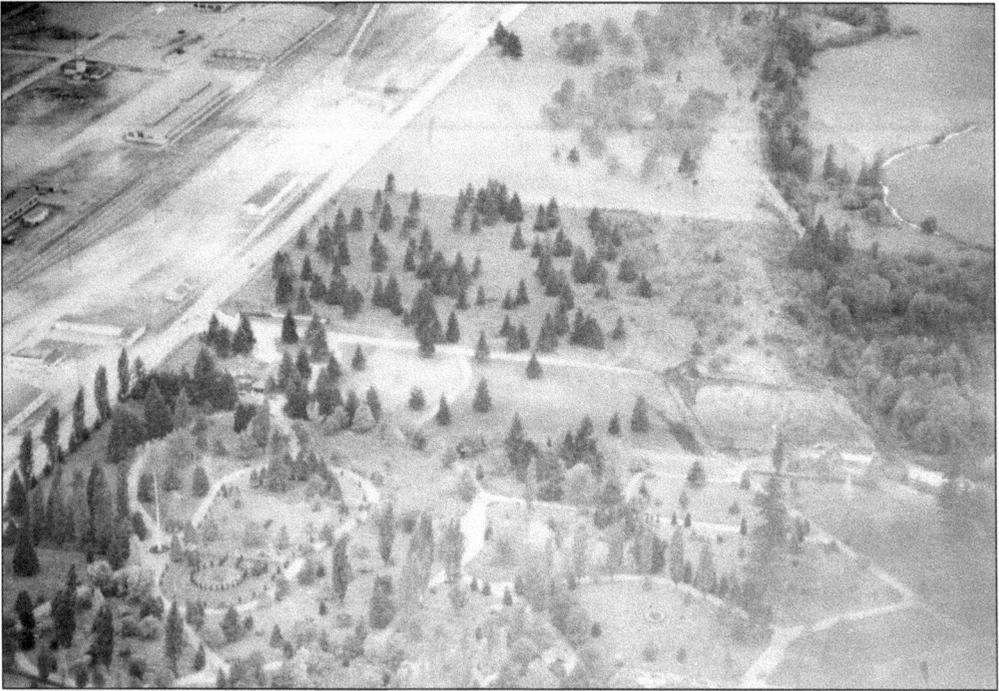

MOUNTAIN VIEW CEMETERY AND FLIGHT SERVICE. This photograph dates to the 1950s. Steilacoom Boulevard is prominent in the upper left corner. The area appears to be largely undeveloped compared to today. Much progress has taken place in the last 60 years. Mountain View invested heavily in advertising in those days, and it paid off. Mountain View was one of the largest operations at that time. It is uncertain when the business added and discontinued flight service. An advertisement states, "The Mortuary plane, with pilots available around the clock, can be dispatched to return the deceased to Tacoma in a matter of hours, a service which might otherwise take days."

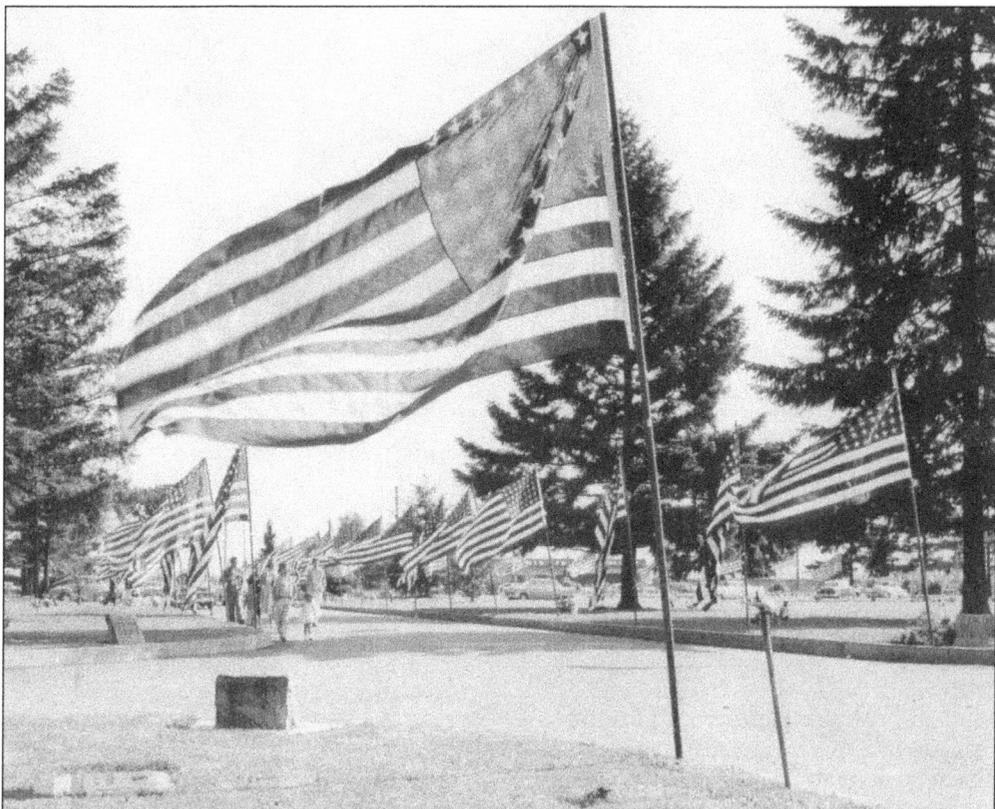

MEMORIAL DAY SERVICES. One can almost hear the flags whipping in the wind as they line the roadway. Keynote speaker for this 1958 Memorial Day celebration was Sen. Henry M. Jackson. Many attended to honor all fallen soldiers.

TENT FUNERAL. Full military honors were given to Cpl. Keith W. Hanson, an armed forces gentleman. Hanson was just 19 years old when he died. Under the tent were his mother, Mrs. Robert Haley of Tacoma, and his father, Clarence Hanson of Wisconsin. This photograph originally appeared on Page 13 of the April 26, 1948, issue of the *Tacoma Times*.

Five

OLD SETTLERS CEMETERY

The Old Settlers Cemetery is all but abandoned. Occasionally, interested groups will take on a gardening project or fence-mending mission. Otherwise, the cemetery sleeps quietly as the crocus bulbs blossom year after year. Attorney Frank Clark donated the land for burials of pioneers only. It has been said that the 10-acre plot of land has no official sexton but is cared for by descendants of the families buried there. The county is responsible for mowing the lawn.

Settlers were buried in Old Settlers Cemetery as early as 1855. Thomas Jefferson Wright and his wife, Anna—both with 1795 birth dates—are buried there. In 1853, Wright was one of the first settlers to wagon train across the Naches Pass and settle in the area.

To make way for the widening of Washington Boulevard, the cemetery fence and graves were relocated. It is rumored that a grave or two may have been missed in the relocation process. Several neighbors testify that there were graves all along Washington Boulevard before the first fence was constructed. When the most recent fence was erected, the county had to move in the perimeter of the graveyard even closer. There may be many residents of the Old Settlers Cemetery resting under the paved road. The cemetery is located next to the Lakewood Christian Church at 8105 Washington Boulevard Southwest.

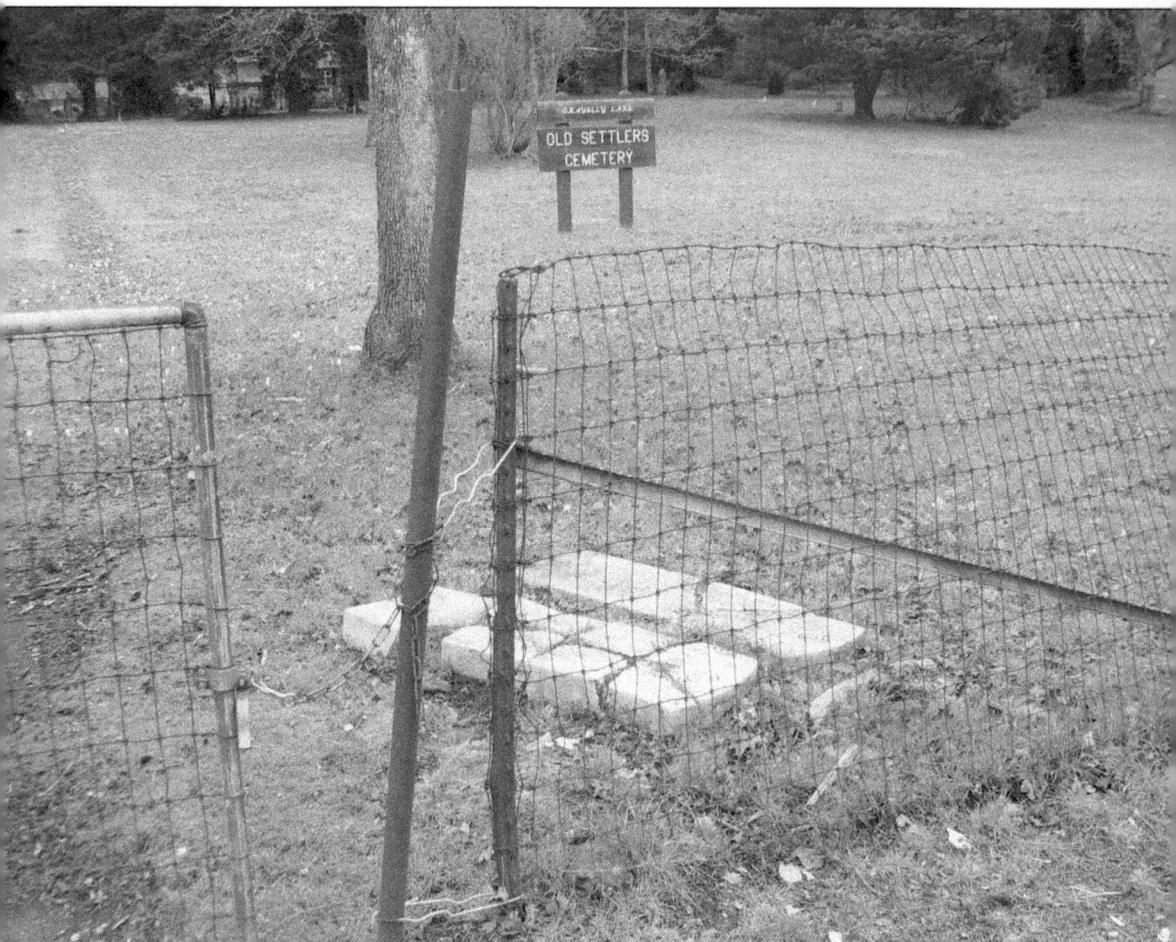

OLD SETTLERS CEMETERY GATE. The Old Settlers Cemetery gate had been in need of repairs for quite some time. In fact, it needed to be replaced all together. Apparently this wasn't the first time the cemetery had succumbed to neglect. In the *Puget Sound Express*, dated November 23, 1876, Julius Dickens has this to say regarding the cemetery: "The graveyard near Gravelly Lake is in as bad a condition, lacking enclosure, besides. Here, cattle, sheep and hogs may be seen at any time feeding on the graves and uprooting the ground. Now, we suggest that for the credit of the good name of our town, our people subscribe money enough to have a fence built . . . half-dollar, dollar, or two from each of our citizens will pay for the work and material." Pictured is the fence that local residents constructed. (Courtesy Rebekah Castro.)

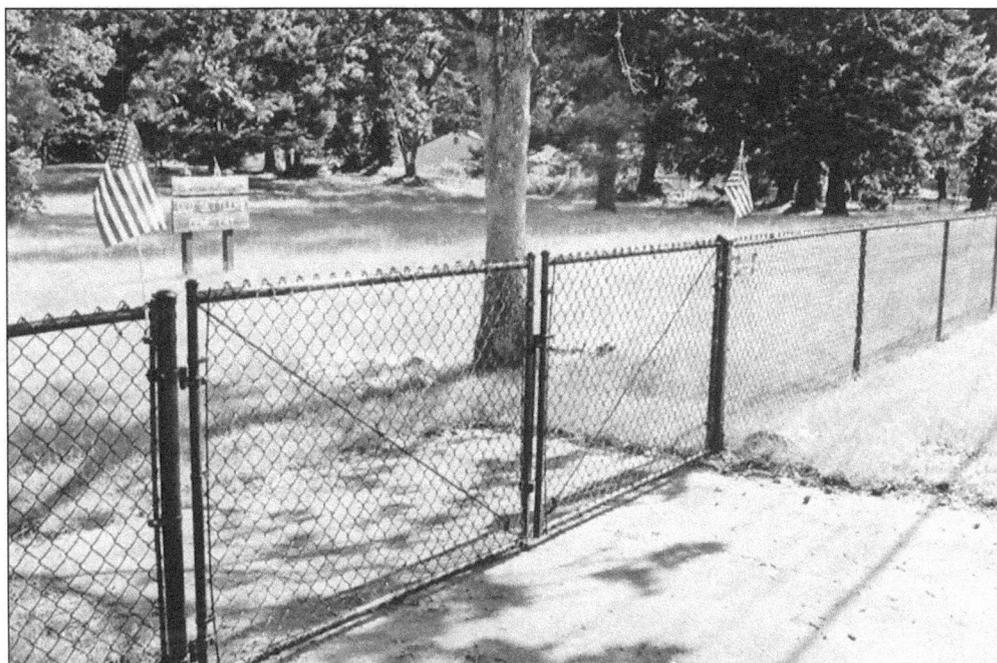

OLD CEMETERY GETS NEW FENCE. After nearly 135 years, the Old Settlers Cemetery received a new fence. Leavitt Castro (right) took on the fence replacement project as an Eagle Scout with Troop 410 of the Boy Scouts of America. With the help of his mother and other community members, enough money to pay for a new chain-link fence was raised. Many volunteers gave money and donated precious time. Local lore says that when residents saw what the group was trying to accomplish, commuters stopped to give money to the volunteers and thank them for their efforts. (Both, courtesy Rebekah Castro.)

OLD SETTLERS CEMETERY. A walk through the Old Settlers Cemetery reveals open spaces with sunken ground every few feet. Many Lakewood pioneers are laid to rest here, and many graves remain unmarked. Little information is available concerning burial information. According to Fred Morley of Piper-Morley-Mellinger Funeral Home, there is no official sexton. The county is responsible for the cemetery's upkeep and care; however, sometimes it falls behind. Caring neighbors such as the Castros keep an eye on the cemetery. Out of respect for the neighborhood and those interred at the cemetery, the Castro family takes pride in keeping Old Settlers dignified. (Courtesy Rebekah Castro.)

Six

CALVARY CATHOLIC CEMETERY, OLD RIGNEY-PIONEER CEMETERY

John Rigney, one of the first pioneers in Pierce County, arrived in the United States in 1847. A year later, he married Irish immigrant Elizabeth Lowry. In 1852, he was given a donation claim of 640 acres whereupon he built his home and raised 10 children. In 1880, the Rigneys moved to Steilacoom. Rigney donated nearly four acres of land to be used for Catholic burial purposes. History is uncertain as to when this land was donated, but an article from the *Tacoma Daily News* dated June 12, 1905 reports that at the "old Rigney cemetery . . . lots are nearly filled with graves." Because the old cemetery was filling up, an adjacent tract of land was purchased. The article goes on to say, "The Catholics of Tacoma will soon have one of the finest cemeteries in the Northwest . . .Only one name has been suggested for the new cemetery thus far, and that is *Calvary*."

Calvary was purchased from Tony Portman in 1905 to supply a burial ground for the Catholic community, as the smaller cemetery was nearly full. In 1950, Calvary had 35 acres and was located next to the four-acre old Rigney Cemetery.

The *Tacoma News Tribune* reports in an article dated November 13, 2005, that the 55-acre cemetery, located in the southwest corner of Tacoma, is the only Catholic cemetery in Pierce County. Nearly 27,000 people are buried there, and although the deceased do not have to be Catholic to be interred there, special sections are designated for Catholics only.

CALVARY CATHOLIC CEMETERY. Calvary Catholic Cemetery is located next to Old Rigney-Pioneer Cemetery. There has been some confusion as to whether or not Old Rigney-Pioneer Cemetery is separate from Calvary. History is loose here, and several different accounts are given. One explanation is that Rigney sold the four acres to the Seattle Archdiocese for $1. That transaction is said to have transferred ownership of the land to Calvary. So the Old Rigney-Pioneer Cemetery is not only adjacent to the Calvary Cemetery, but also a part of it.

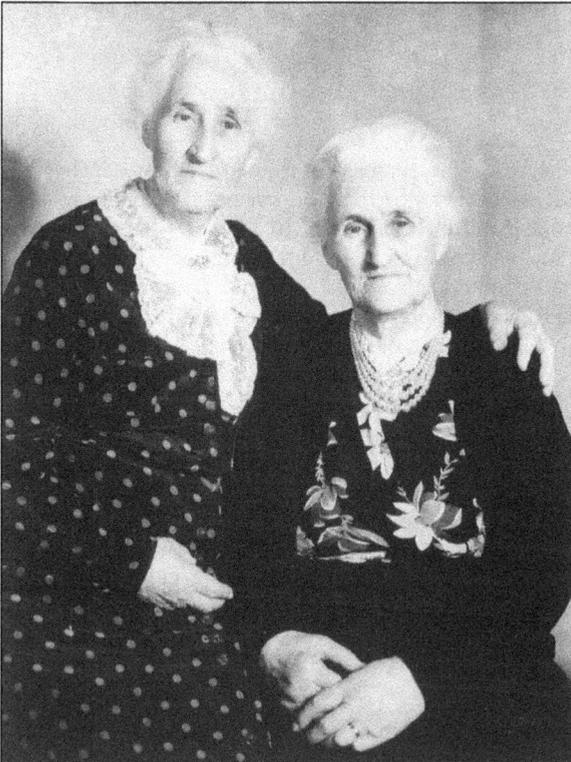

RIGNEY TWINS. Pictured around 1939 are Lucia Rose Rigney O'Donnell (left), and Marcella Catherine Rigney Henly, twin daughters born to Tacoma pioneers John and Elizabeth Rigney. When the girls turned 18, they began to teach at the local schoolhouse, and when they were widowed, they kept records for the Western State Hospital. Marcella died in August 1950 and Lucia followed seven months later when she died in March 1951. They were 89 years old.

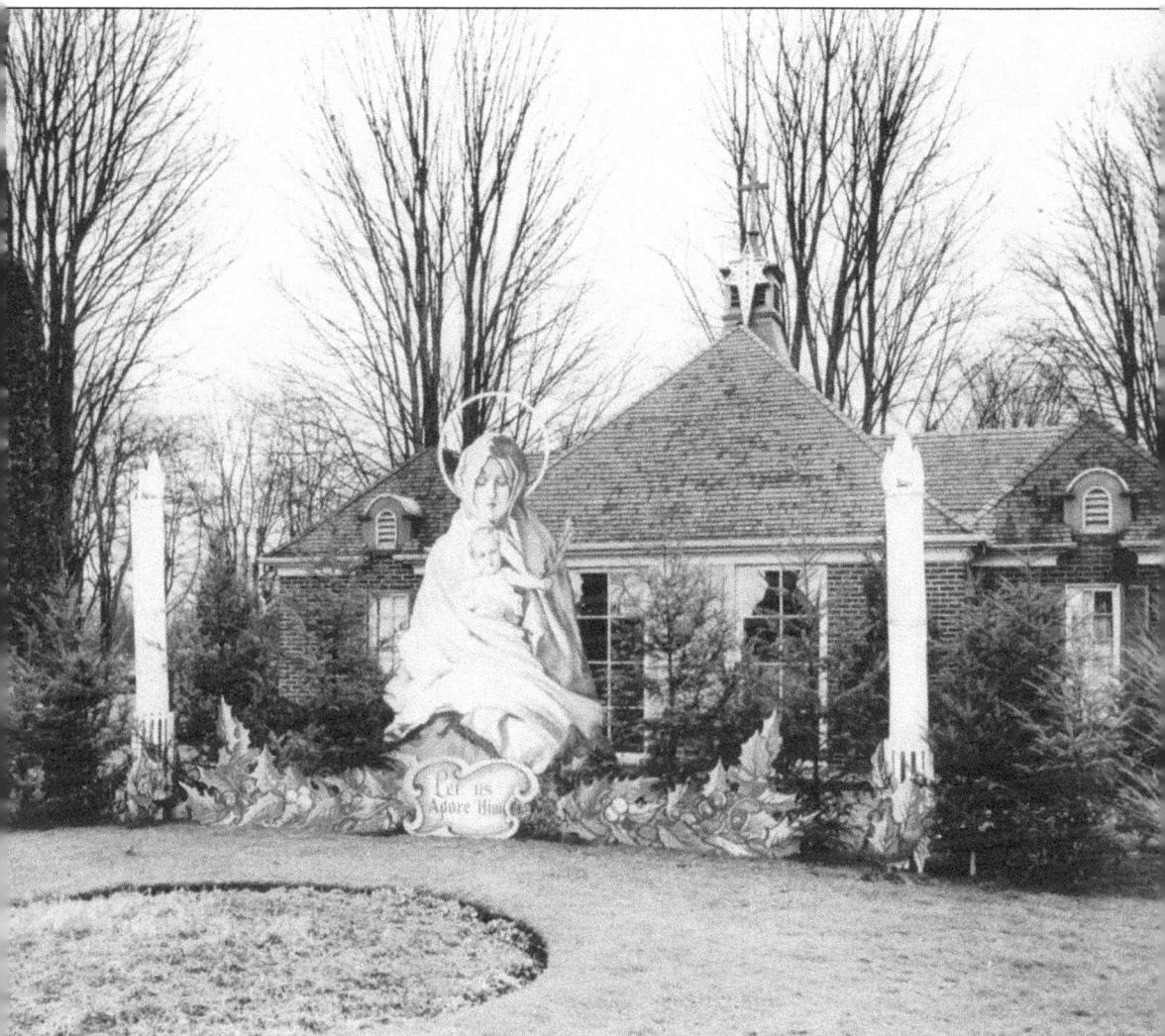

NATIVITY SCENE. Calvary Cemetery was known for its larger-than-life, plywood cutout nativity scene. This photograph is dated December 31, 1954, and is a part of the Richards Studio collection at the Tacoma Public Library. In the evening, up-lights were put into place so that the scene would glow, creating a remarkable sight. This scene was set up in front of a caretaker's house that no longer appears to be present at the current cemetery. Many residents would drive out to the cemetery just to see the lovely dedication to Mary and baby Jesus.

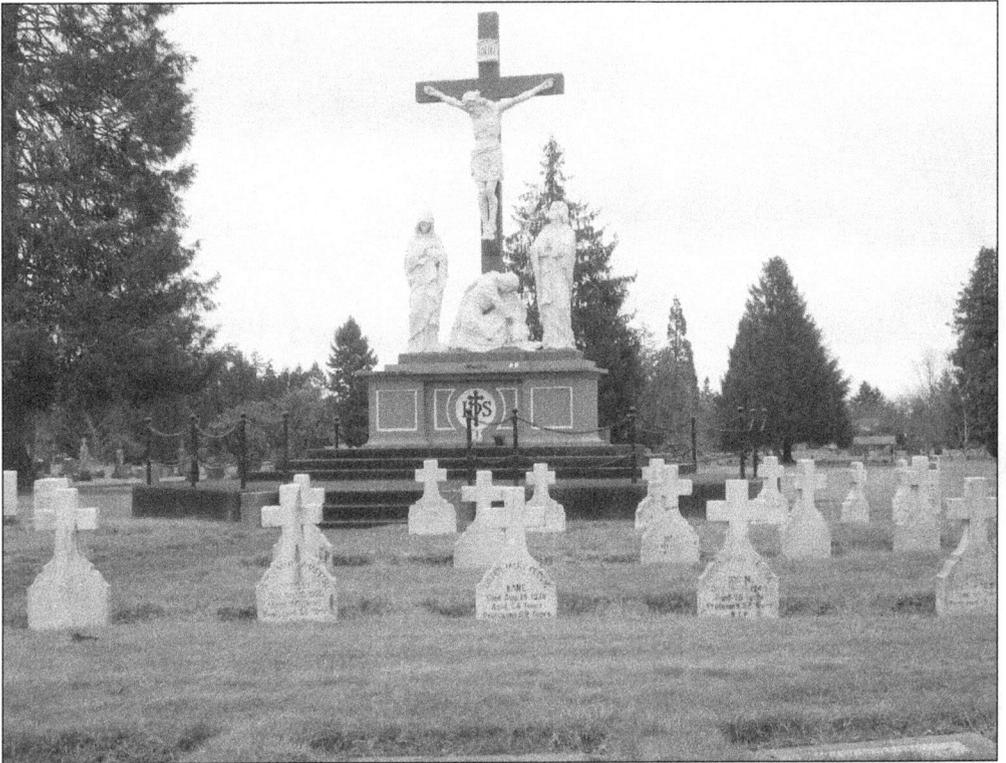

REV. PETER FRANCIS HYLEBOS. The first pastor of St. Leo's Parish was the Reverend Peter Francis Hylebos. The crucifix of Christ was erected as a memorial in his honor. The Hylebos alter at Calvary Catholic Cemetery is surrounded by crosses marking the graves of Catholic nuns. It is quite a sight to see and is an endearing testimony to devotion, dedication, and everlasting faith. The entrance to the cemetery is now located at the intersection of Fifty-Second Avenue and Seventieth Street West. (Courtesy author's collection.)

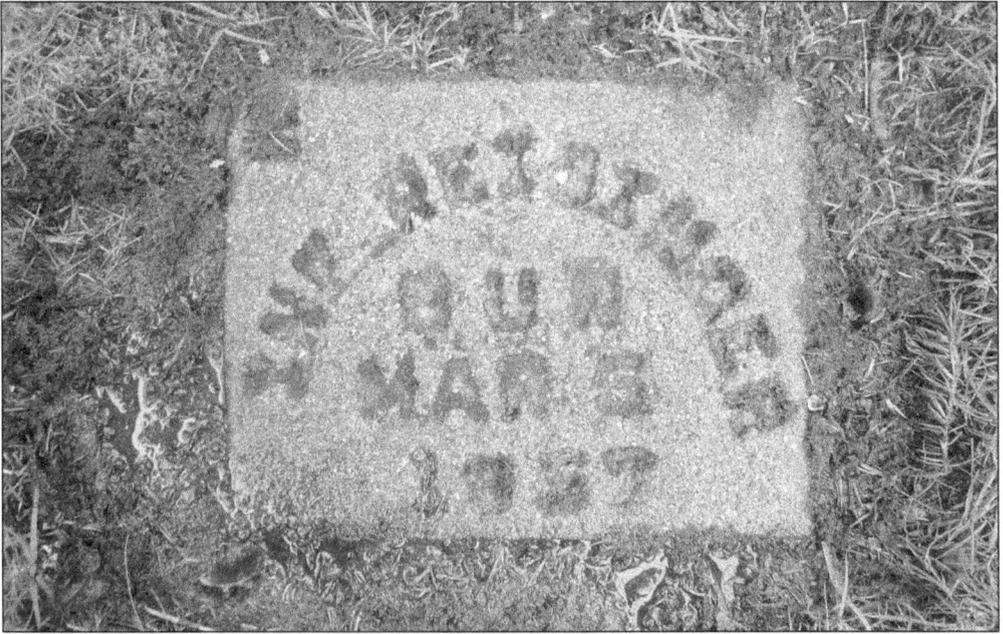

INFANT REISINGER AND PARENTS. Baby Thomas Reisinger was stillborn to John and Patricia Reisinger on March 2, 1957. While the marker indicates March 5, 1957 as the date of death, that was the date of interment into the baby section of Calvary Catholic Cemetery. John and Patricia Reisinger bought one of the city's pioneer businesses in 1962 and renamed it Tacoma Ice & Cold Storage. The company was founded in 1887 under the name Tacoma Ice Company, and ice was delivered by horse-drawn wagon. It has been a family-owned-and-operated business since 1962. In fact, many of the eight Reisinger children worked at the plant through the years, including the author's husband, David Reisinger. The ice plant was at the same location for more than 122 years, until Sound Transit exercised the right of eminent domain and took the property for the Sound Transit Railroad. The ice company, now called Star Ice & Fuel, has set up business in a brand new facility in Fife. (Both, courtesy author's collection.)

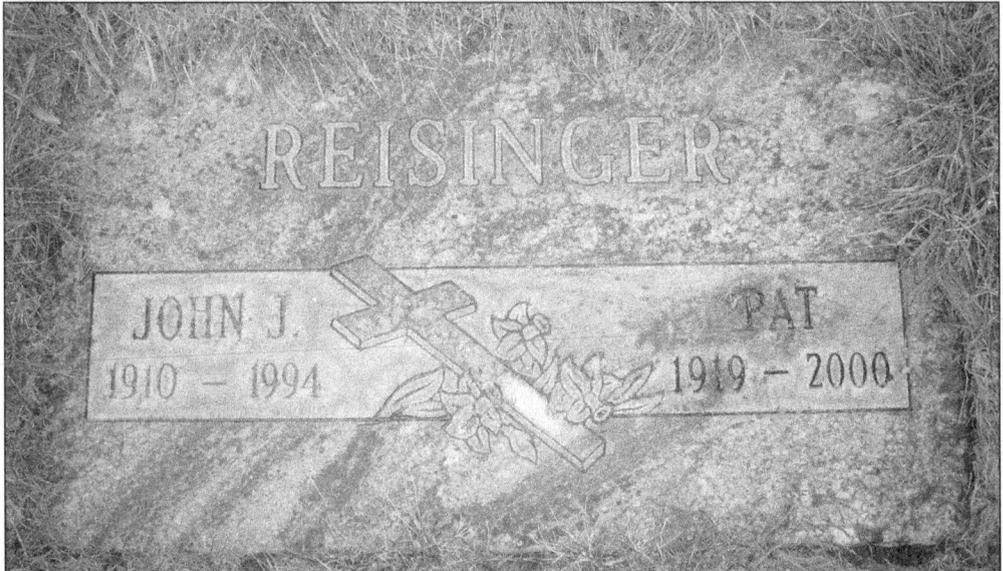

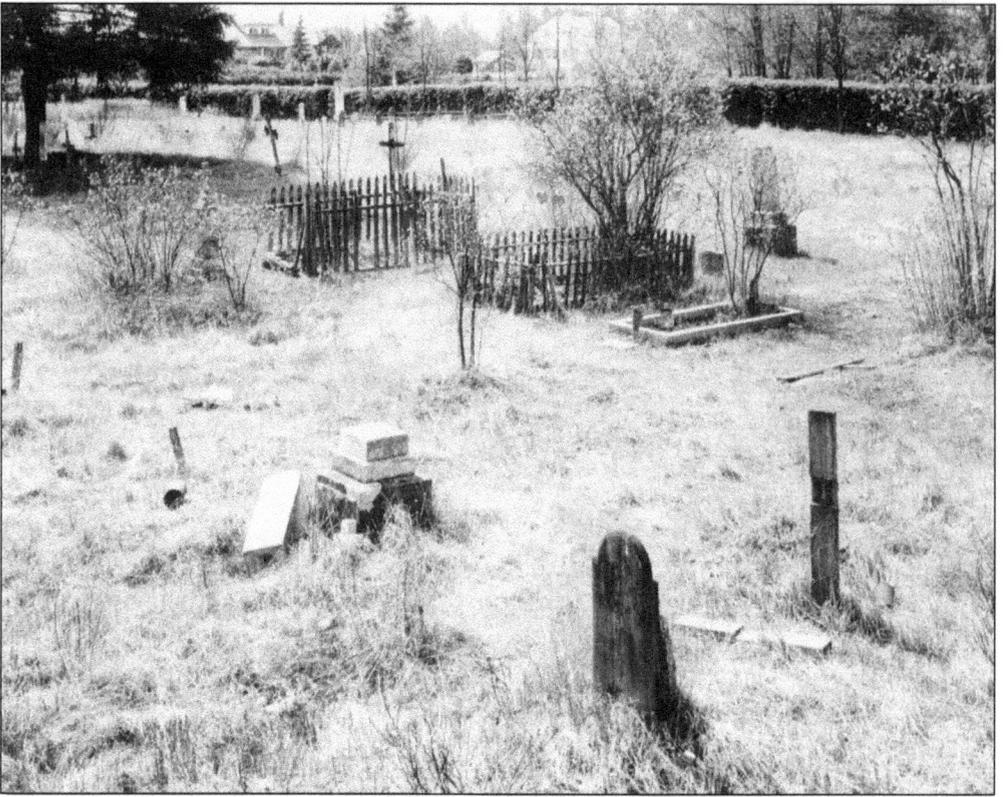

OLD RIGNEY-PIONEER CEMETERY. In 1950, this cemetery had been forgotten and left to weeds. The idea of perpetual care had not caught on yet, and many families of the residents buried here have long since left the area or passed on. The portion of cemetery attributed to Rigney is behind the current caretaker's house and closest to Lakewood Drive West and South Seventy-fourth Street. Tall trees and a fence enclose the nearly even, rectangular cemetery. Most folks who visit Calvary Cemetery would easily overlook it if they didn't know it existed. Below is a fallen marker made of wood. Now, some 60 years later, the cemetery has been cleaned up, and all repairable fallen markers have been restored. Markers beyond restoration were disposed, and many graves remain unmarked to this day.

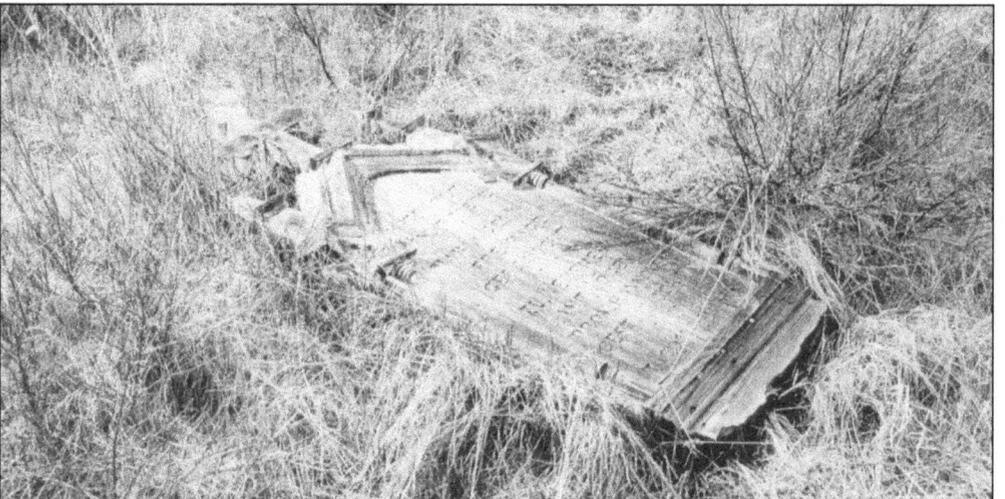

Seven

WESTERN STATE HOSPITAL HISTORICAL CEMETERIES

The Western State Hospital is on the property of the former Fort Steilacoom in Lakewood, Washington. Fort Steilacoom served as a military post from 1849 to 1868 when the federal government abandoned it. The Washington Territory purchased the fort with the intent of turning it into a hospital for the insane. The new hospital, called the Insane Asylum of Washington Territory, opened in 1871 with 15 men and six women patients.

Statehood in 1889 brought about many changes for the hospital, including a new name: Western State Hospital.

Within the compound of the hospital is an old pioneer cemetery called Settlers Cemetery, which is sometimes referred to as the Fort Steilacoom Cemetery. There are no firm records of when the cemetery began, but according to the Washington State Archives, 20 soldiers were buried there at one time, the first of which was in March 1854. There are about 25 more roughly identified graves, and as evidenced by shallow depressions in the grass, perhaps many more which cannot be identified.

The hospital patient cemetery is located across the street in Fort Steilacoom Park (next to the off-leash dog park). The historic cemetery was in use from 1876 to 1953. The Grave Concerns Association, along with the parks department, have taken over its care and restoration. To learn more about their efforts and this historic cemetery, visit www.wshgraveconcerns.org.

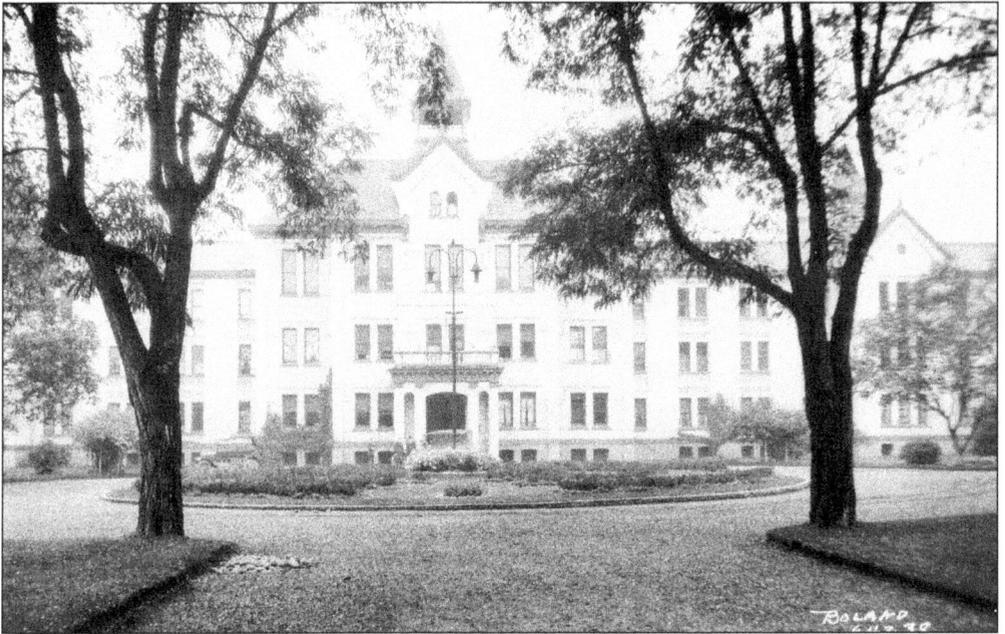

WESTERN STATE HOSPITAL. Over the last 140 years, many renovations, additions, and new buildings have been added to Western State Hospital. Pictured above is an early photograph of the white-washed hospital's main entry, date unknown. Pictured below is the 1916 ivy-clad face of the same main entry. The hospital has survived many fires over the years. Portions of the buildings razed by flames were rebuilt. The Western State Hospital property includes four homes that housed officers in the era of Fort Steilacoom. The hospital and community groups now use the officers' facilities as meeting halls and for other events. One such group is the Grave Concerns Association, which is responsible for attending to the patient cemetery located across Steilacoom Boulevard near the hospital's former dairy. Western State Hospital is the largest psychiatric hospital west of the Mississippi River. It is the second-oldest state institution after the University of Washington.

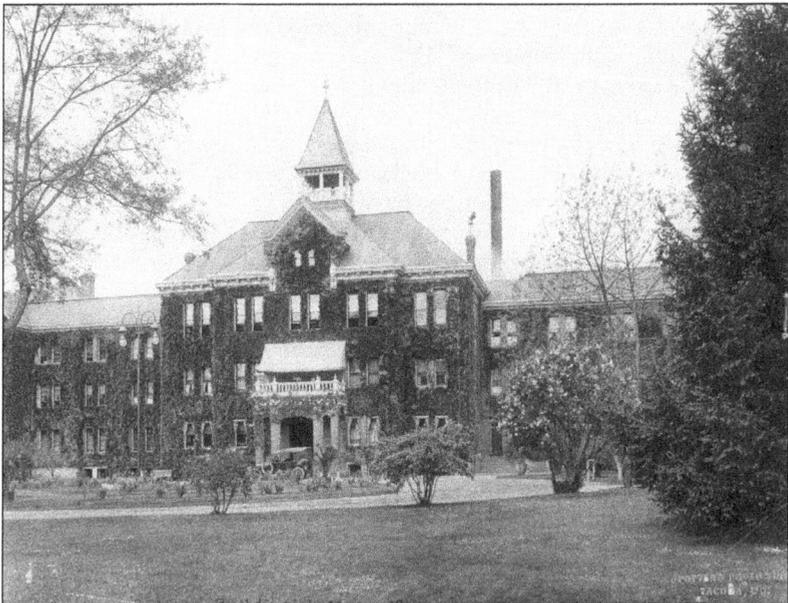

PROMINENT SETTLERS. Pictured above are the original headstone markers for William H. Wallace and his wife, who is only known as M. Luzene. The photograph was taken in January 1934. The markers were made out of wood planks and, unfortunately, deteriorated under the wet weather of the Pacific Northwest. It is uncertain when the wood markers were replaced with a concrete monument and headstone markers (below), but they are still standing today. Wallace was born on July 19, 1811. The Pierce County Census of 1860 lists Wallace as such: "Lawyer, age 49, from Iowa. M. Luzene, age 39. Child W.W., age 16." Wallace's popularity rose and on April 9, 1861, Pres. Abraham Lincoln appointed him the governor of Washington Territory. Wallace was elected the first mayor of Steilacoom 10 years later. He died on February 7, 1879. (Below, courtesy Doug Bridges.)

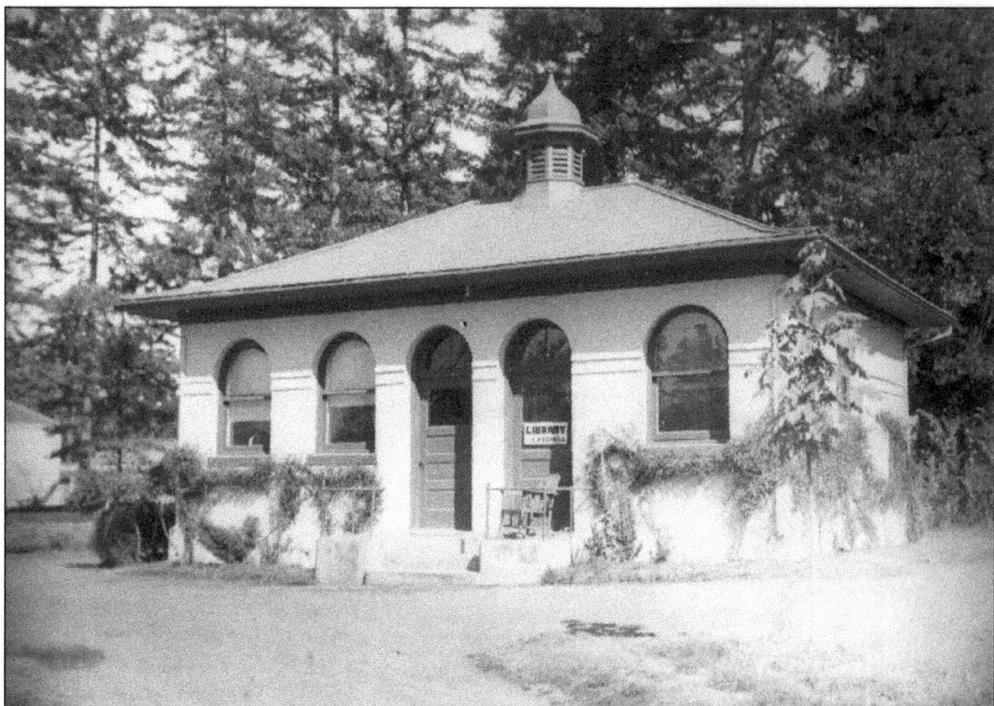

WESTERN STATE HOSPITAL MORGUES. The hospital was in operation for 36 years before a formal morgue was dedicated to the grounds in 1907. The original morgue (above) served as a library for a period of time and is still standing today. It is uncertain when the morgue ceased operations, however according to administrative files from the Washington State Department of Finance, Budget and Business, a new morgue, autopsy, and chapel building (below) was built and became operational between the years 1933–1935. The new morgue sustained earthquake damage sometime in the late 20th century and was demolished. The original centenarian morgue has recently been added to the Most Endangered Properties list by the Washington Trust for Historic Preservation. (Both, courtesy Western State Hospital Historical Society.)

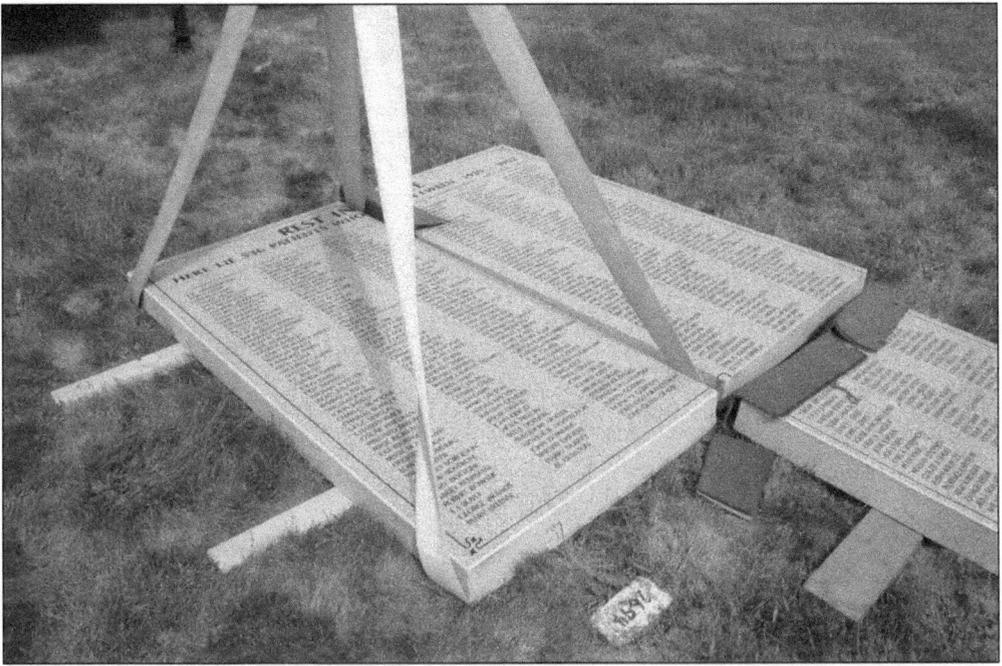

MONUMENTS INSTALLATION. The Grave Concerns Association was founded in 2000 to honor the historic state hospital cemeteries. The group is recognized as a federal 501(c)(3) charity. It raises money to buy proper markers for graves that have only been assigned a number. Pictured below, volunteer Carol Slaughter addresses a group of volunteers during the installation of markers. Large stone pieces are used to properly mark a mass burial of cremated patient remains. (Both, courtesy Laurel Lemke.)

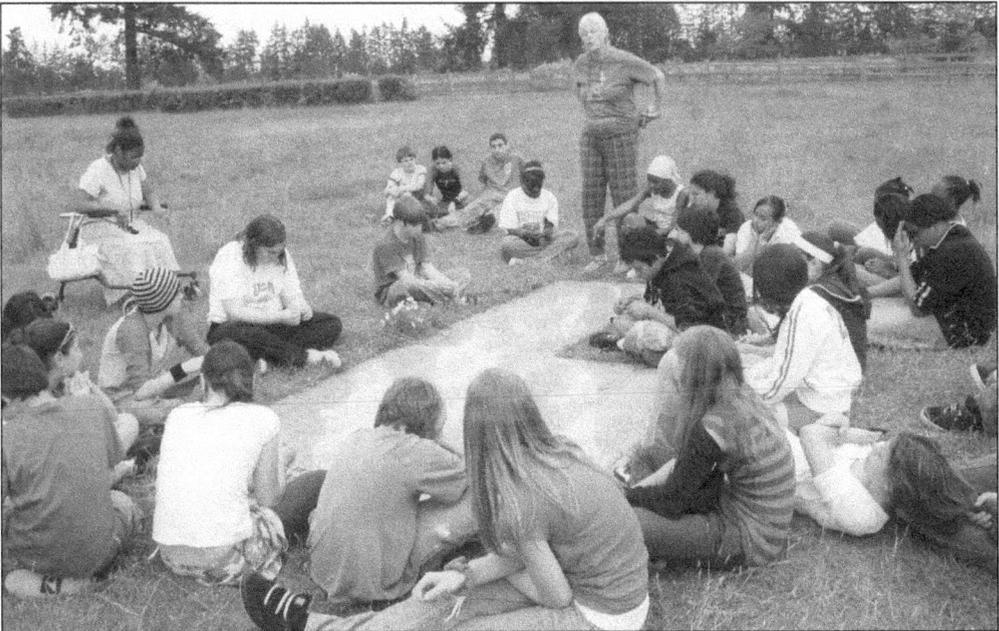

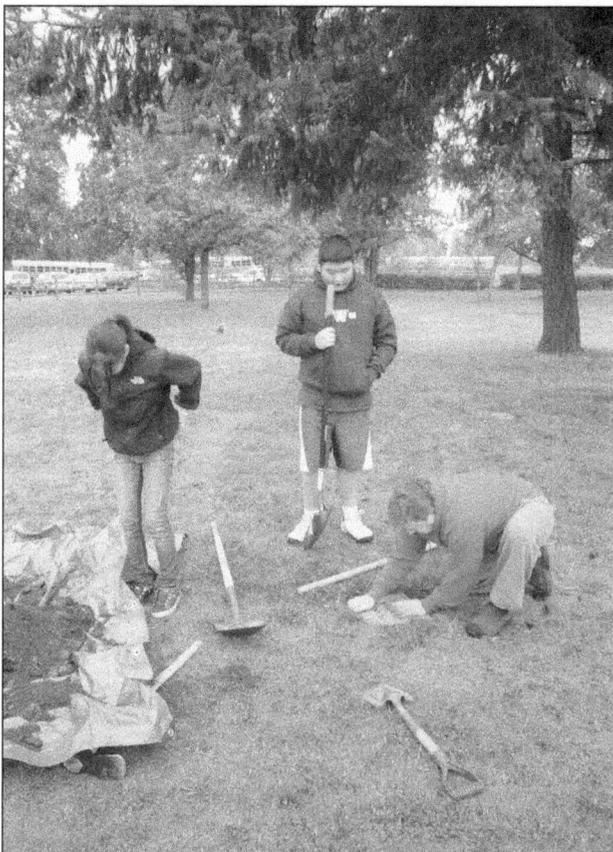

PATIENTS RECEIVE PROPER HEADSTONES. Laws in the State of Washington protect the confidentiality of mental health patients, even after they have died. Patients who died more than 50 years ago are exceptions. This patient cemetery was in use from 1876 to 1953. Most of the patients' names can now legally be released. Through the work of the Grave Concerns Association, volunteers gather to replace old numbered cement markers with dignified granite markers that bear the name of the deceased. Pictured is the author's family, Jessica, D.J., and Dave Reisinger, at a marker installation. (Both, courtesy Laurel Lemke.)

Eight

PUYALLUP TRIBAL CEMETERY

The Puyallup Tribal Cemetery is part of the 33 acres of communal property belonging to tribal members. Originally, the reservation included more than 18,000 acres along the Puyallup River. In 1887, the land was put into parcels and distributed to individual tribal members. Many of these members sold their land to developers. The cemetery parcel was not officially set aside until 1894. It had been used as a sacred place prior to that time. Perhaps thousands of burials were already present before the land was ever officially planned to be used as a cemetery.

Chief Leschi is buried here alongside his daughter Sarah. Leschi was the Nisqually leader who violently opposed the Medicine Creek Treaty in 1854. The treaty cut off tribal access to the Nisqually River, which was the tribe's main source of food and trading. Leschi protested the treaty all the way to the territorial capital but was turned away without being heard. In 1858, Leschi was put on trial for the murder of a territorial militia colonel. A fellow tribesman betrayed him for a government reward. Tacoma attorney Frank Clark fought to delay the eventual guilty verdict and consequent hanging, but his attempts were ultimately futile. Leschi was hanged in what is known today as Lakewood, Washington. The website www.findagrave.com had this to say regarding the conclusion of these matters: "Exactly 146 years later, state lawmakers and Nisqually Tribe members asked the state supreme court to expunge Leschi's criminal record. In March 2004, both houses of the Washington state legislature passed resolutions stating Leschi was wrongly convicted and executed. On December 20, 2004, Chief Leschi was exonerated by the unanimous vote of the Historical Court of Inquiry following a trial in absentia."

The Cushman Indian Hospital originally housed the Indian school. The building was demolished to make way for the new Tacoma Indian Hospital in the 1940s.

The Puyallup Tribal Cemetery was added to the Washington Heritage Registry on February 13, 1970.

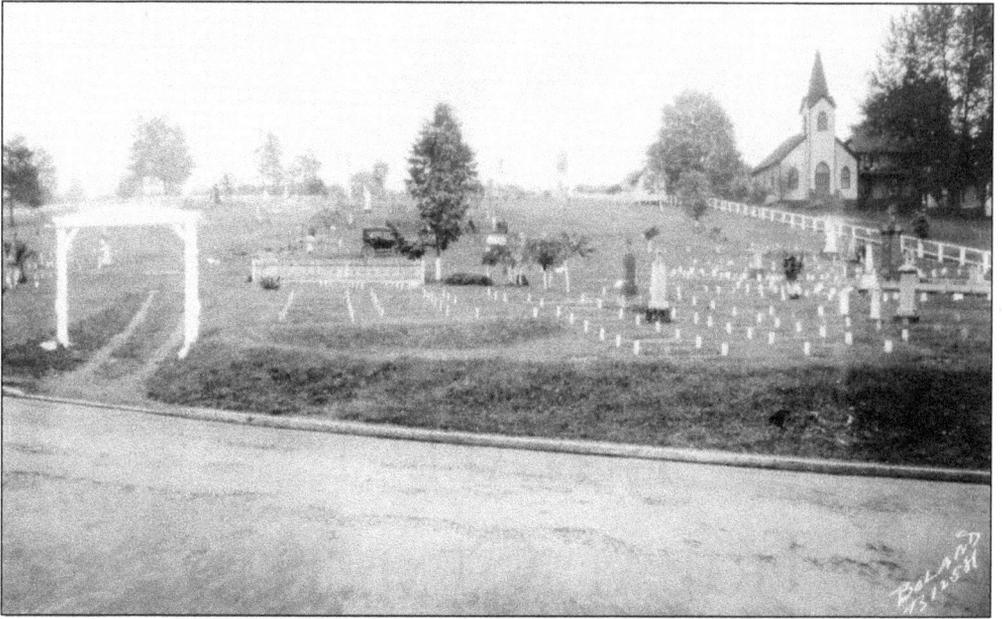

THEN AND NOW TRIBAL ENTRANCE. The above photograph of the Puyallup Tribal Cemetery is dated May 18, 1925. It shows many small, white markers that are not present today. The low-lying, white picket fence is also gone. The wooden fence has been replaced by a very tall fence made of river rock and steel. The new fence is rumored to have cost approximately $1 million. Below is a current picture of the same location pictured above. The road that once fronted River Road is now closed off. Only a little access road to the cemetery grounds remains. The Presbyterian church pictured above was partially destroyed by fire mid-century. The picturesque steeple and bell were removed and a more modern structure took its place.

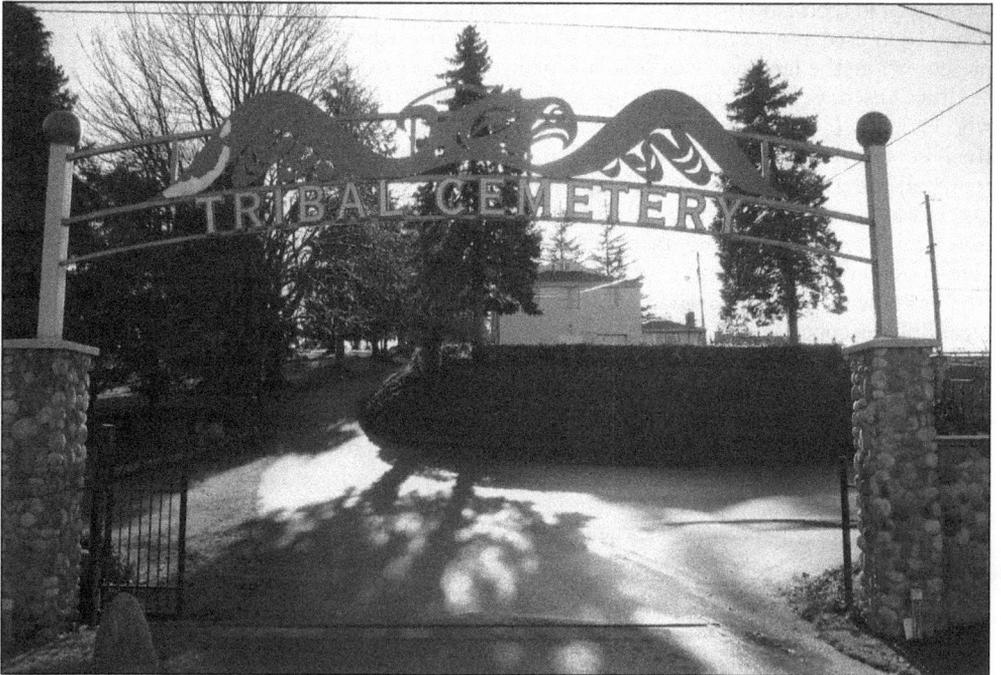

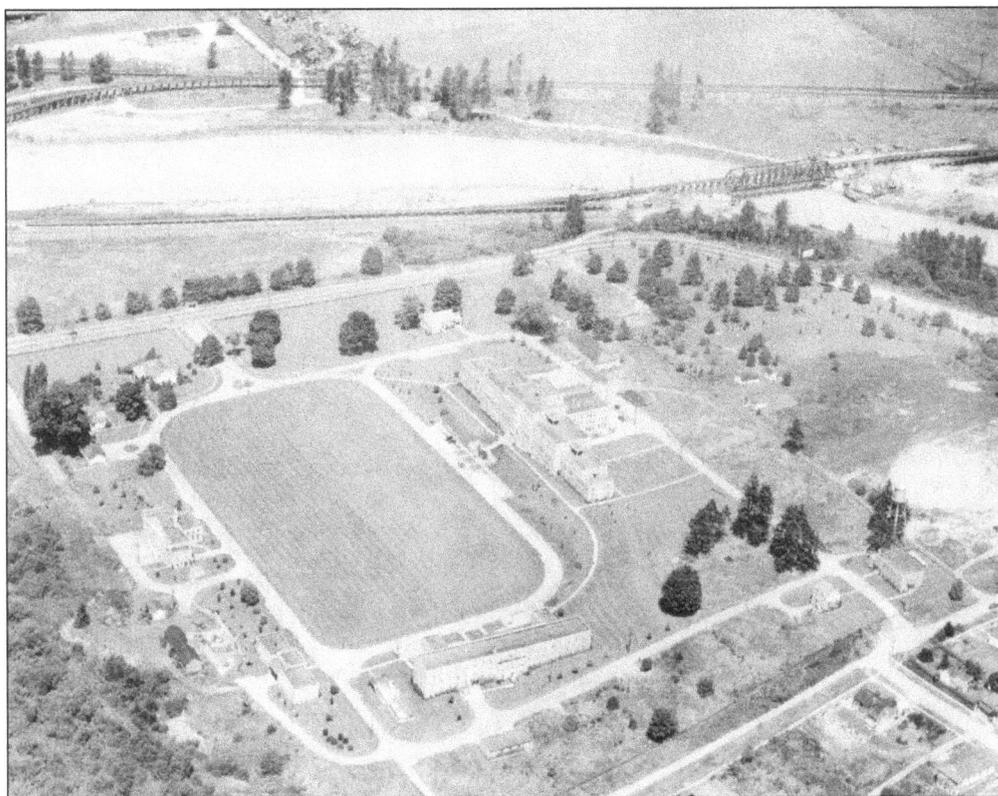

NEIGHBORS OF THE TRIBAL CEMETERY. This rare aerial photograph of the Puyallup Tribal Cemetery is dated August 8, 1948. At this time, the cemetery's closest neighbor was the Cushman Veteran Hospital, which was later demolished to make room for the Emerald Queen Casino.

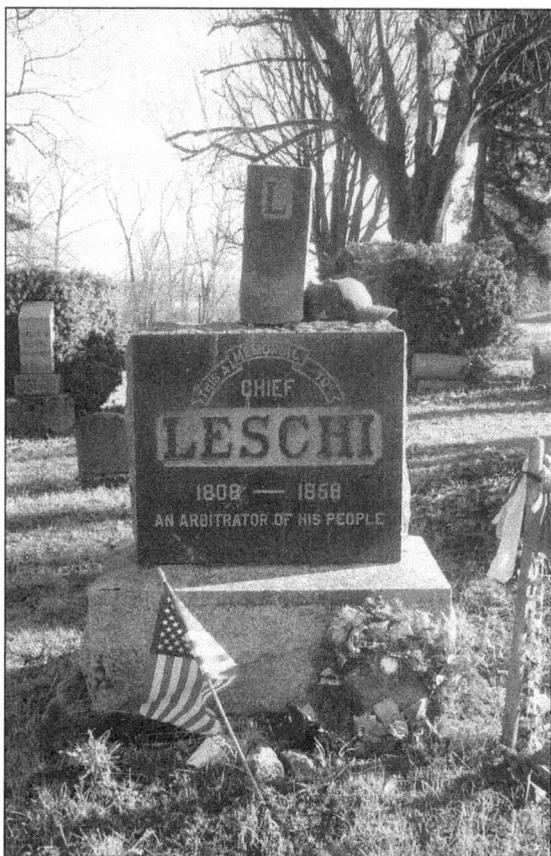

CHIEF LESCHI WITH DAUGHTER. The date of Chief Leschi's birth is unknown. Leschi died February 19, 1858, in the city of Lakewood, Washington. In the beginning, Leschi was willing to work with American settlers, but when he realized that the Puyallup River was going to be taken away from his tribe, he fought to retain it. He lost the battle and was eventually hung for crimes he never committed. He was later pardoned, and his marker tells the story of the exoneration. Buried behind him is his daughter, Sarah (below). (Below, courtesy author's collection.)

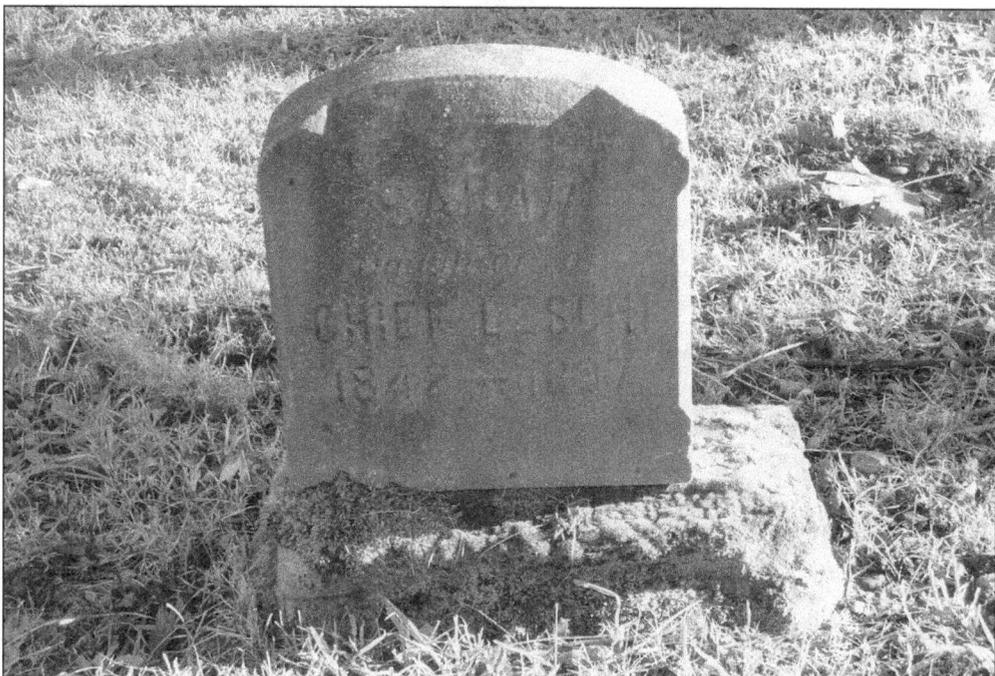

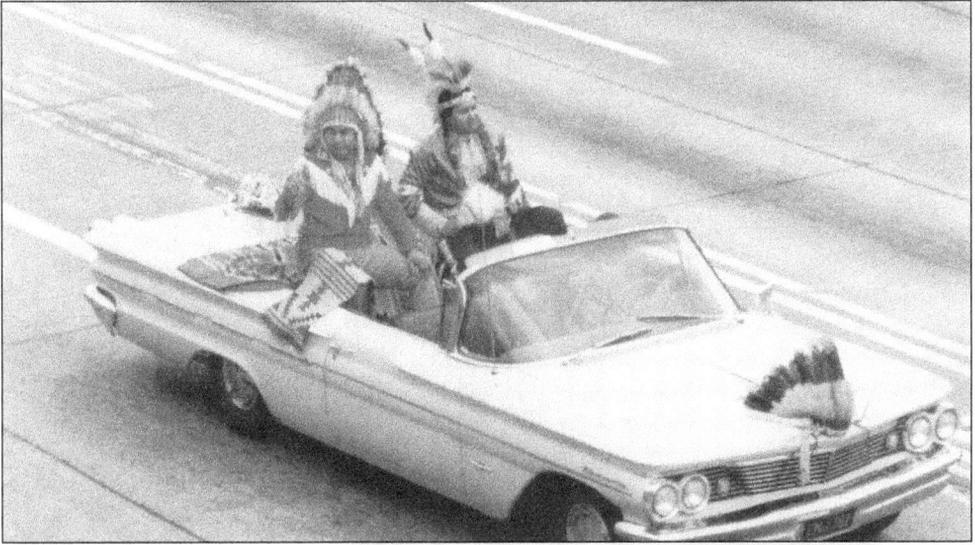

TACOMA'S 100TH ANNIVERSARY. In June 1969, Tacoma celebrated its 100th anniversary. To mark the occasion, a grand parade marched down Pacific Avenue. Pictured here is Puyallup chief Robert Satiacum, perched on a convertible seat and waving to the crowd. Satiacum is wearing formal Indian attire with full headdress. He is known for illegally fishing in the Puyallup River during an organized "fish-in." He was arrested in 1964 while fishing with celebrity Marlon Brando. Satiacum will always be remembered as an advocate of Native American treaty fishing rights in the United States.

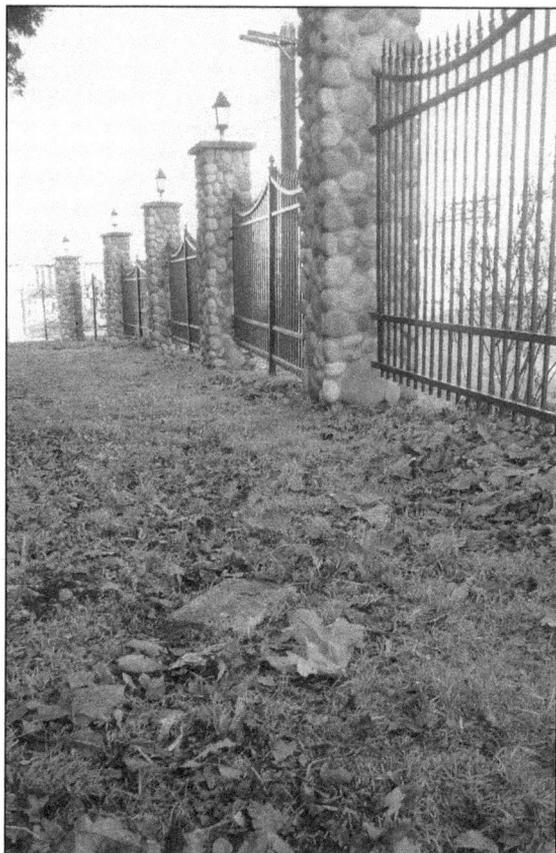

STONE WALL FENCE AND MARKER. The original Puyallup Tribal Cemetery was not enclosed at all. Sometime in the late 1920s a low, white picket fence was installed. About 80 years later, a huge stone and steel fence replaced the wooden fence. Many tribal members were buried outside the fence's perimeter. There is no way to tell how many people are buried there or how far the burials extend. It is said that burials go as far as the edge of the Puyallup River. Of course, this means that many Indian souls are trying to rest under the current River Road and beyond. A marker with the word "Head" inscribed on it is placed when a grave is discovered, but many remain unmarked. Inside the cemetery, a plaque is dedicated to those "outside the gate." (Both, courtesy author's collection.)

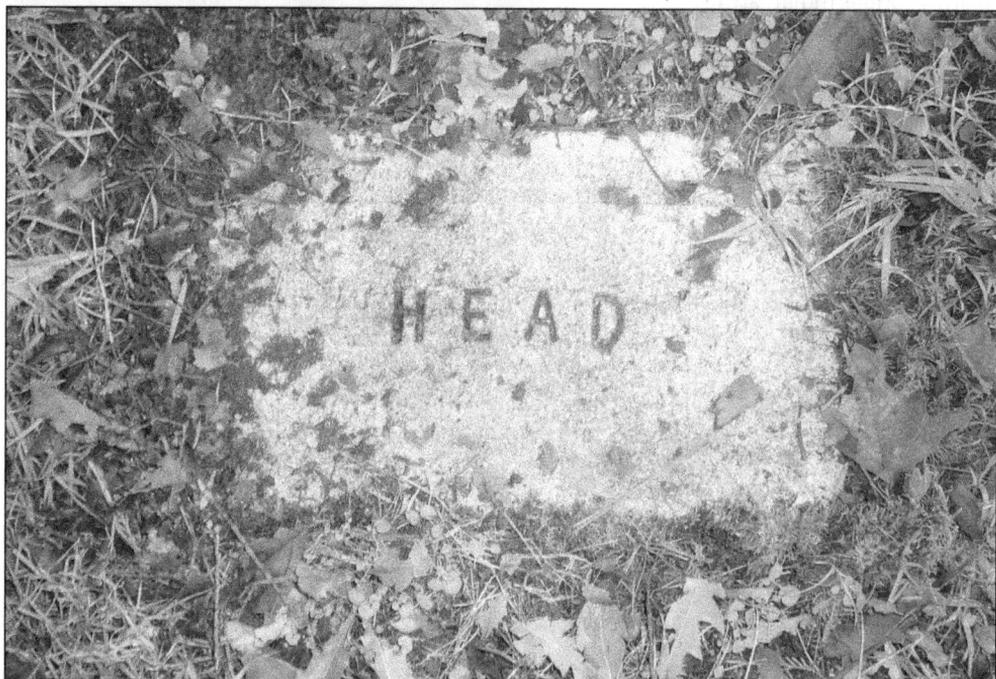

Nine

FUNERAL HOMES

A.J. Littlejohn and Conrad L. Hoska are credited as the first two undertakers in the town of Tacoma during the late 1800s. A detailed history of their grave beginnings can be found in Herbert Hunt's book, *Washington, West of the Cascades*, Vol. 3, page 41.

In the early 1900s, Oscar Storlie worked on wagons and dabbled in the real estate business. As soon as he turned out a few coffins, he realized that he had a good side business and became Tacoma's first funeral director. Women of the time used to lay out the bodies of the dearly departed at home, making the actual funeral director of the day more of a sexton. Fred Morley of Piper-Morley-Mellinger Funeral Home explains that the business used to have "slumber rooms" that were staged after a home bedroom, complete with dressers, chairs, vanities, and a twin bed. These rooms were used for the initial viewing before the family made funeral arrangements. It was a comfort, and it was the custom of that era.

In addition to serving the community, funeral homes are family homes. Generations of children have lived and grown up in funeral homes, many of which are outstanding examples of early architectural design. Many homes are listed with the Tacoma Historic Register, the Washington Heritage Register, and the National Register of Historic Places.

Mortuary science is a calling; some would even classify it as a ministry. The author was once deeply moved when, in the course of hearing a funeral director console a mourning family, she heard him say, "You are safe to grieve here. How can we comfort you and your family during this sad time?"

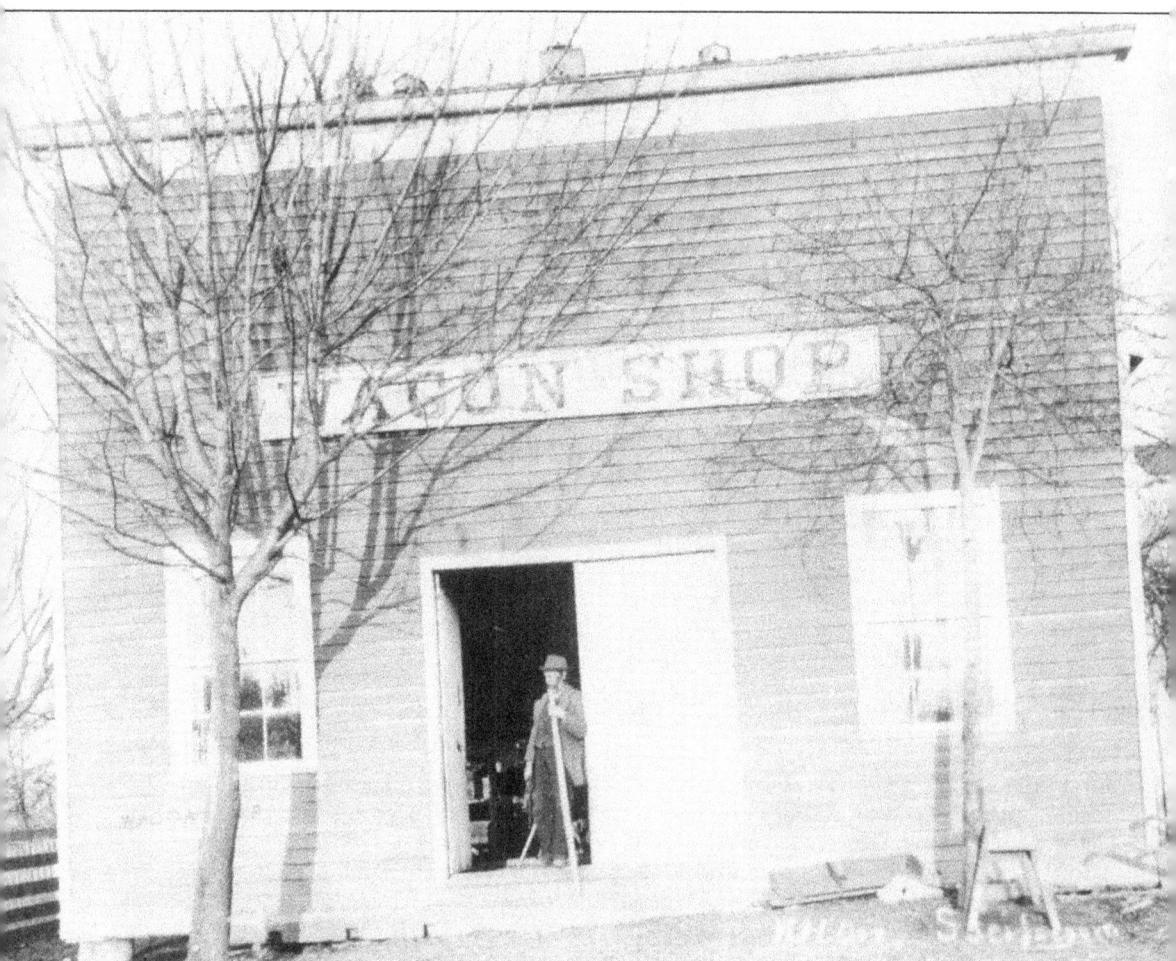

NATHAN ORR'S WAGON SHOP. According to the Steilacoom Historical Society, pictured here is Nathaniel Orr in front of his wagon shop near Saltar's Point in Steilacoom. Orr came to Steilacoom in 1852 and opened his wagon repair shop sometime after that. Soon after he opened for business, other side jobs presented themselves. He made all sorts of furniture, including coffins. Orr married Emma Thompson in 1868. At that time, the wagon shop was converted to a home and a new wagon shop was built lower on the property. That wagon shop, reconstructed by the Steilacoom Historical Museum Association in 1992, is still part of the Orr Home property. After Orr died in 1896, Emma continued to live in the house until her death in 1908. When the Orr family finally sold the property in 1973, included in the sale was original furniture dating to 1868.

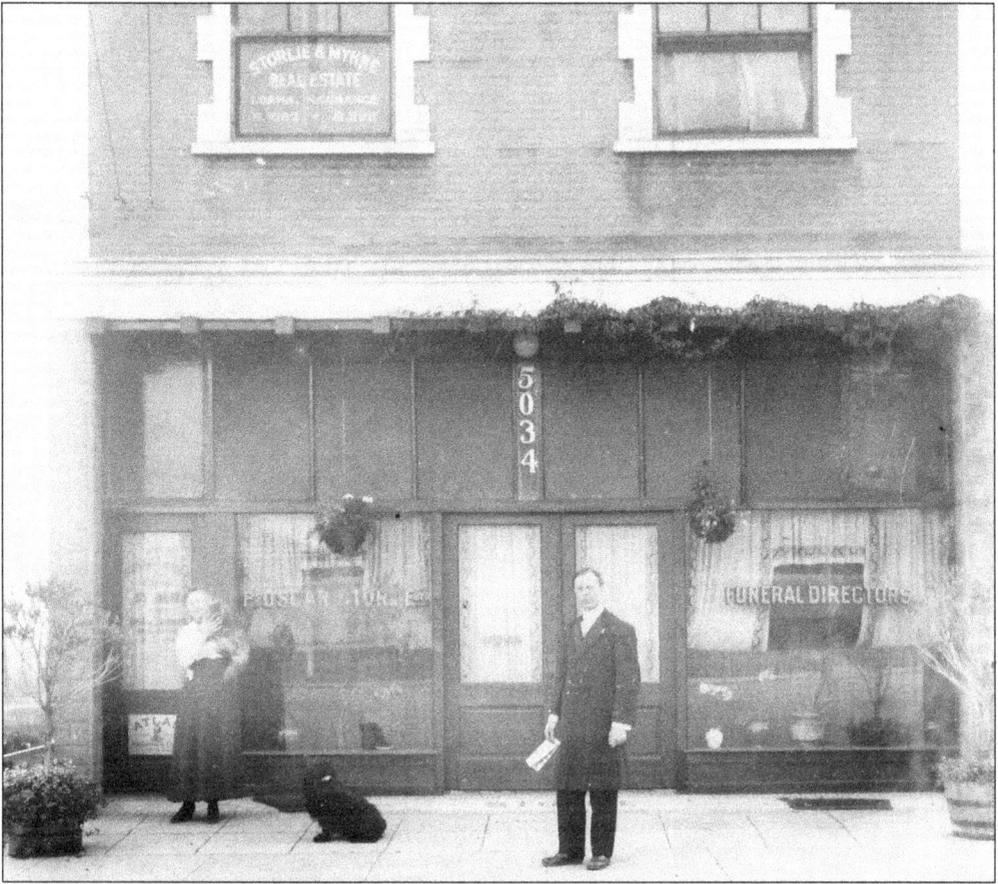

1900s STORLIE STOREFRONT. Oscar Storlie, pictured above, was an undertaker and real estate investor. His funeral home was located at 5034 South Tacoma Way. Storlie is buried at Oakwood Hills Cemetery. A 1956 *Tacoma Star* newspaper advertisement stated that the South Tacoma Undertaking Company, owned by Storlie, had been in business since 1908. (Above, courtesy Bill Habermann; below, courtesy author's collection.)

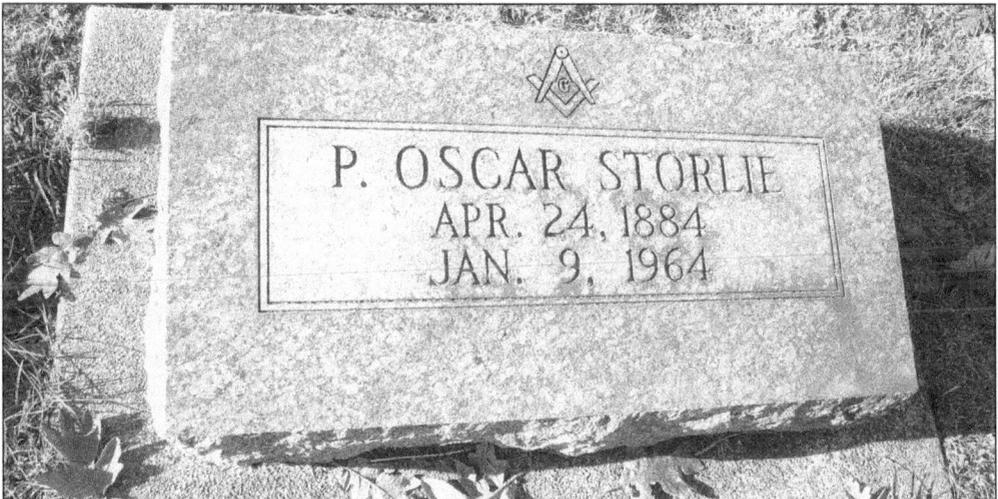

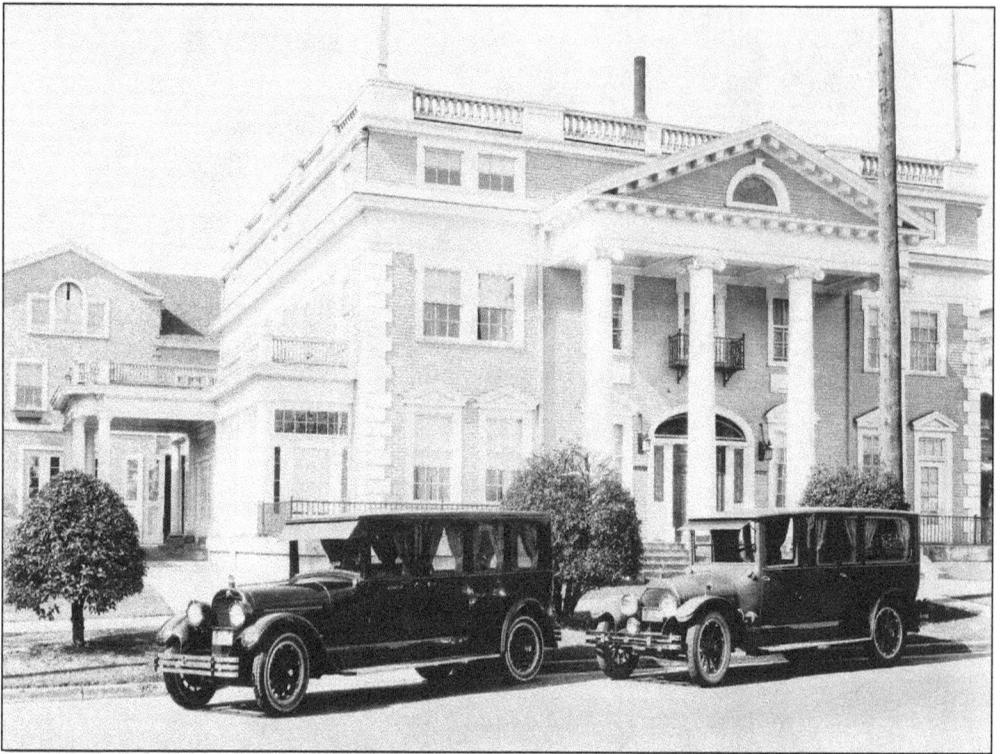

GRAND MELLINGER FUNERAL HOME.
This photograph shows Mellinger's second funeral home located at 510 South Tacoma Avenue. The magnificent Colonial-style home was built in 1909 and designed by architects Heath & Twichell. The family-owned funeral home was operated by James J. Mellinger, president; his wife, Ann, vice president; and Martha Mellinger, treasurer. James had a growing fleet of hearses, and a few of his early acquisitions are parked in front. (Courtesy Fred Morley.)

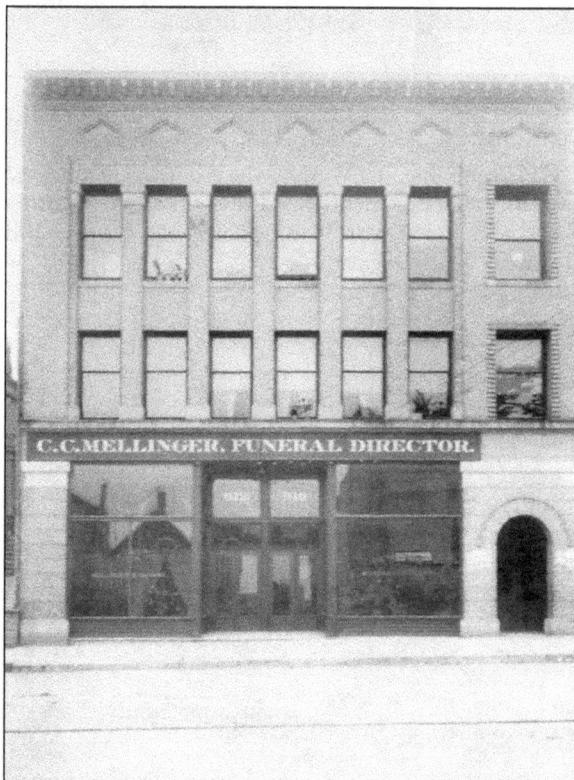

C.C. MELLINGER STOREFRONT.
This late-1800s photograph shows C.C. Mellinger's first funeral home. Mellinger advertised in a local paper and gave the address as 910–912 South Tacoma Avenue. (Courtesy Bill Habermann.)

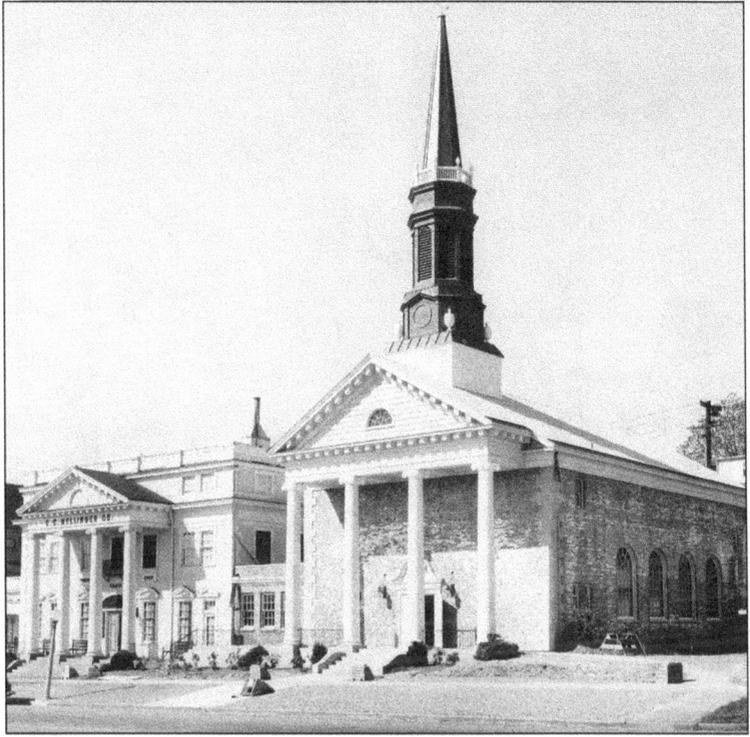

NEW CHAPEL. The new C.C. Mellinger chapel was built in 1945 and was designed by architect Earl N. Dugan. The building and business were eventually bought by Fred Morley and became the Morley-Mellinger Funeral Home. (Courtesy Fred Morley.)

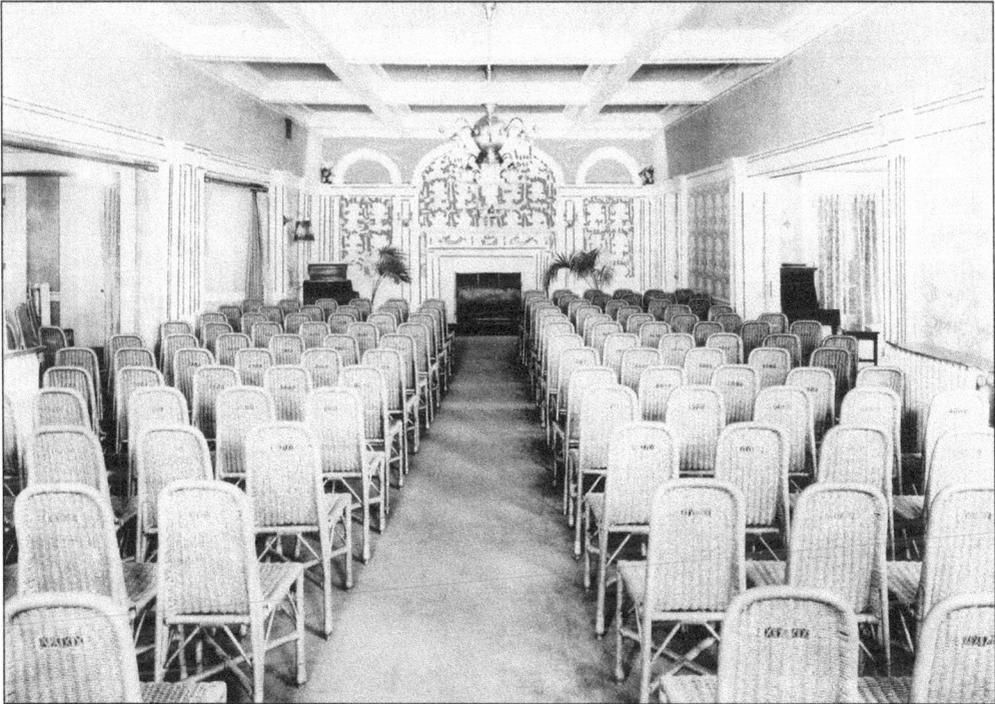

WICKER CHAPEL. In this photograph is a 1920s interior view of the large Mellinger chapel. Rows, and rows of wicker chairs are in place for mourners. The chapel had many side rooms set apart from grieving families. The wicker chairs were later replaced by pews. (Courtesy Fred Morley.)

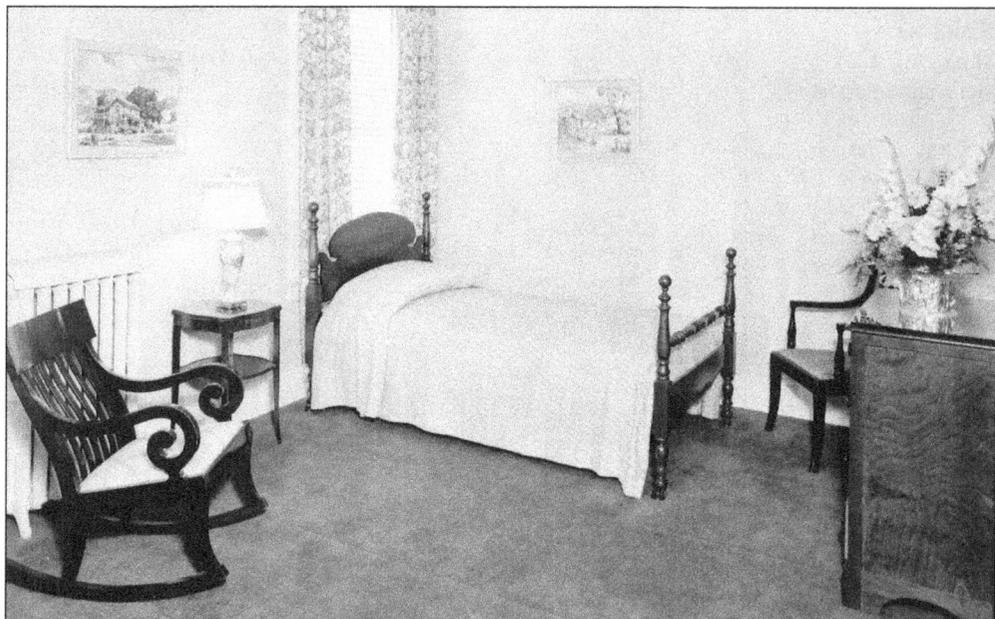

SLUMBER ROOM. In the late 1800s and into the mid-1920s, at-home funerals were more common than they are today. Funeral home directors responded to the public trend and created rooms in their businesses that looked like bedrooms. It was in these rooms that the body of the dearly departed would be viewed first—in the comfort of a home setting. Below is a photograph of a home funeral during the late 1800s. The coffin is displayed in the living room surrounded by flowers. (Above, courtesy Fred Morley; below, courtesy TPL.)

RECORD BOOK. Pictured is a sample from C.C. Mellinger's record log of funerals and burials. The date on the book is 1895. (Courtesy Fred Morley.)

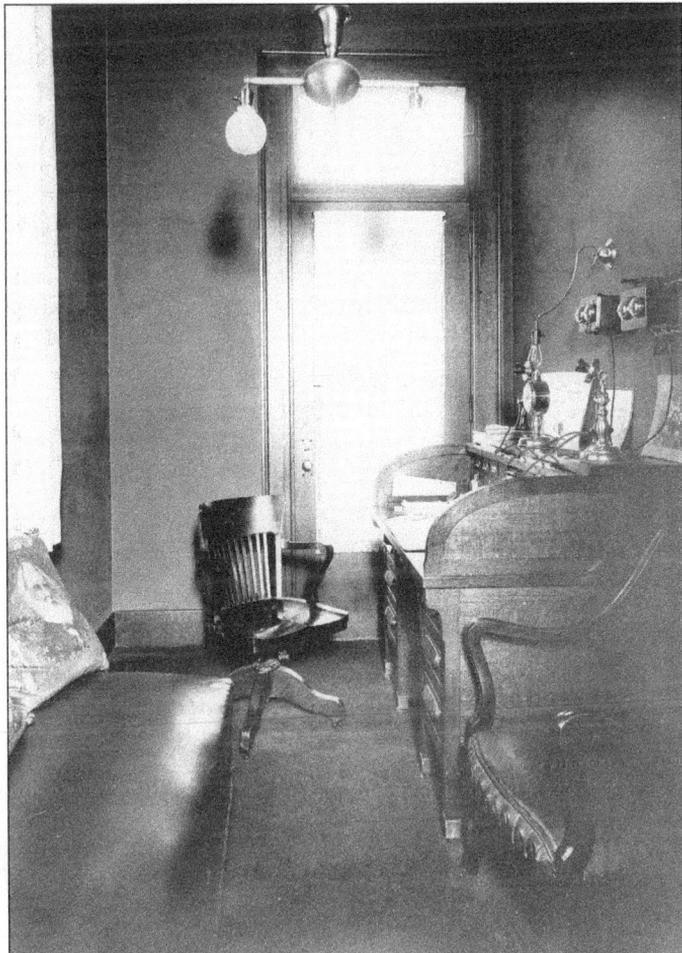

EARLY-1900s OFFICE. This is a picture of C.C. Mellinger's personal desk and office from the early 1900s. Notice the phone system in place at the time. The office was decorated in dark woods in accordance with the interior design trends of the era. (Courtesy Fred Morley.)

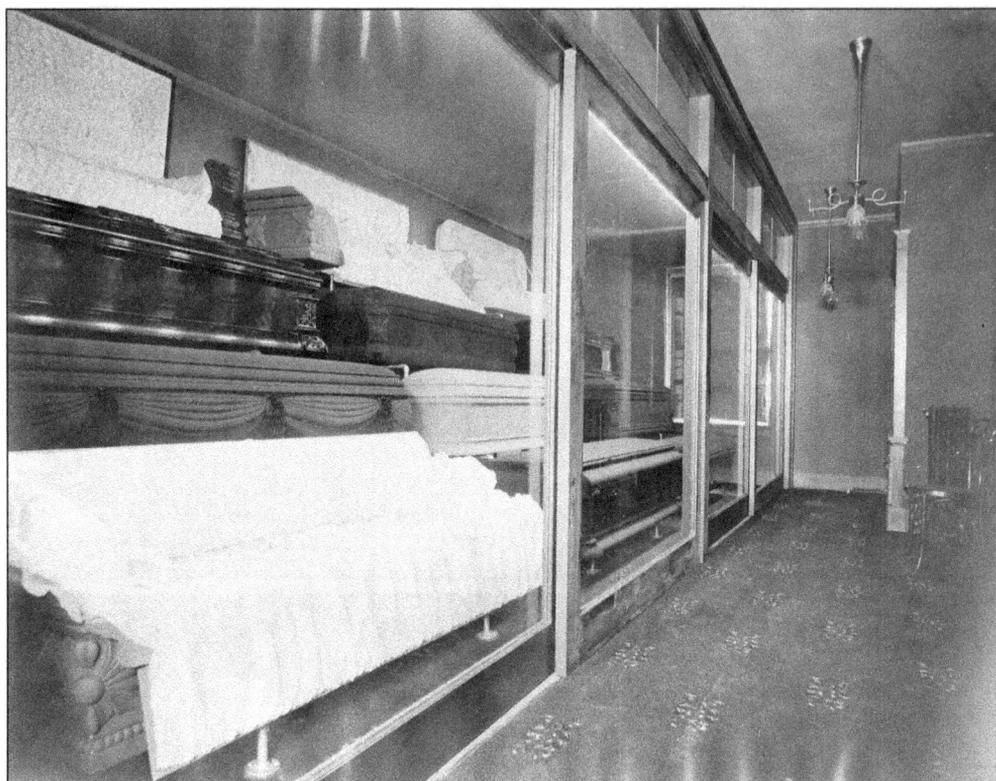

CASKET ROOM REMODEL. It is uncertain when the old casket room (above) was either moved or updated to the new casket room (below). However, it seems that when the addition to the C.C. Mellinger home occurred, the casket room was also updated. The old room appears to have caskets stacked one on top of the other in a showcase fashion behind large sliding glass doors. The new room (below) is large with ample space for the display of many caskets. (Both, courtesy Fred Morley.)

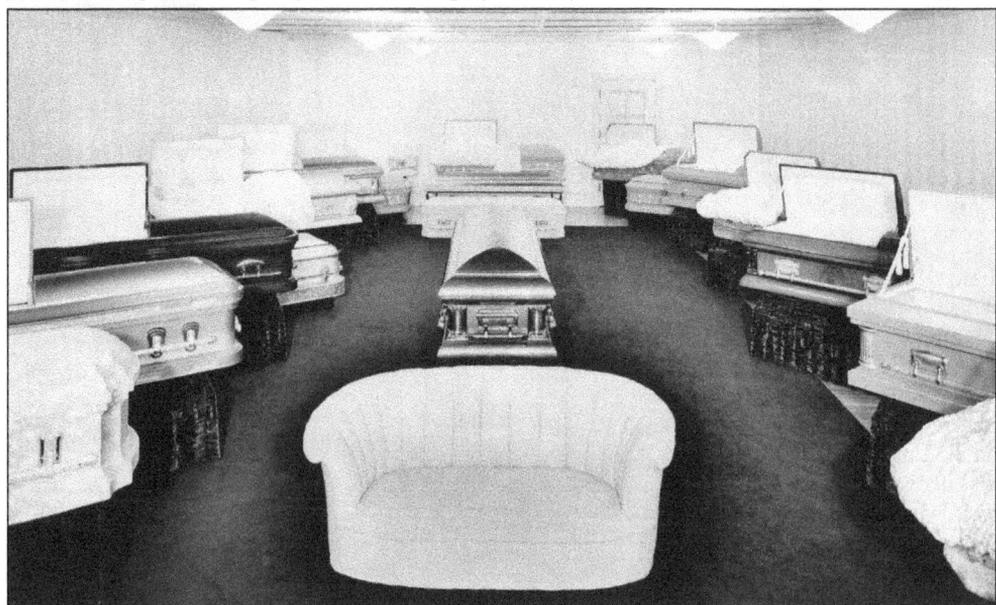

FAMILY ROOM. This room was located just off the main chapel and was reserved for mourning families only. The heavy doors and curtains opened up into the chapel. Families could reserve the room, slip into it during the memorial services, and close the doors or keep them slightly ajar, depending on preference. (Courtesy Fred Morley.)

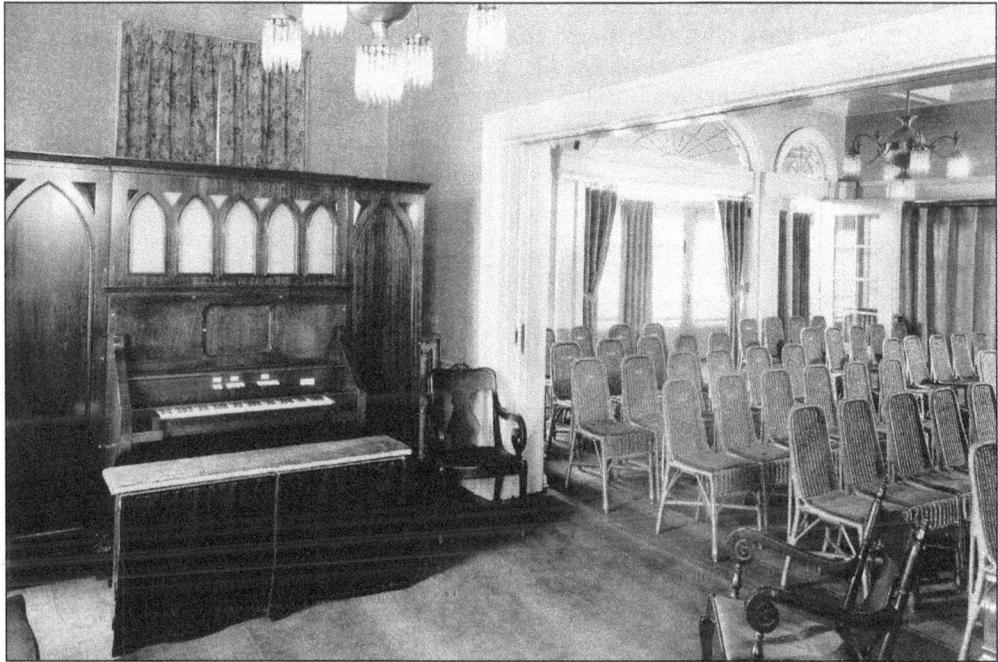

ORGAN ROOM. Every funeral home of this era had an organ. This glorious organ was located at the side of the main chapel and was strategically placed so it could be heard in a smaller, adjacent chapel. (Courtesy Fred Morley.)

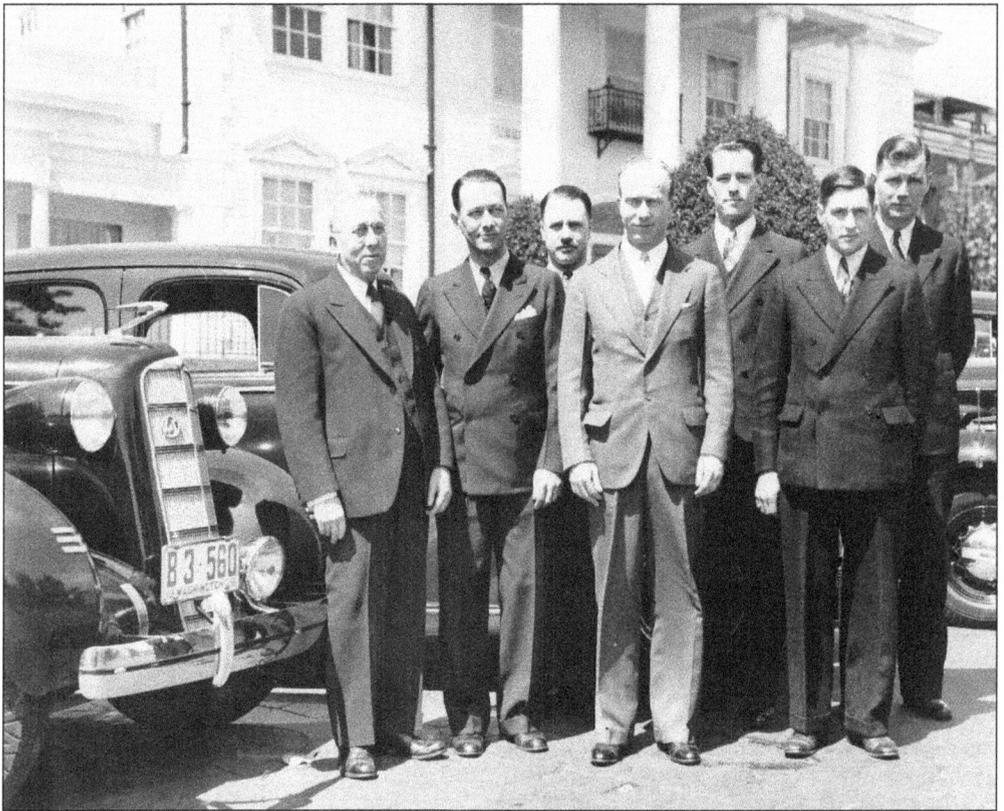

C.C. Mellinger Staff. This photograph from 1936 shows the owners and staff of the C.C. Mellinger Funeral Home during that era. Pictured, from left to right, are C.C. Mellinger, Paul Mellinger, Mr. Drake, James Mellinger, Trav Dryer, Ernie Burk, and unidentified. (Courtesy Fred Morley.)

J. W. SLAYDEN & CO.

UNDERTAKERS

Embalming a Specialty.

Open Day and Night.

TELEPHONE 624.

308 Ninth Street, next to Opera House, TACOMA, WASH.

Vintage Advertising. Between the late 1800s and mid-1930s, numerous undertakers set up shop in the Tacoma area. Many opened their doors for only a short time, while others stayed in business for years. (Courtesy Bill Habermann.)

PIPER HOUSE AND HEARSE. George and Maude Piper opened Piper Undertaking in 1910. They operated out of a garage until they hired George N. Paige to build a mortuary and funeral home in 1938. The funeral home is a lovely example of Art Deco architecture. It is a two-story home with brick veneer. Below is a picture of Piper Undertaking's hearse. In 1984, Fred Morley purchased Piper Funeral Home and merged it with his previous acquisition, the C.C. Mellinger Funeral Home. Fred Morley's business is now known as the Piper-Morley-Mellinger Funeral Home and it is located at 5436 South Puget Sound Avenue in Tacoma. An advertisement in the June 11, 1967, issue of the *Tacoma News Tribune* mentions the "reorganized management" of Piper Funeral Home, stating the business was "dedicated to serve Tacoma professionally with memorial services of dignity and quality . . . with a competent, experienced staff to serve you efficiently [and] economically." Today, the motto is "Sincere service and fair prices." (Both, courtesy Fred Morley.)

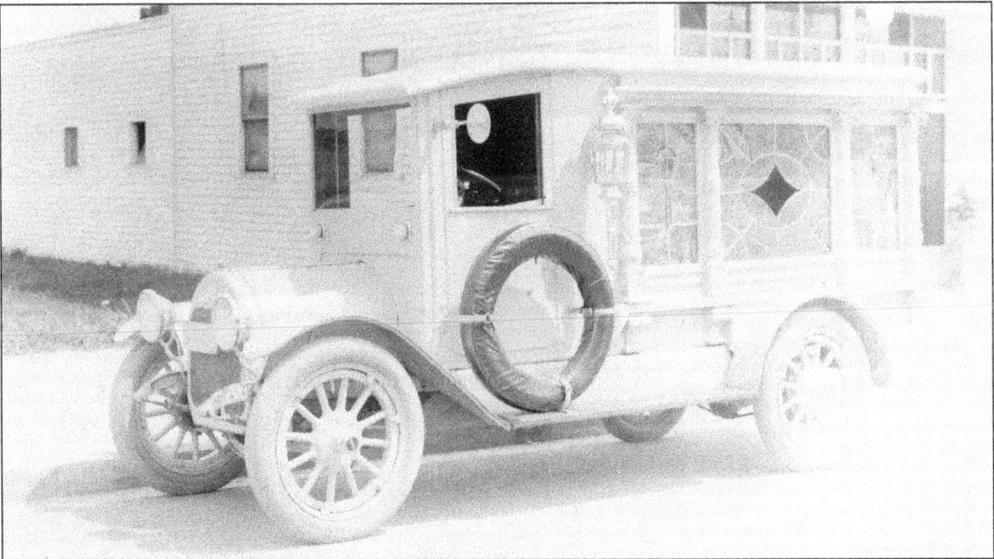

BILL HABERMANN. Pictured on the Art Deco staircase of the Piper Funeral Home is Bill Habermann, keeper of keys and funeral home history. This is not an official title, but he certainly has invested much time and energy in writing down facts and folklore pertaining to the area's cemeteries. Habermann has logged many hours at the Tacoma Public Library, where he has researched much of the Old Tacoma Cemetery as well as Oakwood Hills Cemetery. Habermann gives cemetery history tours in the summer at Oakwood Hills Cemetery. His sense of humor and penchant for lively storytelling captivate people of all ages. (Courtesy author's collection.)

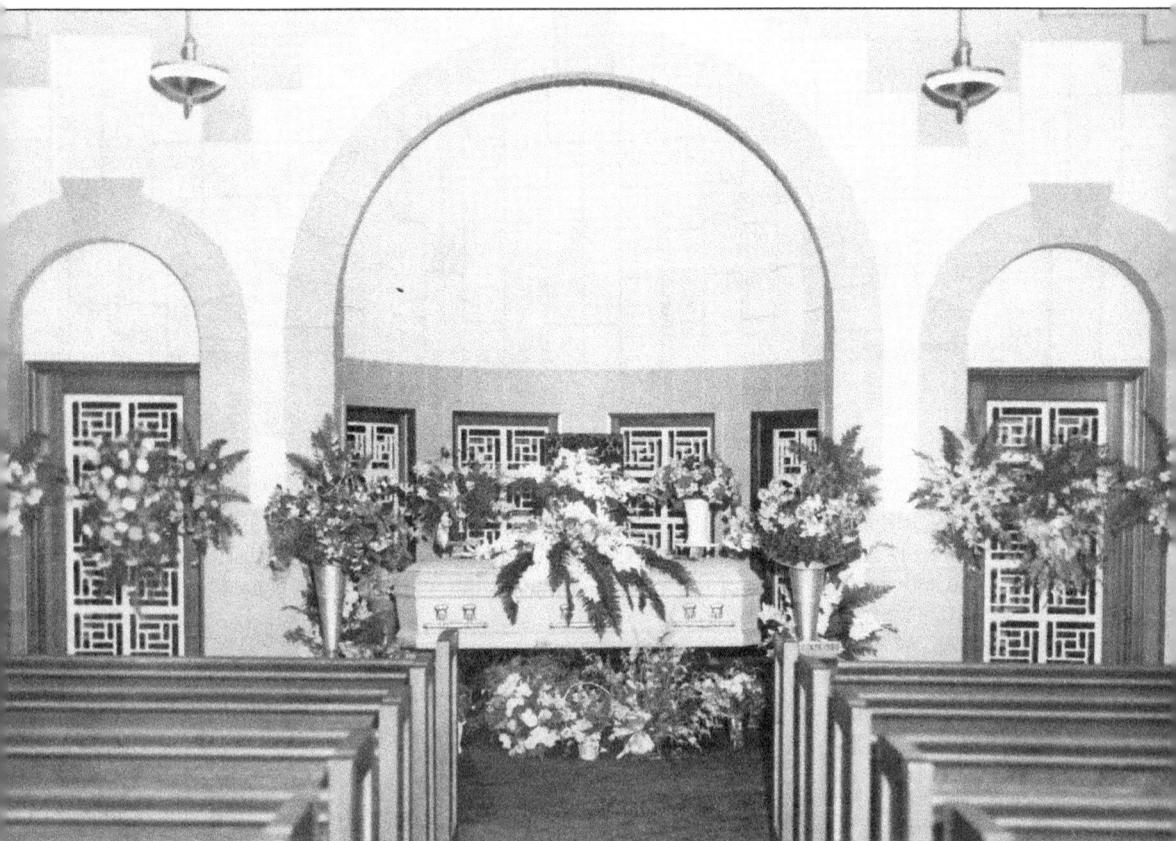

PIPER CHAPEL. Upon entering the Piper-Morley-Mellinger Funeral Home, the lovely chapel can be reached directly to the right. Of the same architectural style as the home, the chapel boasts many Art Deco designs throughout. A quiet place once used by pastors to ready themselves before services is located behind the podium area; it is now used as a storage room. A family room is adjacent to the chapel. High above the chapel is a "sneak peek" window used by Maude Piper. The second floor of the building was the Pipers' residence. It also housed the chapel's only organ. Maude could keep an eye on the services while in her kitchen. When it was time for the music, she would go through a tiny door into a room no larger than a closet where the organ was housed and play for a service as she cooked dinner for her family. (Courtesy Bill Habermann.)

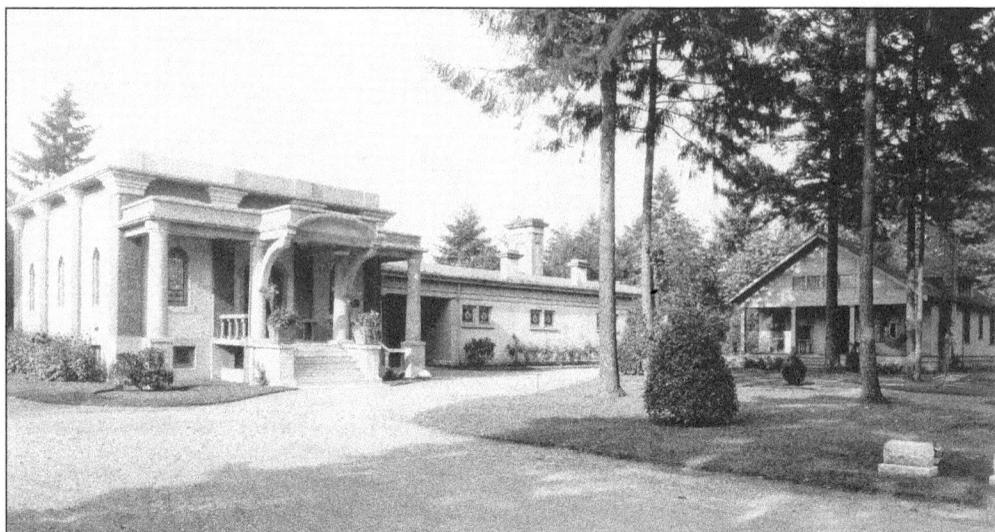

OAKWOOD COLUMBARIUM. The original Oakwood Columbarium and Crematorium was built in 1908. The addition to the structure, a newer columbarium with a stained glass dome, was added in 1923. (Courtesy Bill Habermann.)

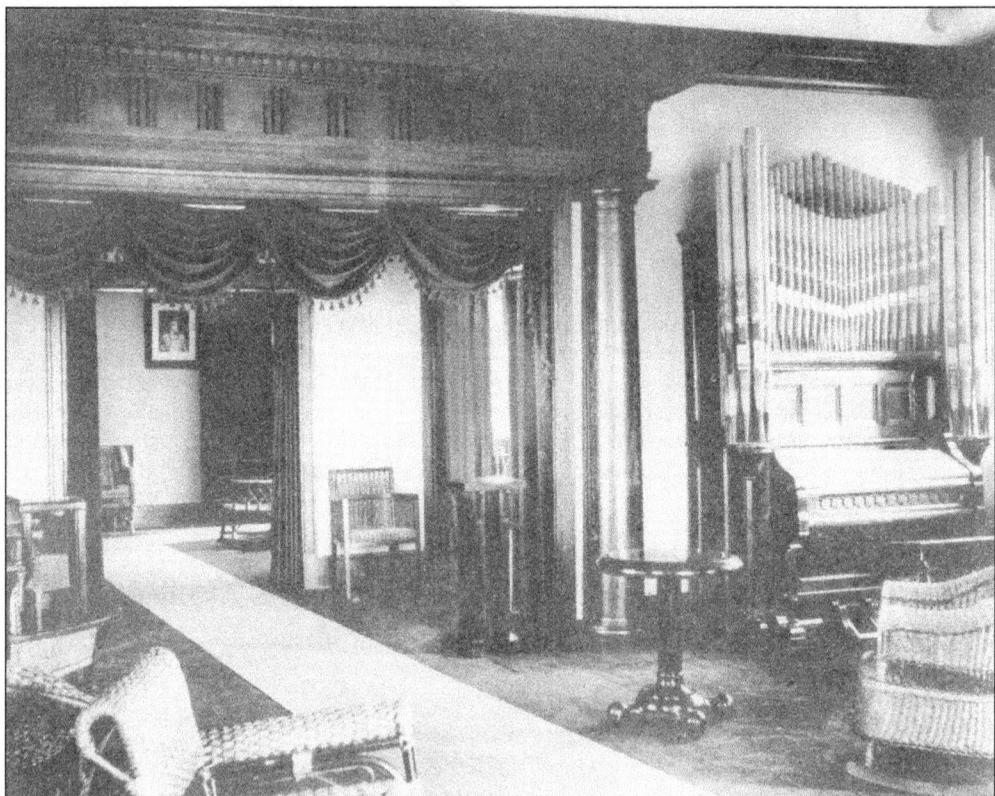

OAKWOOD ORGAN. The beautiful chapel contained one of the nicest organs around. The chapel was decorated with dark wood and heavy curtains with ball tassels. Wicker chairs were placed throughout the various rooms. The organ is still in use today, but the dark wood has been painted over. (Courtesy Bill Habermann.)

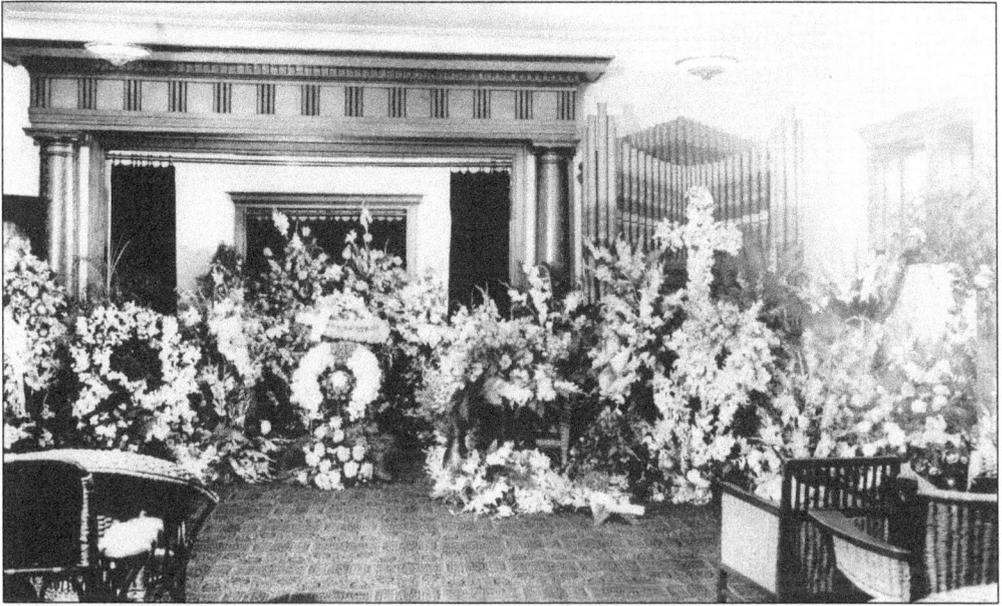

OAKWOOD FUNERAL. Oakwood was one of the first crematoriums in the area. Because of the new trend in cremation, the chapel was busy most of the time. Pictured above is a highly decorated casket with flower arrangements. Oakwood's chapel also has a family sitting room. Pictured below is the fireside room, which was in use from the early 1900s through the 1920s. (Both, courtesy Bill Habermann.)

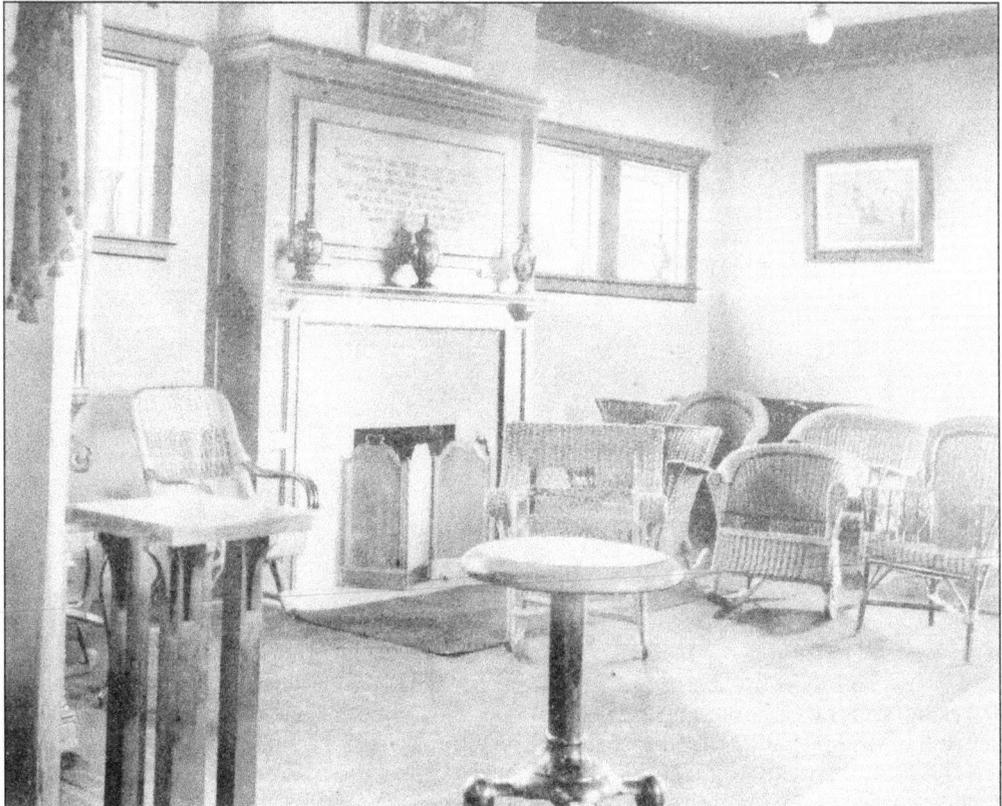

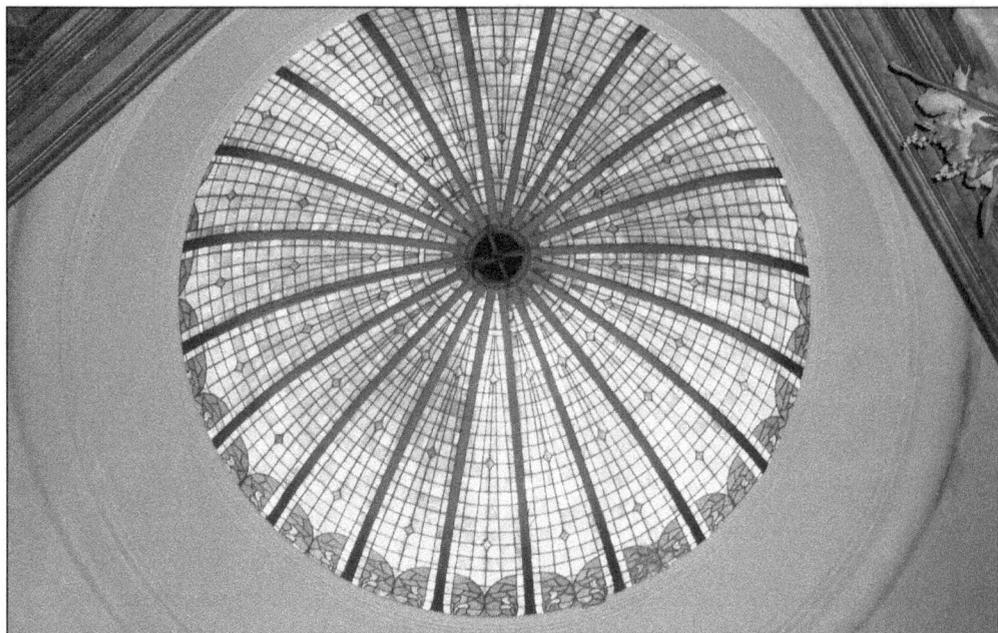

STAINED GLASS DOME. One of the only stained glass domes on the West Coast, the Oakwood dome contains more than 3,000 pieces of stained glass. Conjecture speculates that famed designer Louis Comfort Tiffany created the dome, but there are no records to prove that claim. The top of the dome rises 23 feet from the floor and has a diameter of nine feet. An overlay of protective glass preserves the dome's fragile beauty. (Courtesy author's collection.)

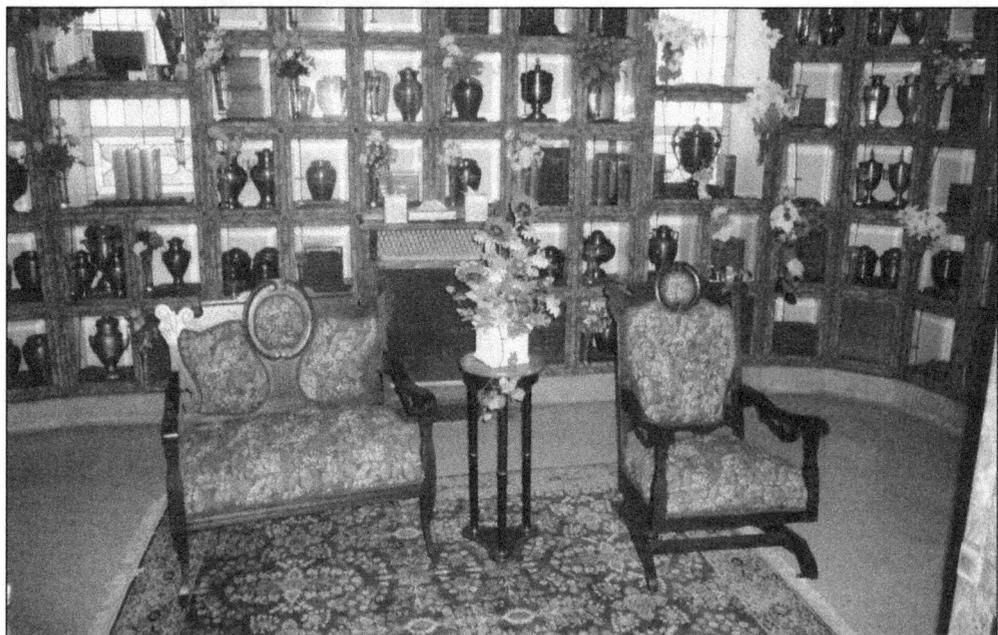

INTERIOR VIEW OF COLUMBARIUM. This is an interior view of the new columbarium built in the 1920s. It has 979 niches with spaces for about 3,000 urns. The older columbarium is located behind the chapel and contains a total of 157 niches, though not all are used. The new niches are designed with lovely faux patina framing and leaded glass windows. (Courtesy author's collection.)

C.O. Lynn Funeral Home.
The Lynns went into the funeral
home business shortly after they
were married in 1905. Clarence
O. Lynn worked for Conrad L.
Hoska, who is believed to be one
of Tacoma's first undertakers.
The Lynn Funeral Home is
located at 717–719 Tacoma
Avenue South. The Lynn family
eventually retired and sold
the home to an organization
that helps battered women.
This home is on the National
Register of Historic Places.

Chapel Funeral. The C.O.
Lynn chapel was decorated with
heavy, painted panels of wood
and crown molding. The ceilings
are low, and heavy curtains keep
extra noise to a minimum.

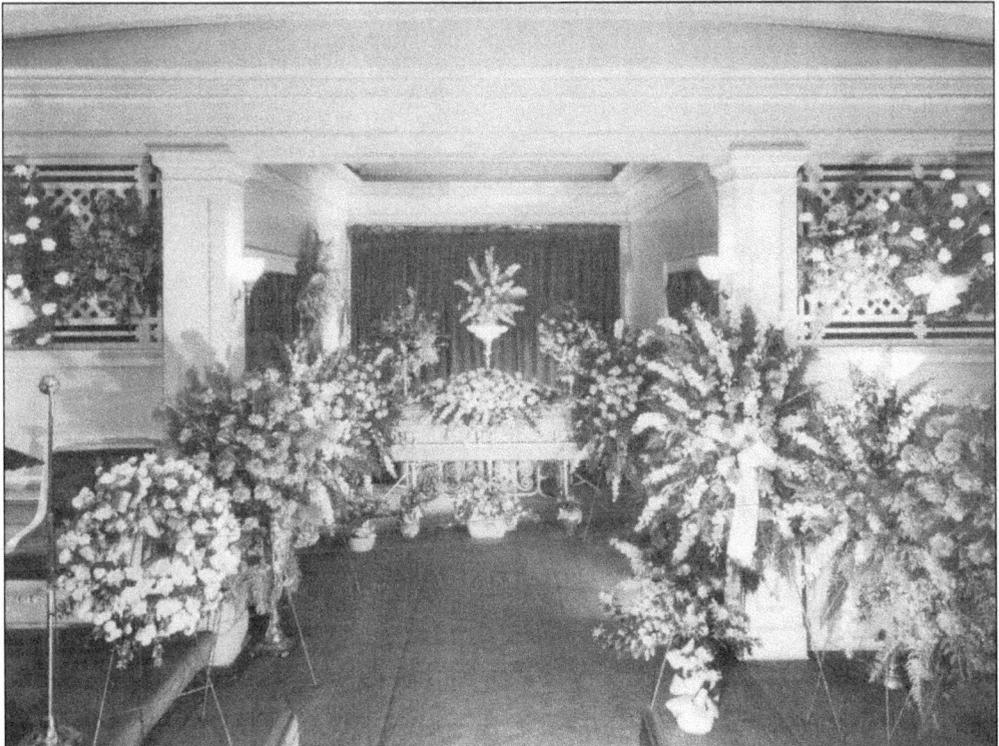

WEDDING PICTURE. Shown in a photograph from their wedding, Clarence O. and Hilma Lynn were married on June 14, 1905. The Lynns raised their two sons, C. Nathan, and J. Marvin, at the funeral home until they later built a separate home in the north end of Tacoma.

50TH WEDDING ANNIVERSARY. A reception was held at the Tacoma Lawn Tennis Club on June 19, 1955, to honor the 50th wedding anniversary of Hilma and Clarence O. Lynn. The Lynns were active in the First Lutheran Church of Tacoma. Clarence was a Freemason and past president of the Washington State Funeral Directors Association.

O. H. HARLAN,
Funeral Director and Embalmer,

1151 C STREET.

TELEPHONE 95.

OPEN DAY AND NIGHT.

TACOMA, - - WASH.

VICTORIAN-ERA ADVERTISING. Shown here is just one advertisement from the numerous undertakers listed in the Tacoma-area directory at the end of the 19th century. Many went out of business as soon as they opened their doors; others stayed and are still in business today. (Courtesy Bill Habermann.)

MODERN ADVERTISING. Many Tacoma funeral homes and cemeteries now have their own websites. With the dawn of the Internet era, advertising has changed considerably. (Courtesy Tuell-McKee Funeral Home.)

1950s NEW TACOMA LOBBY. Pictured here is the interior of the New Tacoma Cemeteries and Funeral Home reception center. The room has been decorated with black and white–checkered linoleum flooring and floral curtains. This photograph, which is part of the Richards Studio collection, is dated November 20, 1950.

2010 NEW TACOMA LOBBY. The New Tacoma Cemeteries and Funeral Home is a progressive company. Over the years, it has included many new services and updated buildings and decor. In fact, the 2010 lobby pictured is set for a face-lift in 2010–2011. Pictured at the reception desk is Linda Rosan, who is generous with her gifts of kindness and compassion to all she serves. (Courtesy author's collection.)

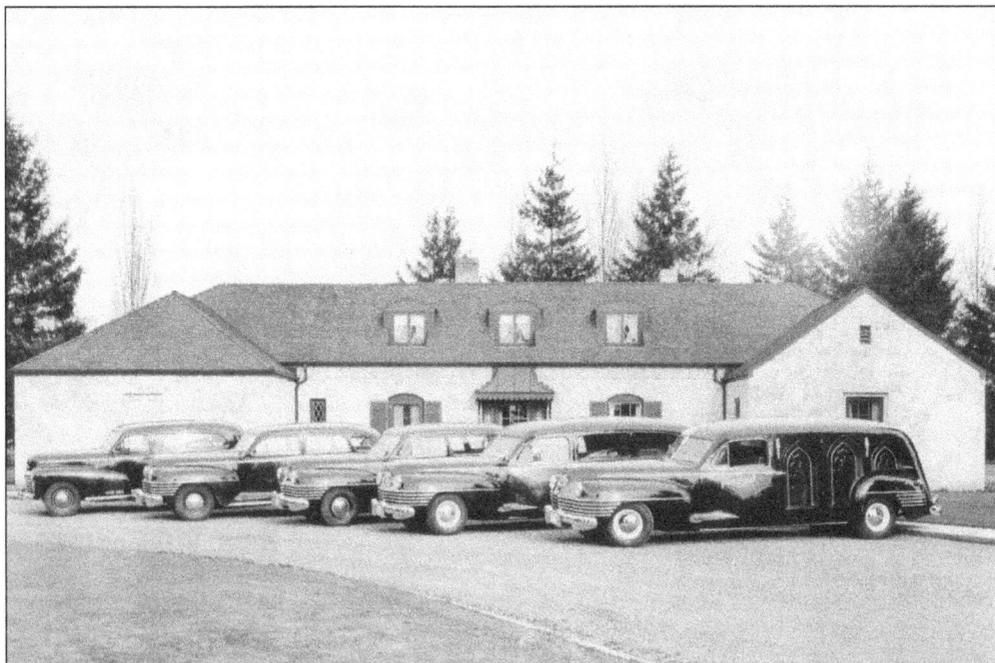

MOUNTAIN VIEW FUNERAL HOME. In the mid-1940s, Mountain View Funeral Home was one of the largest operations in town. Pictured is the funeral home's fleet of hearses and family cars parked in the front of the building.

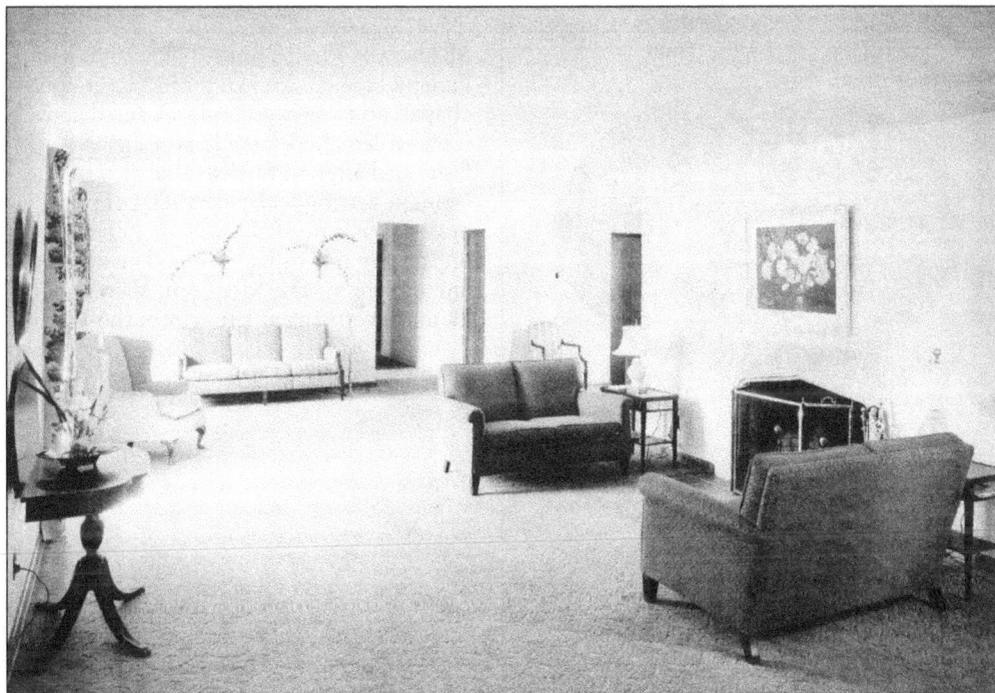

MOUNTAIN VIEW LOBBY. The Mountain View Funeral Home lobby is decorated comfortingly like a home living room, featuring a working fireplace flanked by two love seats. Additional seating is available throughout the lobby for private gatherings.

MOUNTAIN VIEW CHAPEL. Mountain View Funeral Home is known for its picturesque chapels and lovely grounds. Pictured above is its garden chapel, made of stone and fashioned after an English chapel. The intimate setting seats up to 100 people. If more space is needed, two larger chapels on the grounds will accommodate almost any size group. The Mountain View Funeral Home advertising at left is from the 1960s.

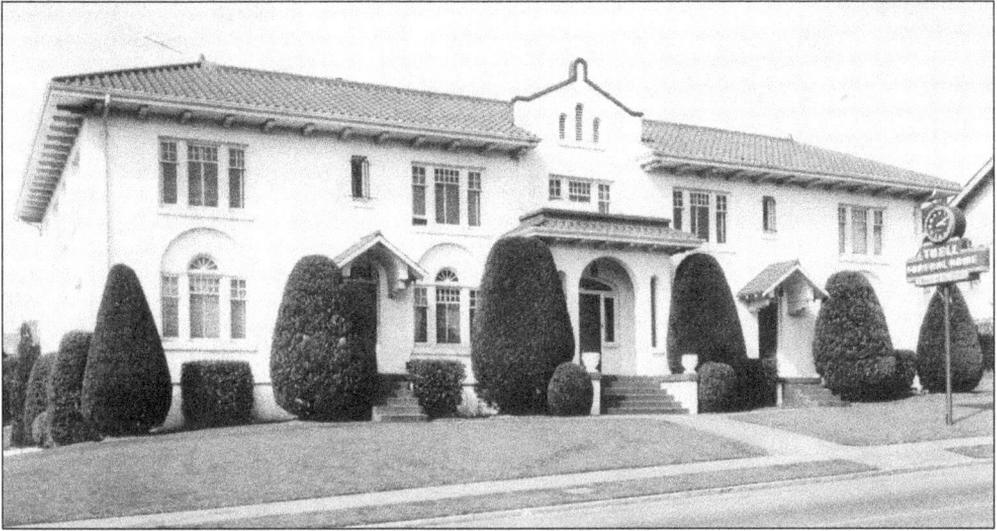

TUELL-MCKEE FUNERAL HOME. Built in 1927, the Spanish-style Tuell-McKee Funeral Home was designed by architect G. Bullard and constructed by Z. Maddux. First owned by David R. Tuell, a local civic leader, the home was originally known as the Tuell Funeral Home and nicknamed the "Chapel of the Chimes." Pictured below is Dave Tuell Jr. (left), president of the Tacoma Athletic Commission. Dave grew up in the Tuell Funeral Home, and his old bedroom now serves as current owner Tom McKee's personal office.

Tuell-McKee Lobby and Chapel. In 1926, the Tuell family opened its doors to serve the community. In 1990, the McKee family continued the tradition of caring for the families of the Tacoma area. Their website reads, "We pride ourselves in offering the finest in funeral and cremation services to people of all faiths, backgrounds, and beliefs." They have a lovely chapel that can seat up to 200 people. (Both, courtesy author's collection.)

CASKET SELECTION ROOM. Located on the second floor of the Tuell-McKee Funeral Home is the casket selection room. The industry for funerals has changed dramatically in the last few years, and the directors confess that most casket ordering now takes place online. The casket selection room and physical examples of final resting places may become unnecessary in the future. (Courtesy author's collection.)

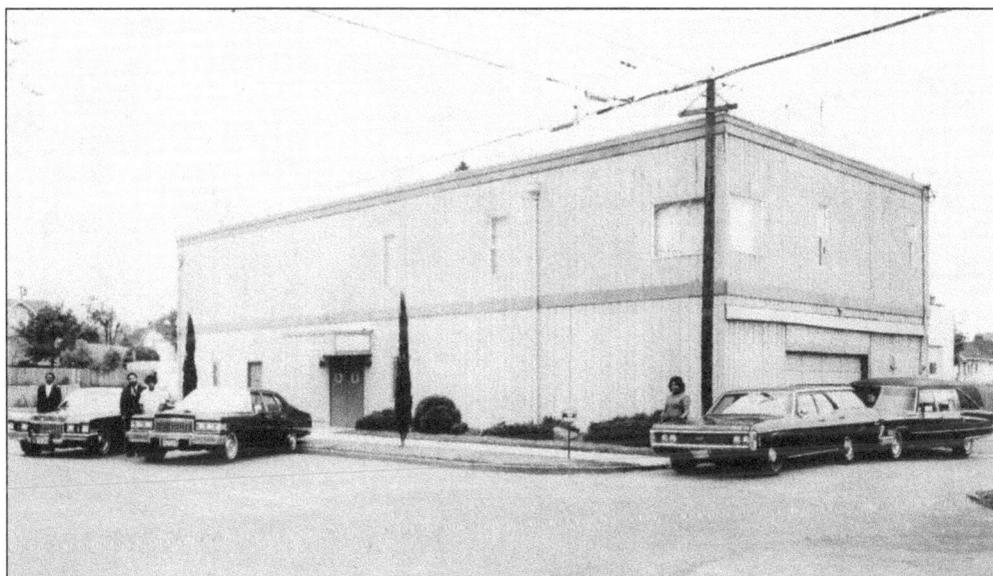

HOUSE OF SCOTT MORTUARY. This photograph is a part of the Richards Studio collection and is dated June 21, 1976. The mortuary is located at the corner of South Twenty-third Street and Sheridan Avenue. The business opened in October 1968 in a building that was erected in 1910 and first used as a bakery. The House of Scott has been serving families for more than 40 years.

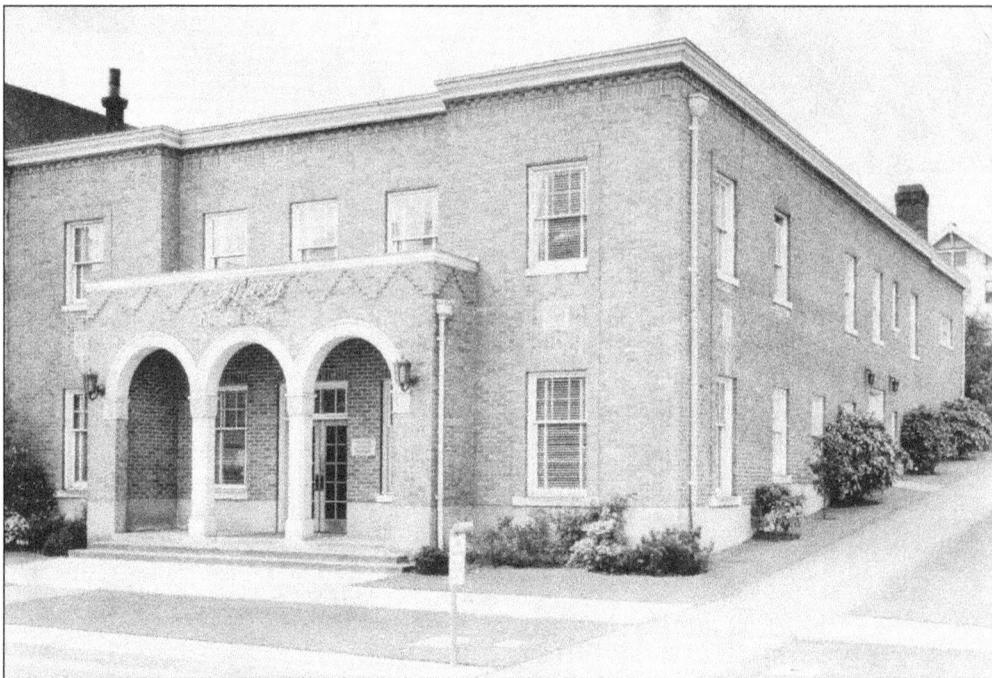

GAFFNEY FUNERAL HOME AND FAMILY. The Gaffney Funeral Home is one of the oldest family-owned-and-operated funeral businesses in the area. Theodore Gaffney and family have been in business since 1905. The mortuary has been located at 1002 Yakima Avenue South since 1932. Pictured below is Theodore Gaffney as a boy. The photograph is dated November 28, 1952.

Ten

TOOLS OF THE TRADE

Many who are drawn to and fascinated by cemeteries also may feel a sort of morbid curiosity about what transpires behind the scenes of a funeral home. During the research phase of this book, the author was privy to the "restricted tour" of various cemeteries and funeral homes. Because of the generosity of these cemeteries and funeral homes, the author is able to share pictures of select tools of the trade that would otherwise not be available to the public.

In addition to the inner rooms of funeral homes and private areas of cemeteries, there are also other necessary props in the procession of the death ceremony: morgues, caskets, sextons, burial vaults, florists, hearses, and headstones.

Choosing a headstone or marker is an emotional decision for families to make. A new, emerging trend in grave markers is an inexpensive technology that allows families to record a message that will be imbedded into the headstone. Loved ones may then play this message over and over again.

Many funeral homes have a plethora of vintage, business-related oddities tucked away in the basement such as an old Batesville casket key, an embalming machine from the 1960s, a box of disposable casket spray holders, open-backed suits in plastic, old funeral home signs that were attached to hearses, and old portable makeup kits. They are, within themselves, a miniature history museum of the trade.

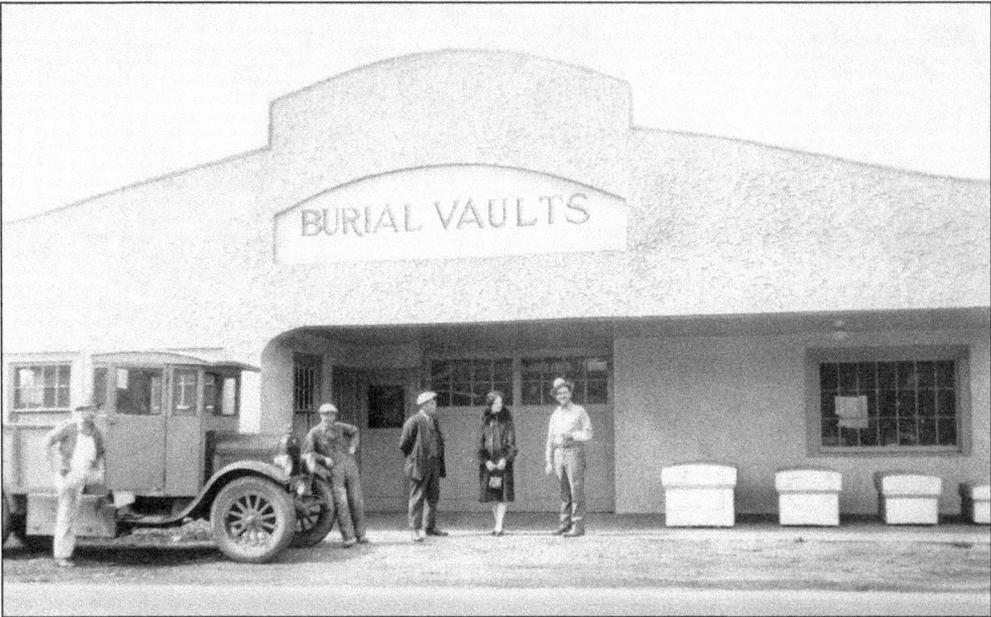

BURIAL VAULT COMPANY. Dan Trippear founded the Automatic Sealing Burial Vault Company in the early 1920s. During the early years, funeral directors would bring their clients directly to the store to choose their burial vaults. The vault company would then deliver the vault right to the designated grave. (Both, courtesy Catherine Goldsmith.)

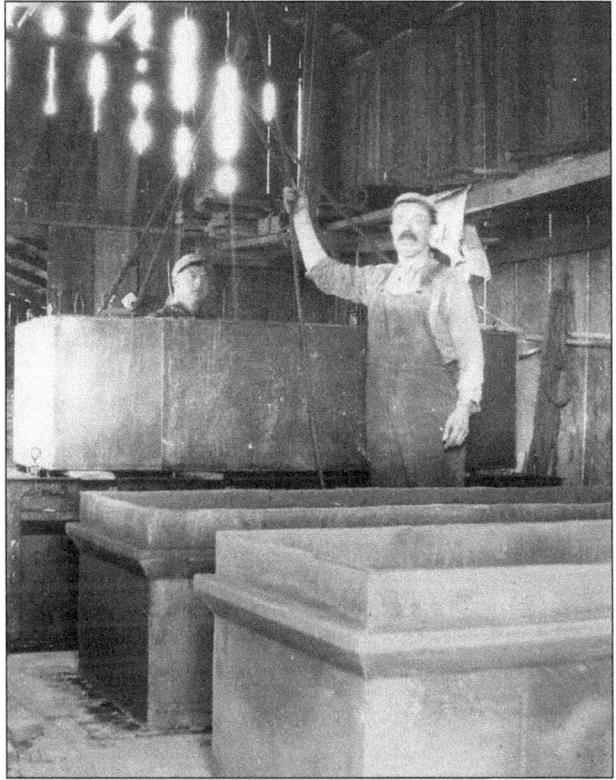

ORIGINAL WAREHOUSE ON CEMETERY PROPERTY. The Automatic Sealing Burial Vault Company was originally set up in an outbuilding on the property of the Old Tacoma Cemetery. Pictured is an unidentified employee manufacturing concrete burial vaults. (Courtesy Catherine Goldsmith.)

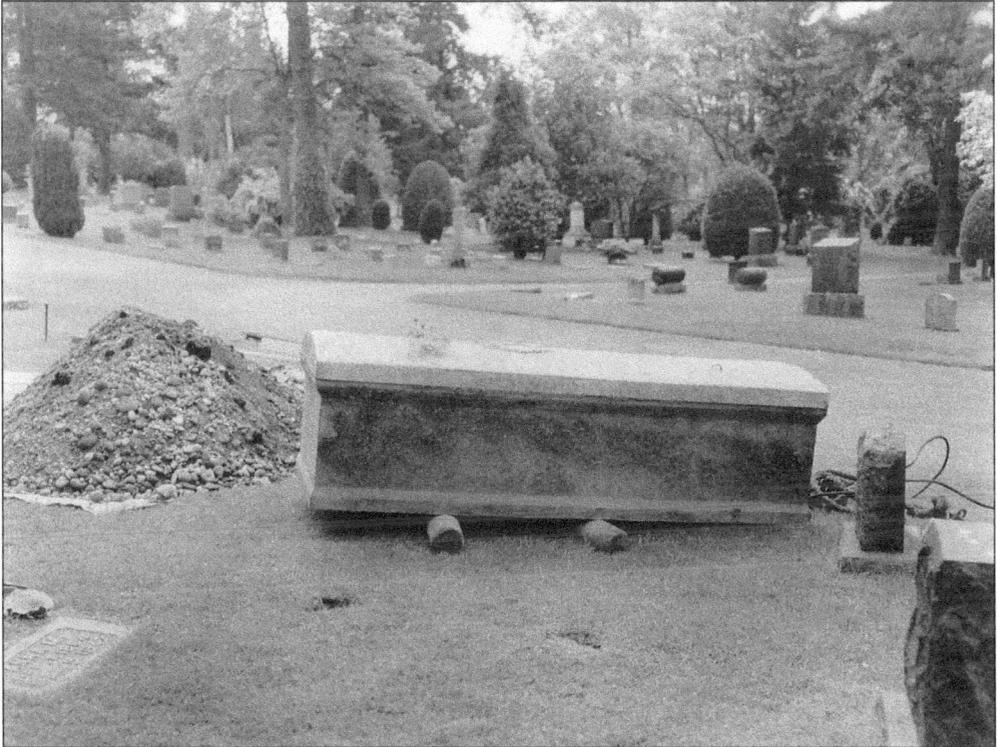

EXHUMING A VAULT. Sometimes families wish to move their loved ones to different locations within the cemetery. In this photograph is a vault that was exhumed and is prepared for a move. (Courtesy Catherine Goldsmith.)

NEW TO-DAY.

UNDERTAKING

HOSKA & LITTLEJOHN.

THE above named firm wishes to inform the people of New Tacoma and surrounding country that they have opened a first-class Undertaking establishment on Eleventh street, between Pacific avenue and A street, New Tacoma, W. T. They are prepared to furnish everything pertaining to the business, from a plain Rosewood Coffin to the finest Metallic Casket.

C. L. Hoska, of the firm, has had many years experience in the business.

Bodies Preserved and Embalmed!

Orders by telegraph or mail will receive prompt attention. 110 1m

THE TACOMA DAILY LEDGER — Wednesday — Aug. 15, 1883

FIRST UNDERTAKING BUSINESS. Littlejohn and Conrad L. Hoska are credited with being the first undertakers in Tacoma. At left is an advertisement placed in the *Tacoma Daily Ledger* on August 15, 1883. It reads, "Bodies Preserved and Embalmed!" (Courtesy Bill Habermann.)

HOSPITAL MORGUE. The morgue is used to store corpses that are waiting to be identified or bodies that are waiting to be transferred to a funeral home. This photograph, dated 1928, is of the Pierce County Hospital Morgue.

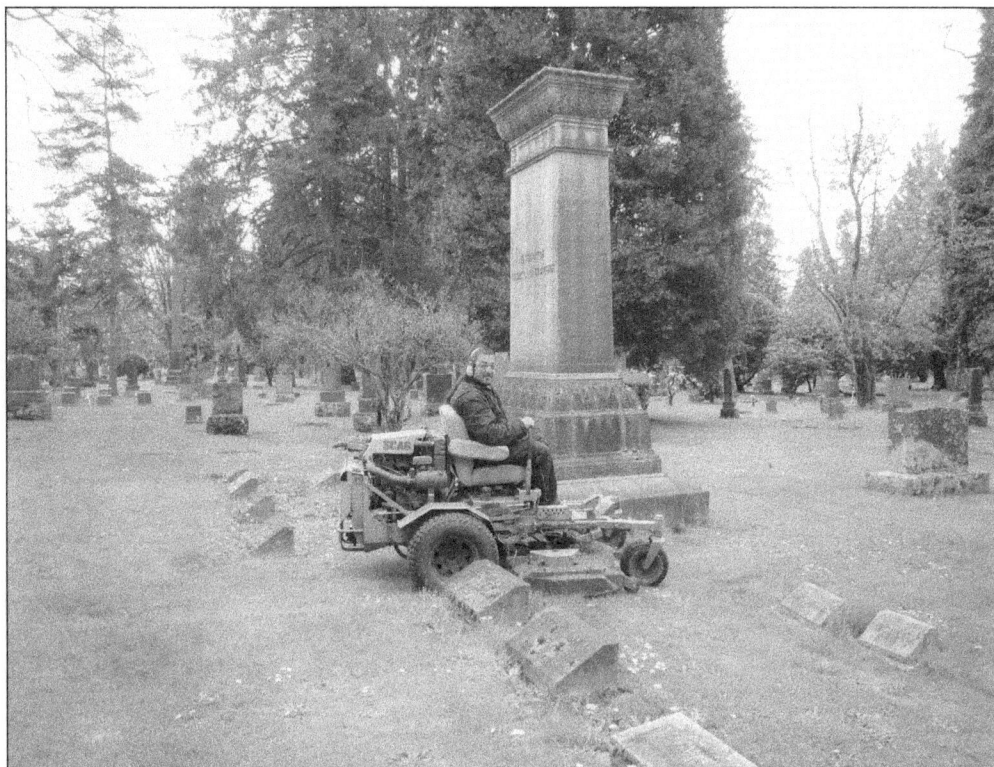

OLD TACOMA CEMETERY GROUNDSKEEPER. Ron Anijio, the groundskeeper for more than 20 years at the Old Tacoma Cemetery, neatly mows around the raised markers and upright monument of Robert Laird McCormick. McCormick was a prominent attorney and the namesake of a much-beloved north end library. (Courtesy of author's collection.)

PIPER-MORLEY-MELLINGER TOOL LOT. Pictured is a case reminiscent of a fishing tackle box that is filled with various embalming tools, as well as an old box of casket spray holders to hold flowers securely on top of a casket, a Batesville casket key, and other oddities. Also pictured is an old Piper Funeral Home sign that may have been attached to a family car or hearse during a funeral procession. (Courtesy of author's collection.)

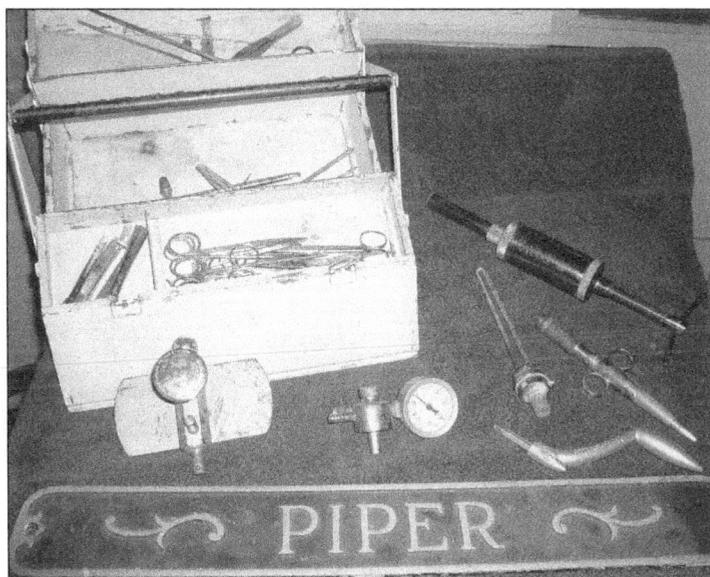

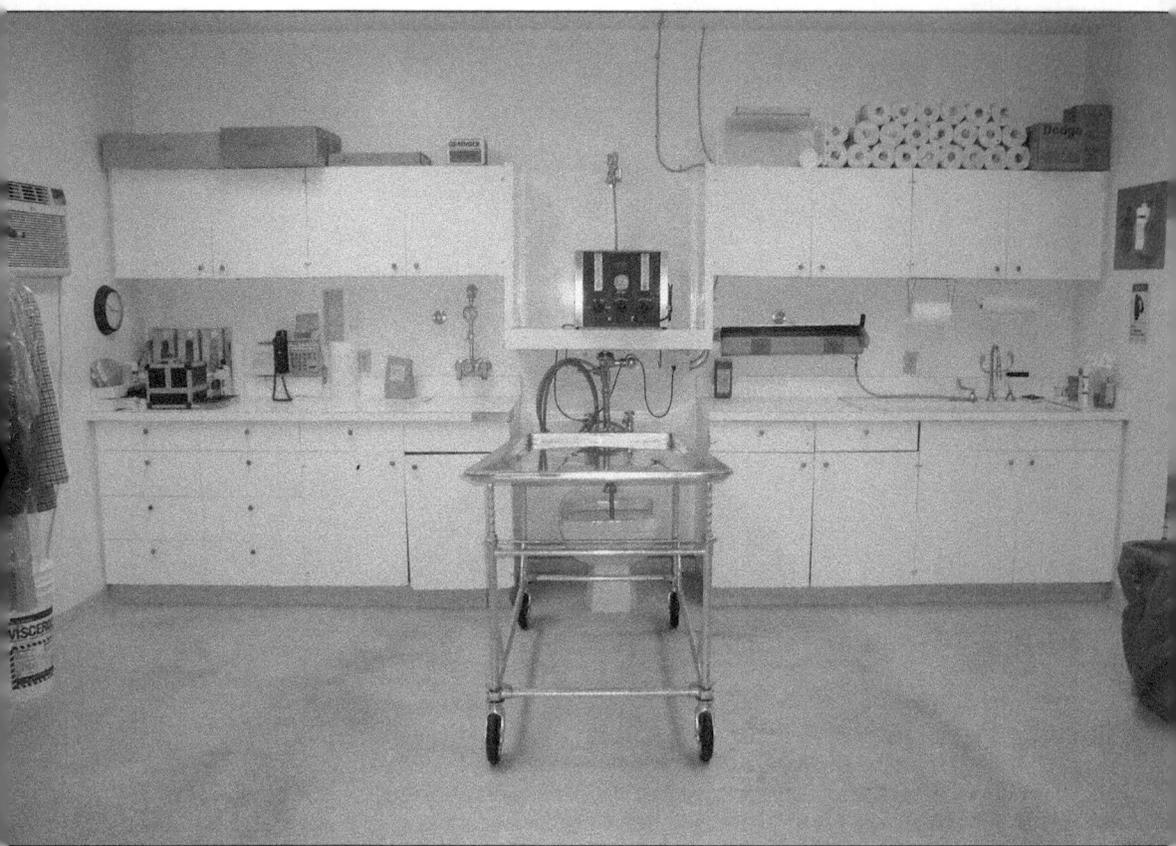

STATE-OF-THE-ART EMBALMING ROOM. The New Tacoma Cemeteries and Funeral Home has one of the newest embalming rooms and some of the most modern equipment in the area. This embalming room is known as the preparation room. This room is used for embalming, sanitation, and restoration of human remains. (Courtesy author's collection.)

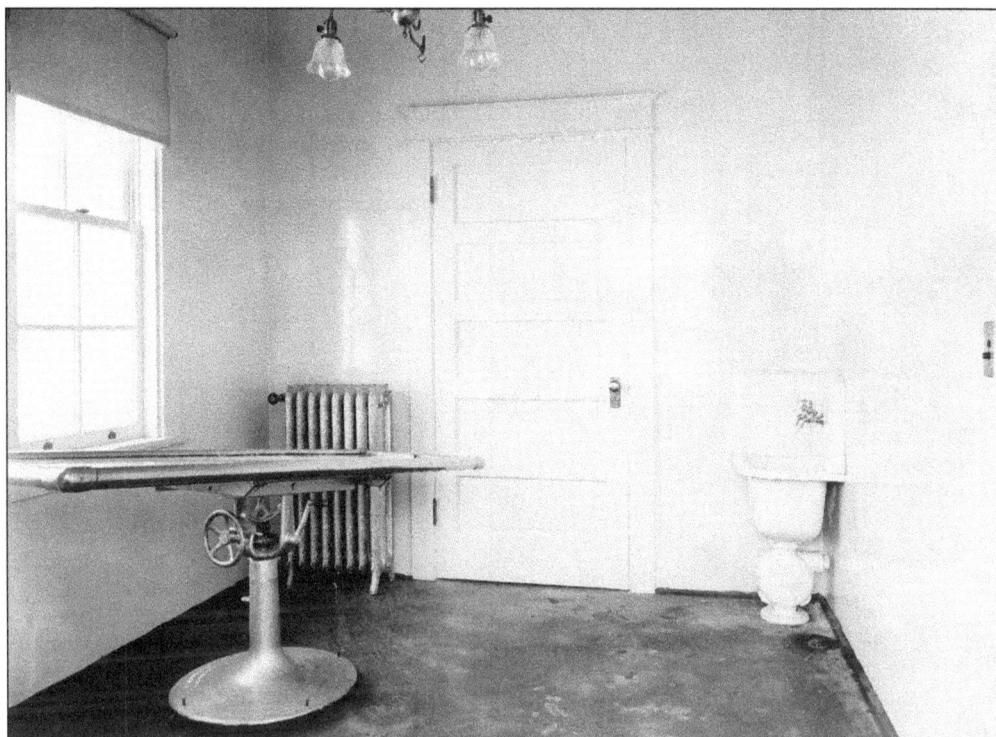

VINTAGE EMBALMING ROOM. Pictured is C.C. Mellinger's embalming room. This photograph was probably taken in the early 1900s. The actual embalming machine was probably portable and moved into the room when it was ready to be used. Most preparatory rooms are located in the basement of funeral homes. It is interesting to note that this room appears to be at least at ground level and has a picture window. (Courtesy Fred Morley.)

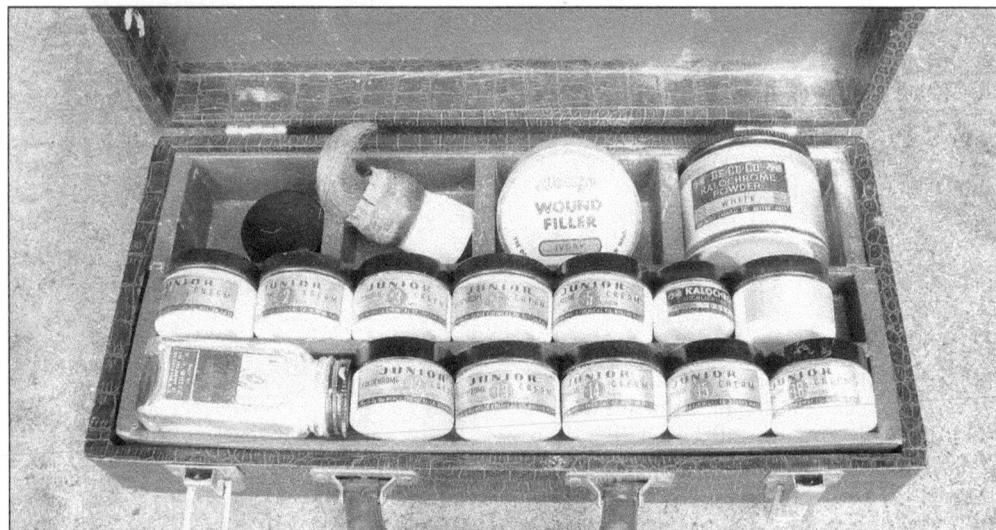

VINTAGE MAKEUP CASE. This leather case was made by the Dodge Chemical Company of Cambridge, Massachusetts. The company was established in 1957, and this case is one of its earlier products. The case is complete with "wound filler" in ivory and other powders and bases—no color cosmetics seem to be included. (Courtesy Bill Habermann.)

MODERN EMBALMING MACHINE. A Dodge-manufactured embalming machine is used for vascular introduction of embalming fluid into the deceased. Pictured is the modern embalming machine of the New Tacoma Cemeteries and Funeral Home. (Courtesy author's collection.)

MID-20TH-CENTURY EMBALMING MACHINE. Pictured is an embalming machine from the 1960s with its hoses still attached. It is made from a heavy porcelain material, whereas the newer machines are all stainless steel. Various vintage pressure knobs and gauges are in working order. This machine belongs to the Piper-Morley-Mellinger Funeral Home, and it is no longer in service. (Courtesy author's collection.)

REFRIGERATED ROOM. Perhaps one of the largest refrigerated rooms of the industry belongs to the New Tacoma Cemeteries and Funeral Home. This room is also referred to as "the cooler." (Courtesy author's collection.)

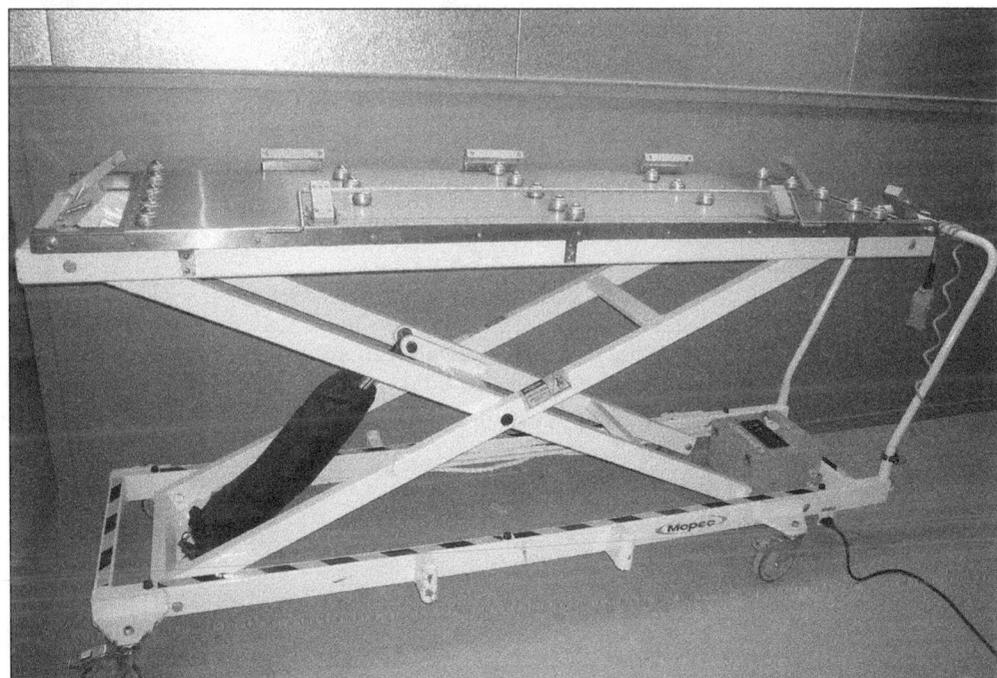

HYDRAULIC SCISSOR LIFT. This newly designed scissor lift aids in the process of transferring human remains within the prep room, cooler, and crematory. It belongs to the New Tacoma Cemeteries and Funeral Home. (Courtesy author's collection.)

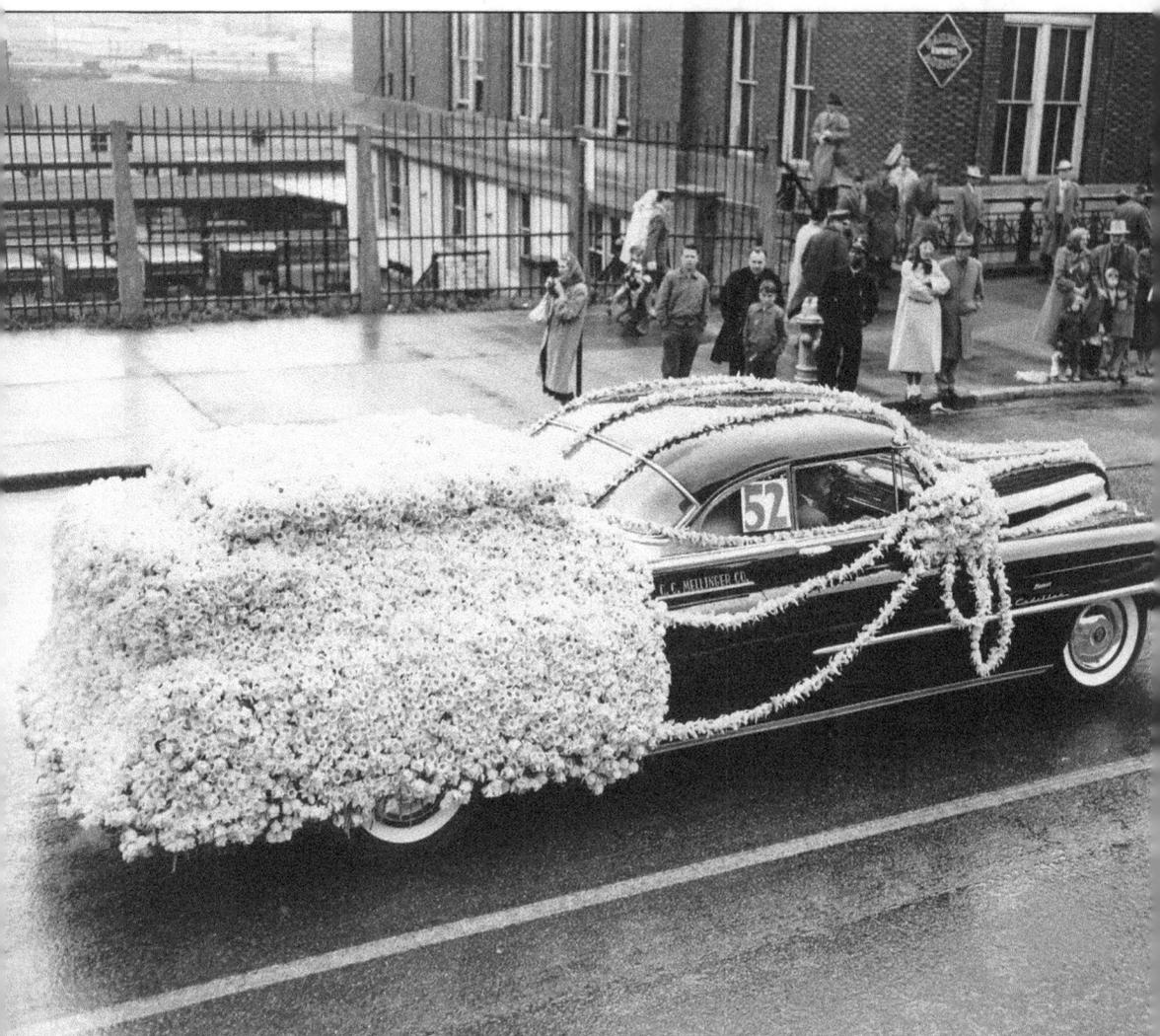

C.C. Mellinger Flower Car. The C.C. Mellinger Company was a very wealthy funeral business. Mellinger had several hearses, family cars, and specialty cars in his fleet. Pictured is a Cadillac Meteor that was used for transporting flowers to funerals. Perhaps showing off a bit, and rightly so, the car participates in Tacoma's favorite street parade of the 1950s, the Daffodil Parade.

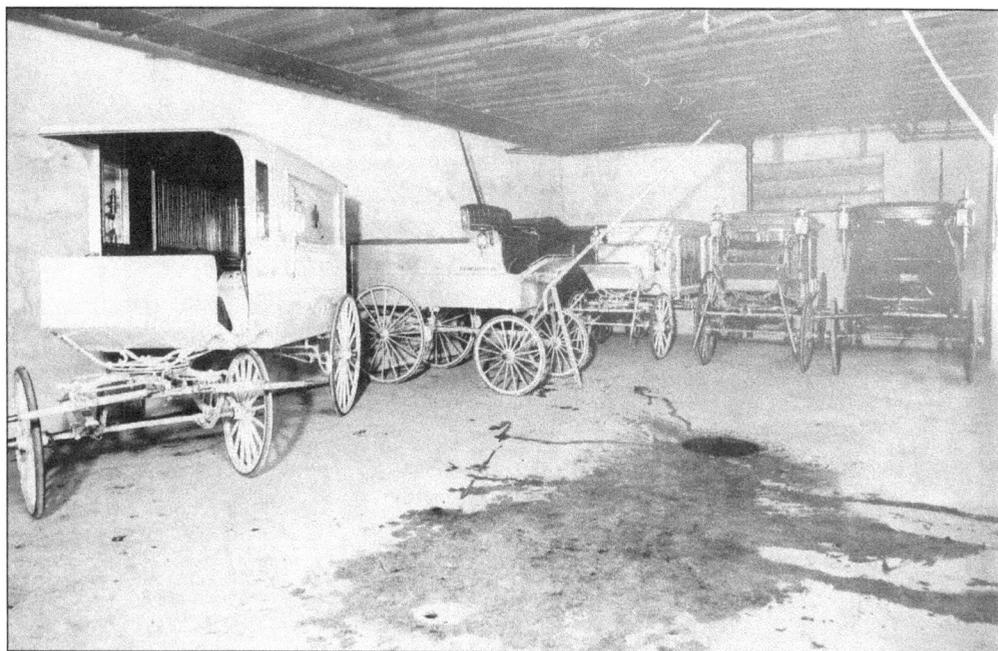

C.C. MELLINGER "STABLE." Located beneath the C.C. Mellinger Funeral Home was the so-called "stable" where Mellinger kept his hearses, removal wagons, and other modes of transportation, including an electric ambulance. The mess on the ground shows that horses were nearby but were kept at a different location. (Courtesy Fred Morley.)

FAMILY CARS. Sleek family cars were used to transport family and staff. In this photograph is a family car parked below the ground-level entrance. This was considered a staff-only area, and the car is probably waiting to be dispatched. (Courtesy Fred Morley.)

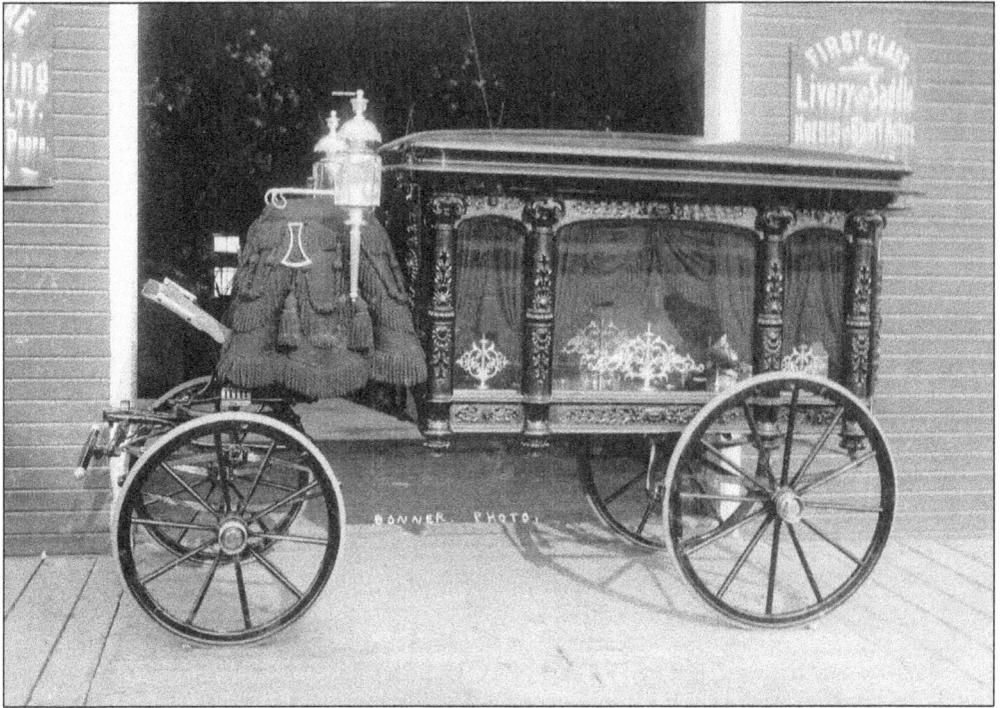

BLACK AND WHITE HEARSES. C.C. Mellinger had two hearses among his fleet. One was black and masculine, reserved for men. The other was white, a bit smaller, and more feminine and was reserved for women and children. Both were incredibly ornate, plush on the inside, and lavishly embellished on the outside. (Both, courtesy Fred Morley.)

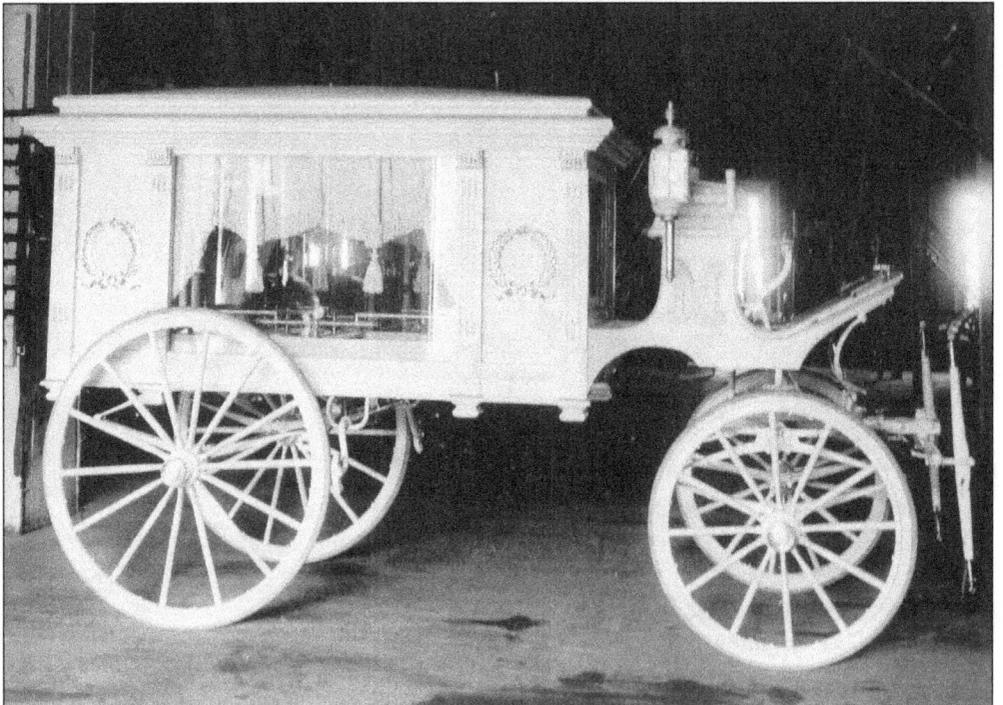

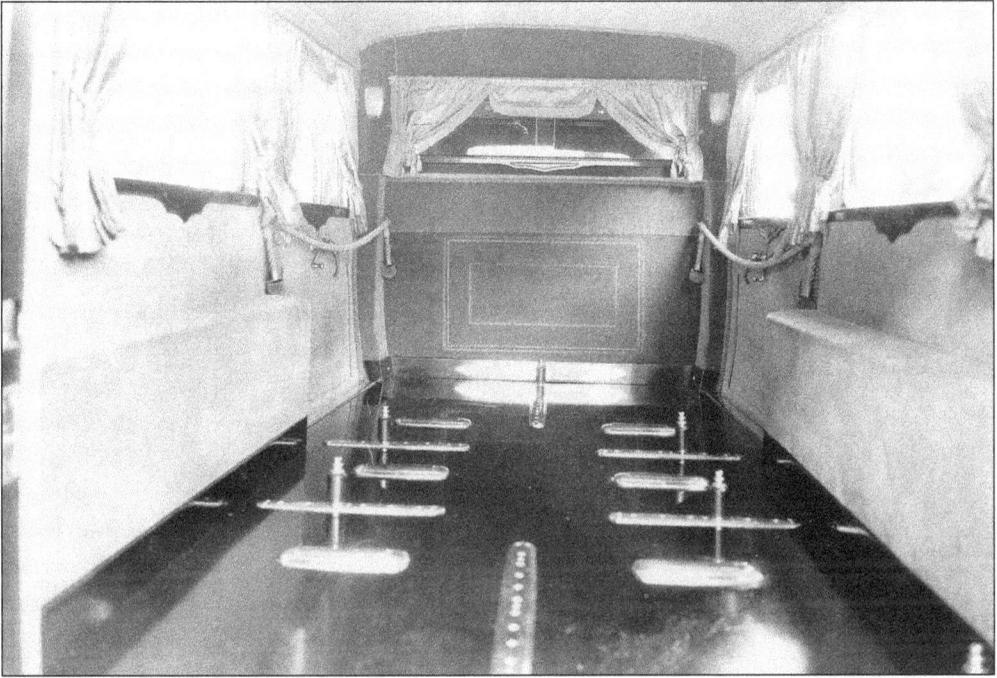

INTERIOR OF VINTAGE AND MODERN HEARSES. Pictured above and below are the interiors of vintage and modern hearses. Above is Mellinger's hearse from the 1920s, and below is Tuell-McKee's 1996 hearse. Not a lot has changed in 90 years. They are both plush with heavy curtains, and they both have a system of rollers to glide the casket easily inside. (Above, courtesy Fred Morley; below, courtesy Tom McKee.)

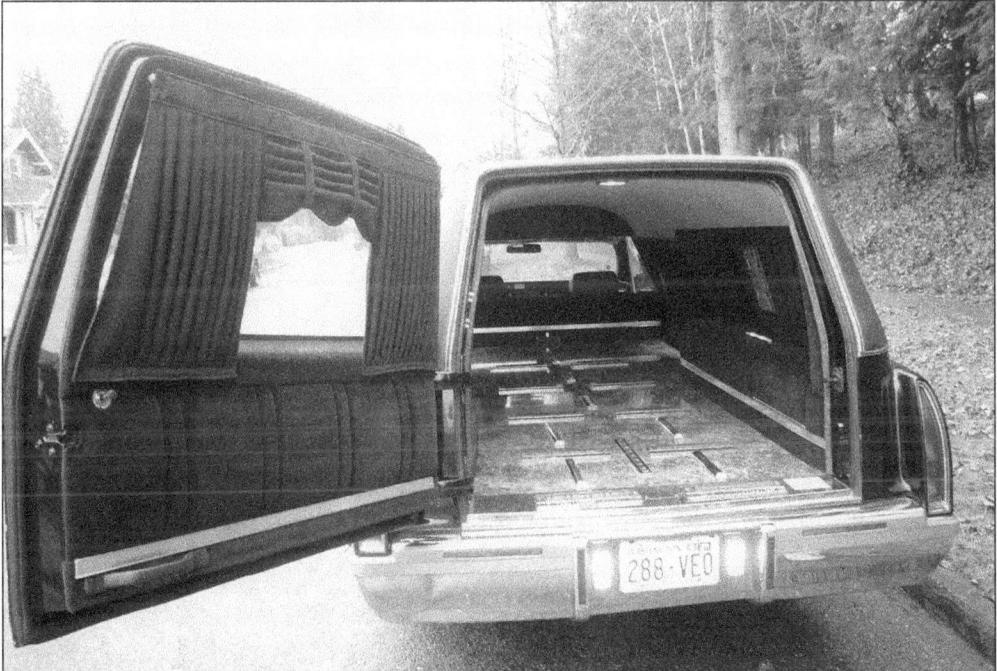

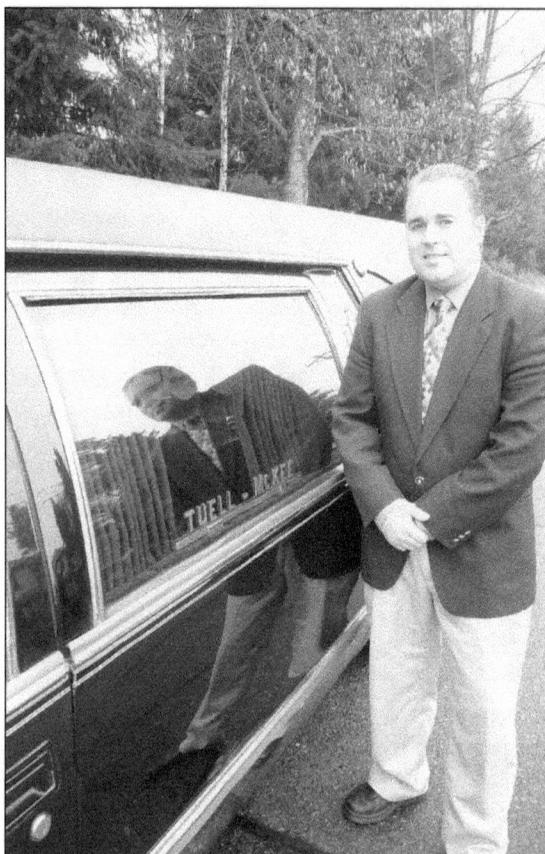

TUELL-MCKEE HEARSE. Jeff Gollihur is a funeral director with Tuell-McKee Funeral Home and is pictured here next to a modern, 1996 Cadillac Fleetwood hearse. The funeral home has been known to use this hearse in long funeral processions. It is equipped with a flashing light system for such purposes. (Courtesy author's collection.)

EMBALMING TOOLS. Pictured is a pair of eye caps and a mouth former. The eye caps are a thin, dome-like shell made of plastic, placed under the eyelids to restore natural curvature and maintain the position of posed eyelids. The mouth former is used for similar purposes when preparing the mouth of the deceased for viewing. (Courtesy author's collection.)

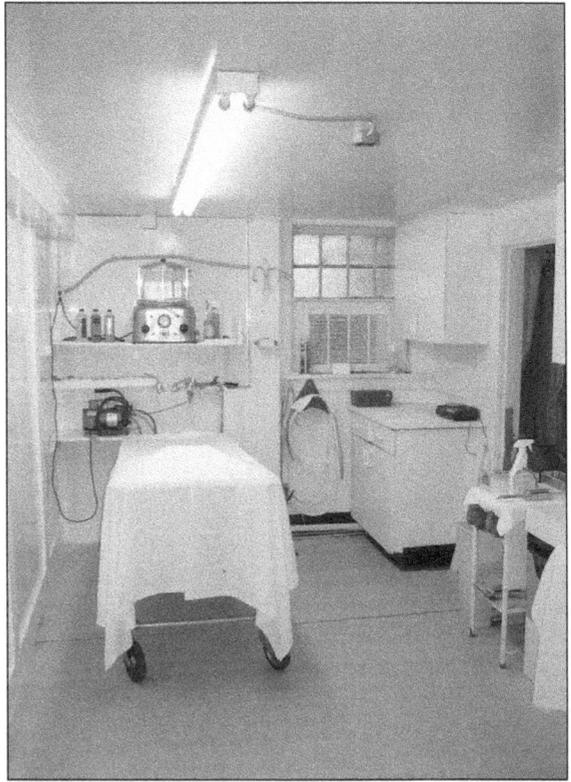

TUELL-MCKEE EMBALMING ROOM.
Here is a modern example of
an embalming room complete
with all the necessary tools,
machines, and fluids. (Both,
courtesy author's collection.)

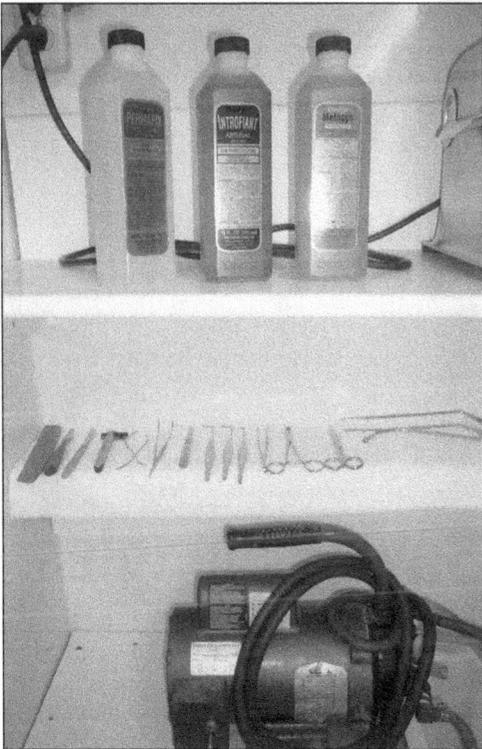

MONUMENT STOREFRONT. The Western Monument Works Company specialized in cemetery monuments and grave markers. It opened in 1926 and was located at 1114–1116 Center Street in Tacoma. This photograph is dated 1956.

VINTAGE MONUMENT ADVERTISEMENT. It is uncertain which newspaper this advertisement appeared in; however, it is a typical example of late-19th-century advertising for monuments. When strolling through any Victorian cemetery, one can see several of these monument types represented. (Courtesy Bill Habermann.)

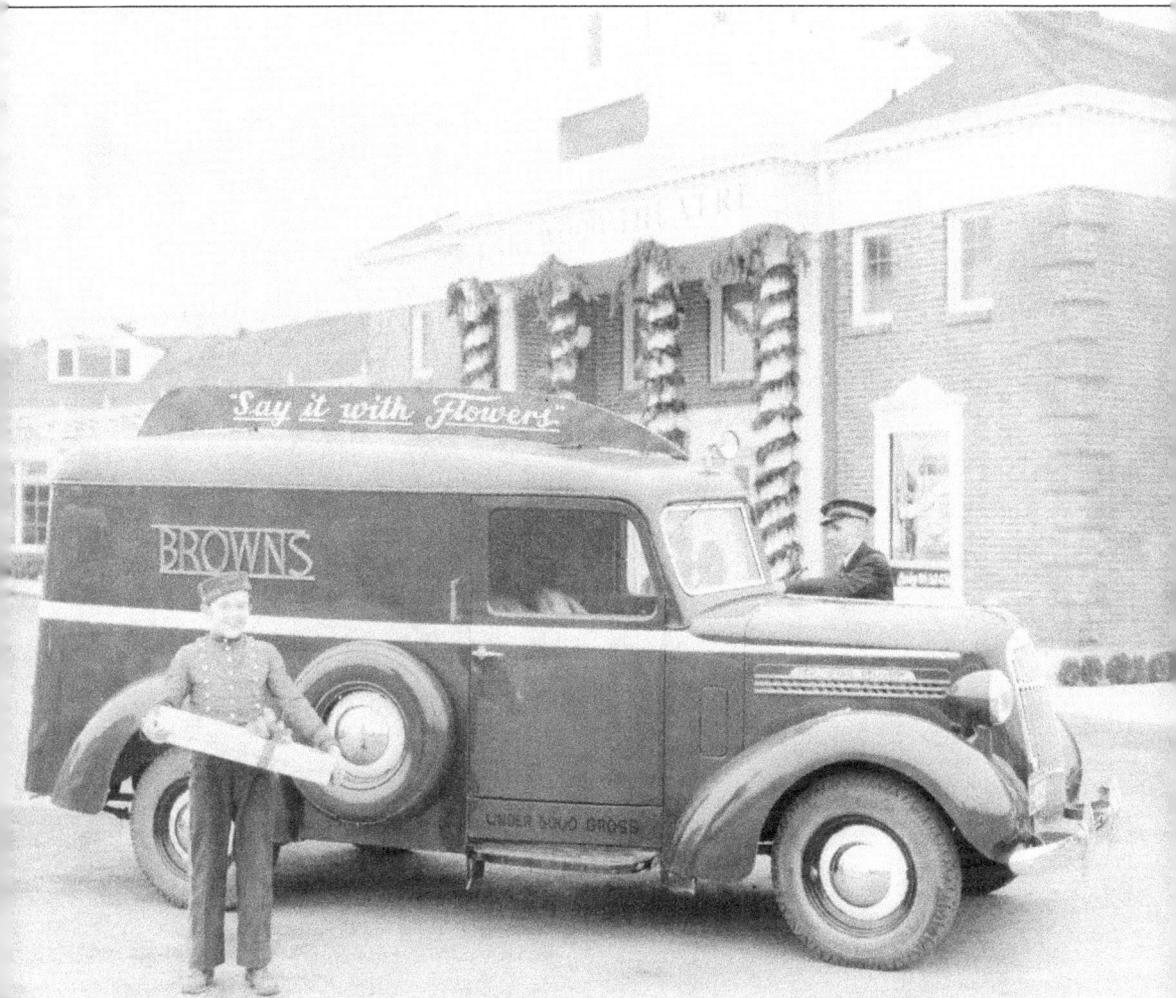

BROWN'S FLOWERS. "Say it with Flowers," reads the slogan for Brown's Flowers in 1926. Pictured is delivery boy Chris Turlis. Notice his uniform, complete with hat. Brown's Flowers is a close neighbor to the Old Tacoma Cemetery, so it has provided floral arrangements for funerals for decades. This photograph is dated December 1937. Brown's guarantee is 100 percent satisfaction. One of Tacoma's oldest and most trusted florists, Brown's Flowers is located at 4734 South Tacoma Way. The company has a website and takes online orders as well. Pictured in the background is the Lakewood Theatre. The theater's grand opening was on July 8, 1937.

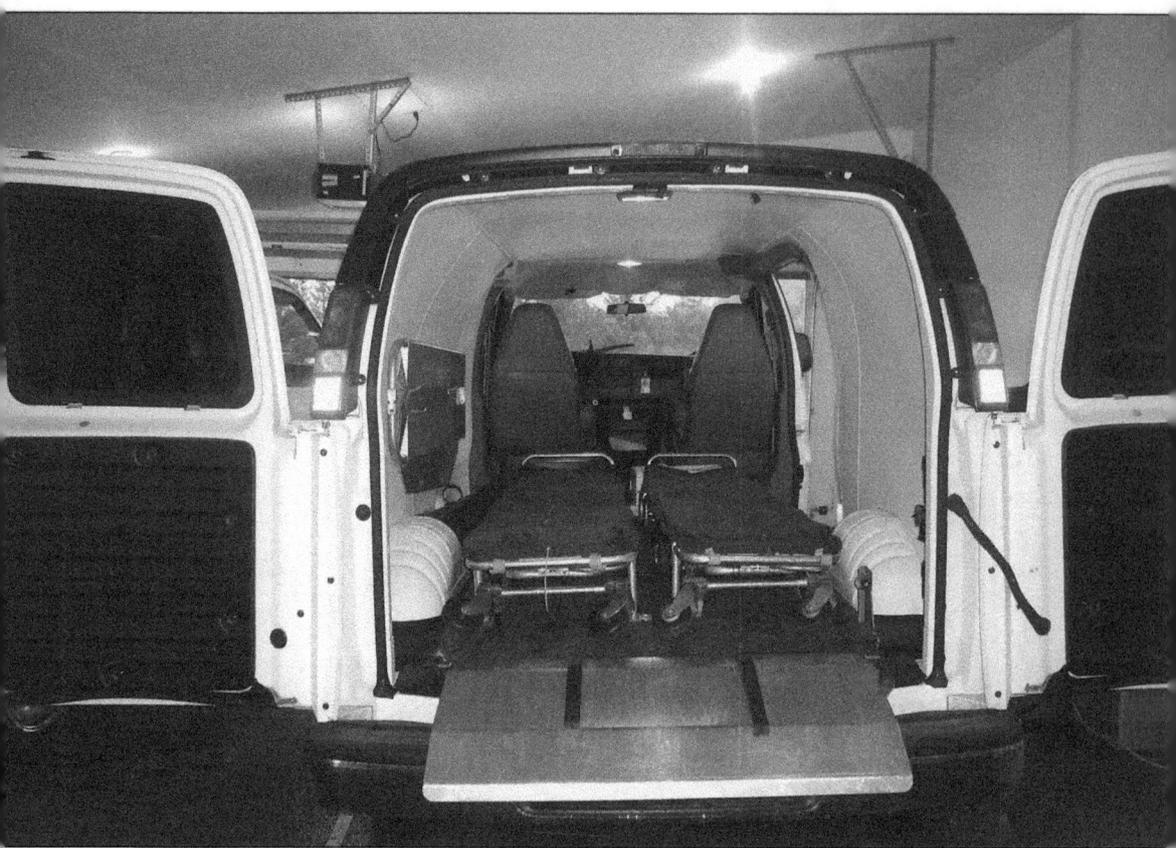

FIRST-RESPONSE VEHICLE. In Victorian times, first-response vehicles were called removal wagons. They were draped with black curtains and equipped with bells that were attached to each lamp post. The bells were to alert the townspeople that someone in their community had passed. Residents would come out of their homes to line the streets and mourn with their fellow neighbors. Today, these first-response vehicles are unmarked white vans, like the one pictured above. Attitudes toward death have changed over the years, and privacy is now preferred as it is considered more dignified.

PUGET SOUND CASKET COMPANY. Coming out of the Great Depression in the 1940s, Americans felt more optimistic. Wages increased, and families began to hope for a better future. They began to spend more money. The Puget Sound Casket Company catered to families who desired plush caskets. Many of the caskets, like the one above from the 1930s, were made-to-order. The fabric is a floral, velvet cutout pattern. The York Group acquired Puget Sound Casket Company in 1996. Caskets are also available online these days. Even the discount chain Costco carries a line. Pictured below is a vintage box of casket spray holders. They were meant to keep the large floral spray of flowers on the top of the caskets in place. (Below, author's collection.)

VINTAGE AND MODERN RETORTS. A retort is a machine used for cremation. A processor is then used to break down bone fragments into smaller particles. Pictured above is a vintage retort used in the early 20th century (no longer in operation), and at left is a modern retort that is currently in operation at a local funeral home. (Above, courtesy Bill Habermann; left, courtesy author's collection.)

RETORT VIEWING AREA AND TOOLS.
The modern retort comes with two
windows for viewing and monitoring
the interior. Below, some of the tools
used, from left to right, are a foxtail
brush, a magnet, another foxtail brush,
a scoop, and surgical scissors. These
items are used to collect cremated
human remains for processing and to
remove metal parts from the deceased.
(Both courtesy author's collection.)

PAINTED CURTAIN. The cinema was extremely popular in the mid-1920s. Here is a painted cinema curtain that was used for advertising; the cinema where the curtain hung is unidentified. A Seattle-based funeral parlor is advertised on the left. Photographs of these curtains are rare. This one is dated 1925.

C.C. MELLINGER ADVERTISING. Here is one of many successful advertisements by the C.C. Mellinger Company. It reads, "Pay what you can afford," as folks of the early 1900s were mindful of their money. Today, C.C. Mellinger is owned by Fred Morley, who is one of the only funeral directors in town that will rent a casket for viewing. The company is still in the business of helping families with affordable funerals. (Courtesy Bill Habermann.)

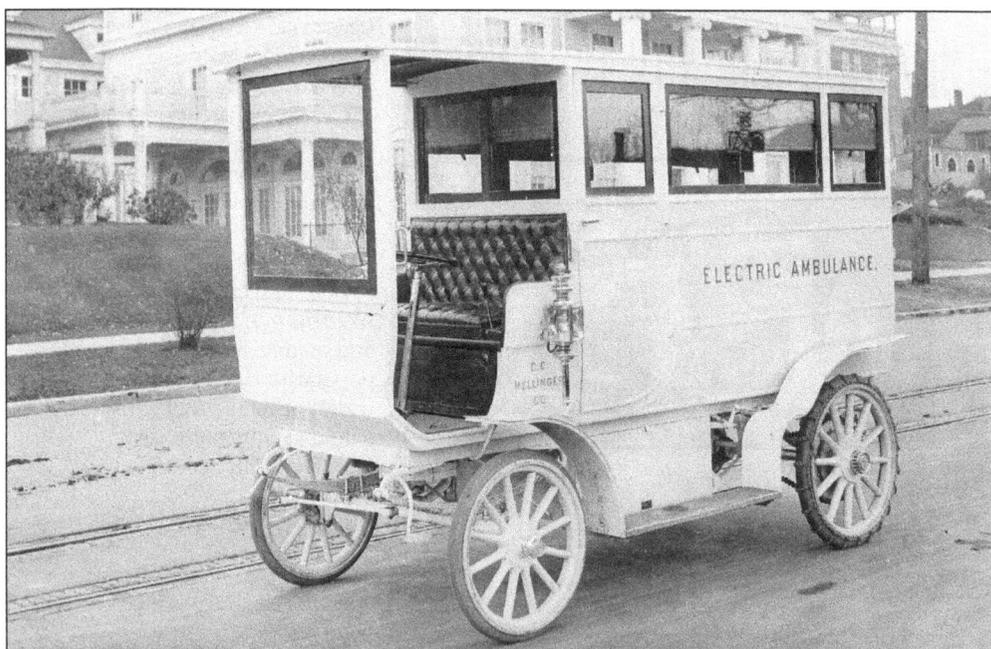

ELECTRIC AMBULANCE. In 1920, C.C. Mellinger Funeral Home was the only firm that owned an electric ambulance. The electric car was a status symbol as well as a widely used community service vehicle. Electric cars were more expensive than the combustion-engine vehicles that Henry Ford made widely available. By the 1930s, these cars were largely out of use. (Courtesy Bill Habermann.)

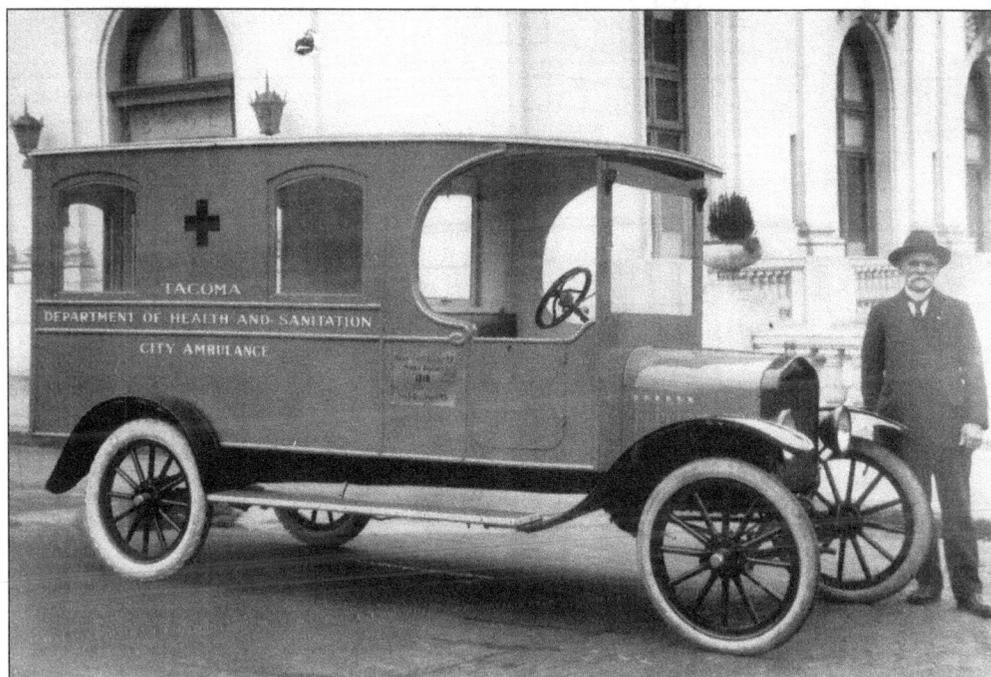

TACOMA AMBULANCE. In this photograph is the Tacoma Department of Health and Sanitation's city ambulance. Dr. Ivan Balabanoff is pictured next to the ambulance, which he donated to the department in the early 1900s.

Cremation Society of Tacoma

By the Process of Cremation the Human Body Never Sees Decay

For information and literature on Cremation write

CREMATION SOCIETY OF TACOMA
Tacoma, Wash.

CREMATION ADVERTISEMENT. Cremation was considered an alternative way of burial in the early 20th century, and it required clergy support to bring about its acceptance. However, once the public embraced the new burial trend, they appreciated it as an economical option. Advertisements like this one reached many, and cremation increased in popularity. Today, cremation is widely accepted and considered a land-saving alternative. (Courtesy Bill Habermann.)

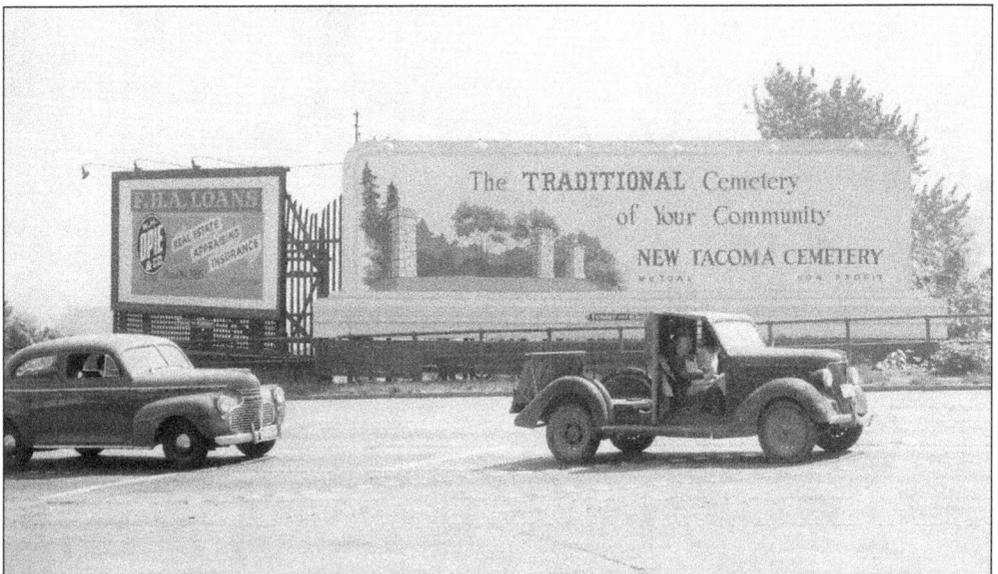

BILLBOARD ADVERTISEMENT. The New Tacoma Cemeteries and Funeral Home advertises on billboards, reminding travelers that the journey of life must end at some point. Today, prearranged funerals are on the rise as folks realize the benefit of paying over time for funeral expenses, which can exceed $10,000.

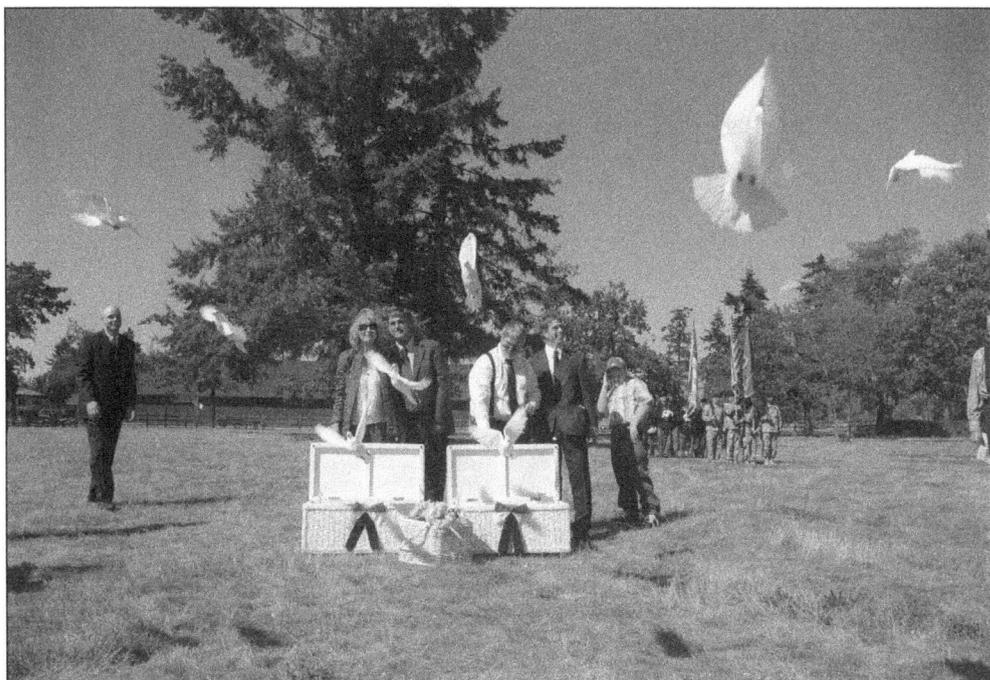

THE GRAVE CONCERNS ASSOCIATION. Cofounded and chaired by Laurel Lemke, the Grave Concerns Association is a volunteer organization dedicated to the restoration of the historic Western State Hospital Cemeteries. The group, a 501(c)(3) charity organization, raises money to replace deteriorating numbered markers with granite markers that have actual names etched in them. The group hosts installation events, celebrations, and fundraising projects, and it provides educational opportunities to various outreach groups. The Grave Concerns Association joins its efforts with those of other community members to meet their mission of restoring and enhancing the patient cemeteries. Volunteers are always needed, and interested individuals can learn more by visiting the association's website at www.wshgraveconcerns.org.

Visit us at
arcadiapublishing.com

. .

www.ingramcontent.com/pod-product-compliance
Lightning Source LLC
Chambersburg PA
CBHW080608110426
42813CB00006B/1439

* 9 7 8 1 5 3 1 6 4 9 7 2 2 *